The Peloponnese

A traveller's guide to the sites, monuments and history

E. Karpodini-Dimitriadi
Archaeologist

EKDOTIKE ATHENON S.A.
Athens 2002

ISBN 960-213-013-X

Copyright © 1981
by
EKDOTIKE ATHENON S.A.
1, Vissarionos Street
Athens 106 72, Greece

PRINTED AND BOUND IN GREECE
by
EKDOTIKE HELLADOS S.A.
An affiliated company
8, Philadelphias Street, Athens

Publishers: George A. Christopoulos John C. Bastias
Managing Editor: Efi Karpodini - Dimitriadi
Translation: Louise Turner
Art Director: Nicos Andricakis
Cover Design: Angela Simou
Special Photography: T. David, N. Kontos, R. Schoder,
M. Skiadaressis, S. Tselentis, S. Tsavdaroglou, St. Stournaras

CONTENTS

3

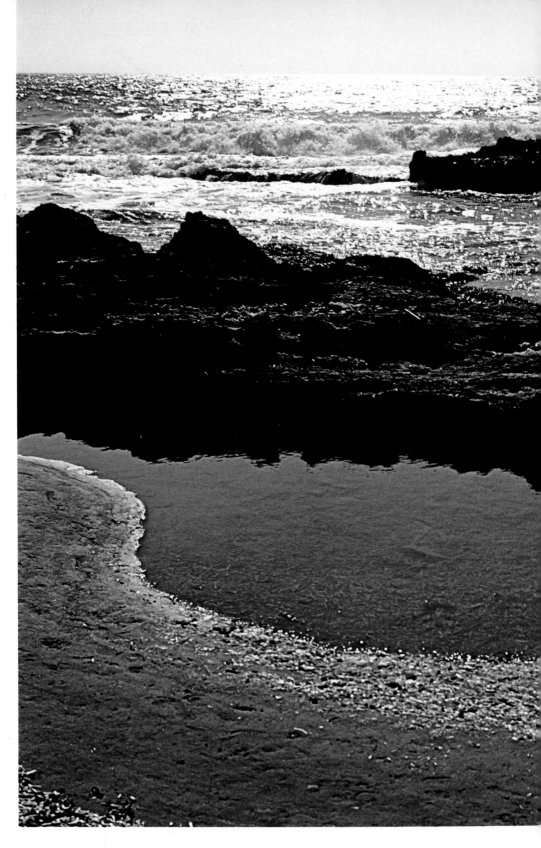

1. The Peloponnese, shaped like a plane leaf, extends southwards from the Isthmus of Corinth. Fringed with idyllic beaches like this one at Kyllene, the peninsula not only offers the visitor the chance to admire interesting sites, but also affords him endless opportunities to explore a past inextricably mixed with the present against backgrounds of incomparable beauty.

2. Set in enchanting landscapes one may see the monuments of a long and turbulent period of history. The ruins of temples especially leave a strong impression of grandeur with their columns reaching magnificently into the sky as if to conquer it (Bassae, the Temple of Apollo). ▶

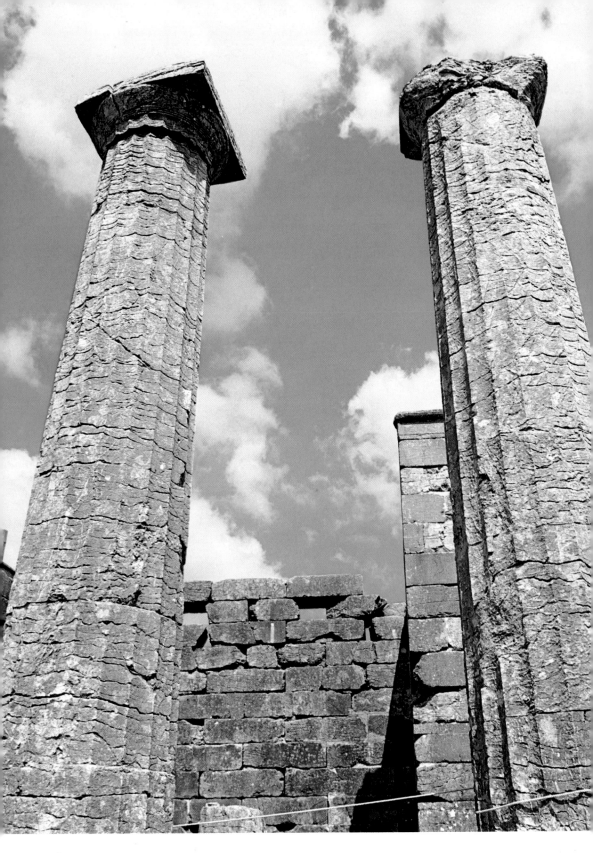

INTRODUCTION

THE HISTORICAL
AND GEOGRAPHICAL SETTING

The Peloponnese is the southernmost extremity of the Balkan peninsula. Itself a peninsula, the largest in Greece, it is linked to the Greek mainland by a narrow neck of land, the Isthmus of Corinth, only 5 kms. wide. In 1893 a Canal was cut across it, to shorten the sea passage from East to West. The Peloponnese covers an area of 21,439 sq. kms., and has a population of 986,912 (1971 census). The terrain is mountainous, levelling out to fertile alluvial plains at the head of inlets and along the coast. The morphology of the area and its favourable geographical situation have played an important part in the history of the Peloponnese, attracting many peoples of similar or differing origins.

Today it is divided into seven prefectures (nomes), still preserving the names they bore in antiquity and approximately the same boundaries: the *Argolid* (eastern), *Corinthia* (north-east), *Achaea* (north), *Elis* (north-west), *Messenia* (south-west), *Laconia* (south-east) and *Arcadia* (central). Part of Corinthia extends into *Sterea* (central Greece), beyond the Isthmus, which today is regarded as the dividing line between the Peloponnese and Central Greece. Here again tradition is upheld, because in antiquity Corinthian authority extended into *Sterea* as far as Mt. Gerania. Conversely, a section of the Argolid peninsula and most of the islands lying close to the eastern Peloponnesian shore (Kythera, those of the Argolic and Saronic Gulfs) belong administratively to the nome of Piraeus.

Each region of the Peloponnese offers special interest to the visitor, both because of the unique grandeur and beauty of the scenery and because of the many archaeological sites, where the past is so vividly present.

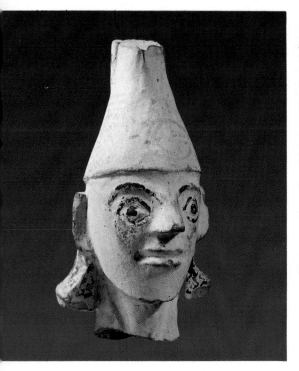 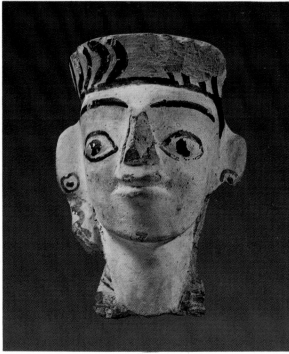

3-4. Two terracotta heads from the vicinty of Amyclae (Sparta). The first, with its decisive expression, dates to the Geometric period, the second is Mycenaean. (Athens, National Archaeological Museum).

The Peloponnese was already inhabited in prehistoric times. Its first settlers, according to Herodotus, were the Pelasgians (3000 B.C.). They were followed around 2000 B.C. by Indo-European peoples, the ancient Achaeo-Aeolians and Ionians, who came to the area in great numbers and established themselves in the south-eastern, western and northern parts of the peninsula. The Pelasgians, i.e. the pre-hellenic tribes, retained the central Peloponnese, the Arcadian mountains. The Achaeans soon became experienced and courageous seamen, and during their voyages, they came into contact with the Minoan civilisation, by which they were strongly influenced. As time elapsed, they came to dominate the Minoans and this created a new and brilliant civilisation, the Mycenean. By about 1300 B.C. they had spread over Crete and to the Aegean islands, the shores of Asia Minor, Cyprus and even as far as the Egyptians coast. At the same time, in the Peloponnese, many centres of civilisation flourished: Mycenae 'rich in gold', Argos, Tiryns, Amyclae and Pylos, whose wealth is testified by the rich and valuble objects excavated from their sites. Towards end of the twelfth century B.C., the Mycenean civilisation came to an abrupt end. Its important centres were destroyed, most of them by fire. The causes of this disaster remain unknown. The ancients attributed it to the Herakleides, the descendants of Heracles, who returned to establish themselves in the area their forebears had inhabited and from which they had been expelled by Eurystheus. After the collapse of

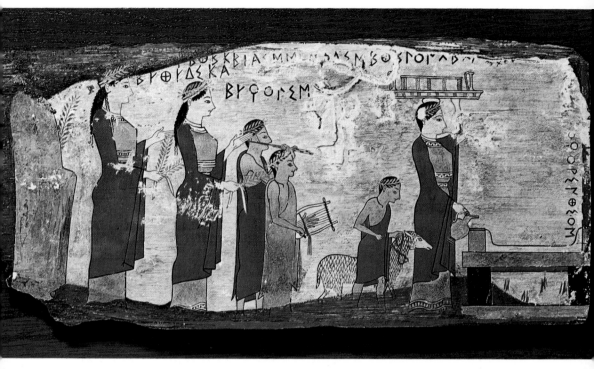

5. *Wooden painted tablet depicting a scene of sacrifice found in a cave near the village of Pitsa, Corinthia. Second half of the 6th century B.C. (Athens, National Archaeological Museum).*

the Mycenean empire, Greek lands felt the impact of a new wave of migration, when the Dorian tribes penetrated as far south as the Peloponnese. With their settlement, the historic era in Greece begins. The Dorians occupied the Argolid, Corinthia, Laconia and Messenia. Some areas seem to have offered little or no resistance, others were conquered only after bitter fighting. At the close of the ninth and the beginning of the eighth century B.C., the Peloponnese had acquired its definitive racial composition which it was to preserve throughout antiquity, and it was then that its political structure began to take shape.

Among the more important events in the history of the Peloponnese during the succeeding centuries were the First Messenian War (735-715 B.C.), in which Sparta gained ascendancy over Messenia, the colonization of Corcyra by the Corinthians and their foundation of Syracuse in Sicily (734-733 B.C.). During the eighth century B.C. the peoples of the Peloponnese competed with the Ionians of Asia Minor to establish colonies in Sicily and southern Italy. Peloponnesian art developed new forms of expression. This is the period of Geometric Art, so named because decoration was based on the use of geometric patterns. The most common examples of this style are clay vases. Another important step was the construction of the first trireme - the warship of ancient times - in Corinth at the end of the eighth century B.C.

In the seventh century B.C. tyrants ruled in many cities, for example the Orthago-

9

rides at Sicyon and the Kypselides at Corinth. The establishment of colonies continued: the development of sea-faring and the flourishing of crafts created a new class - the bourgeois class - whose members caused shifts in political opinions and spurred the development of intellectual and artistic life. The sixth century B.C. opened with the First Sacred War (600-590 B.C.) waged against Delphi by Cleisthenes, the tyrant of Sicyon, assisted by his allies the Athenians and the Scopades of Thessalia. The war ended with the destruction of the city of Krisa, which had defied recognition of the independence of Delphi and the elevation of the Pythian Games to the status of a pan-hellenic contest. Thereafter, however, Sicyon's power declined and Sparta rose to pre-eminence amongst the cities of the Peloponnese. So powerful did she become that her king, Cleomenes, invaded Attica in 508, intervened repeatedly in the internal affairs of Athens after the fall of the Peisistratids and established the governorship of Isagoras, leader of the aristocrats.

In the course of the seventh and sixth centuries B.C. a quest for intellectual and artistic standards can be observed; artistic expression was henceforth governed by new concepts. This expansion in both the intellectual and the artistic spheres was due to contacts with the inhabitants of other regions, and to the social changes brought about by the agricultural and other occupations of the inhabitants.

The new art style emerged is known as Archaic Art. Although its works were based on the strict Doric style, the earlier ornamental geometric patterns were replaced by plant-like decoration and the depiction of animals. This change is most marked in architecture. Interest shifted from the construction of tombs and palaces to concentrate on other structures, especially temples. Noteworthy examples of this change are the temples of Apollo at Corinth and the Heraion at Olympia. At the same period an astonishing development in sculpture and the plastic arts is to be noted in the Peloponnesian towns. The chief workshops were at Sicyon, Argos and Corinth. The latter came to be the most important centre of vase-painting. Corinthian vases must have been in great demand, for they are found widely dispersed, not only throughout the Peloponnese, but also far beyond.

Neither did the Peloponnese lag behind the other parts of Greece in intellectual activity. The peak of its achievement, however, was reached in the fifth century B.C., coinciding with two important historical events, the Persian wars (490-479 B.C.) and the Peloponnesian War (431-404 B.C.).

In the autumn of 481 B.C. a pan-hellenic congress was held at Corinth at the instigation of Athens and under the aegis of Sparta, resulting in the organisation of an anti-Mede alliance. Sparta held the chief command at Thermopylae, Salamis, Platea and Mycale. All the Peloponnesian cities, except those of the Achaeans and Argos, took part in the struggle against the Persians.

Two important events took place during the period separating the Persian from the Peloponnesian War: firstly the bestowal of honours on the victor of Salamis, Themistocles, at Sparta and Olympia, and secondly, the disastrous earthquake of 464 B.C. which devastated Sparta and gave the helots and Messenians the opportunity to revolt. The Athenians came to the assistance of the Spartans; the latter, however, treated the Athenians with so much distrust that a breach in relations was precipitated. The Athenians, offended, formed an alliance with the Argives. The resultant small scale feuds came to an end in 446/5 B.C. with the Thirty Year Truce concluded between Athens and Sparta and their respective allies. Unfortunately, this non-aggression pact was broken after only ten years. In 435 B.C. Corinth came into conflict

6. Bronze statuette of the 5th century B.C., an example of Argive sculpture. (Berlin, Archaeological Museum).

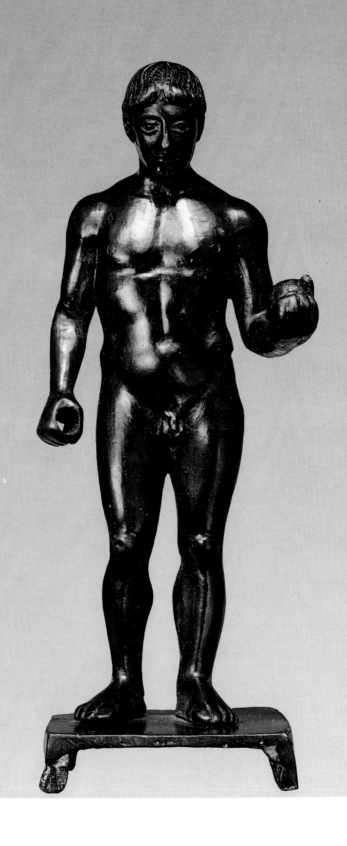

with her colony Corcyra over the issue of the civil war in their joint colony, Epi-damnus. This incedent was the prelude to the outbreak of the Peloponnesian War in 431 B.C. which lasted for twenty-seven years, raging over the whole of Greece, Sicily, and the shores of Asia Minor. Its conclusion was a victory for Sparta over Athens and her allies, but it impoverished and demoralised both victors and defeated, laid Greece waste and impeded its growth and culture. So although Sparta was the victor, she had no real strength to forge bonds of unity between the cities under her sway. More than that: she was unable even to defend her own territory. Thus, though only for a short while, a new city dominated the historical scene - Thebes. Taking advan-tage of the weakness of both Athens and Sparta to increase their own strength, the Thebans made repeated raids into the Peloponnese, building the cities of Megalopo-lis and Messene as a provocation and threat to a debilitated Sparta. Theban supre-macy was brief, and was brought to an end by the inconclusive outcome of the battle of Mantinea (362 B.C.) and the death of the Theban Leader, Epaminondas. Events then took a different turn, bringing Philip of Macedon into the limelight of history. The cities of the Peloponnese, their resources drained, could not afford to take significant part in later Greek events. From the middle of the fourth century B.C., control of Greek affairs passed to the king of Macedonia, Philip II, who from 342 B.C. began actively to intervene in matters concerning, the Peloponnese. Philip was recognised at Corinth as commander of the war against the Persians. Under his protection the autonomy of the Greek cities was respected and their prosperity ensu-red. His successor, Alexander the Great, was also acclaimed at Corinth as comman-der of the war against the Persians. The consequences of the unsuccessful revolt against his authority were felt even after his death. The Peloponnese again became a theatre of war, split into two rival camps. This state of affairs was brought to an end in 303 B.C. when the Macedonian Demetrios Poliorcetes led a military expedition to the Peloponnese. Having occupied the most important towns, he summoned re-presentatives of the Greek cities to Corinth, in order to revive the League of Co-rinth. He too was acknowledged as commander in chief.

The following century saw the antagonism of two claimants for supremacy over the Peloponnese, the Achaean League (founded in 280 B.C.) and Macedonia. The Mace-donians succeeded in retaining cotrol, but it was short-lived, for soon afterwards the Romans began to intervene in Greek affairs, an intervention which resulted in 146 B.C. in the subjugation of Corinth and the rest of Greece.

The Peloponnese under the Romans

Only Sparta and the cities of the League of the Free Laconians succeeded in maintaining their independence and privileges when all the other areas of the Pelo-ponnese were subjected to Roman rule. The Confederacies dissolved and the Pelo-ponnese, along with central Greece, Thessaly, Epirus and the Ionian islands dwin-dled to the status of a mere province, the province of Achaea. Its proconsul had his headquarters at Corinth. Several cities were self-governing and from time to time favours were conferred by emperors on cities of their choice. Despite this, the abuses and bad administration of the Romans and the heavy texation reduced the populace to ruin. This wretched situation was not improved either by Caracalla's decree grant-ing political rights to all free subjects of the Roman state or by the administrative

7. Peloponnesian coins: a) Sicyon; b) and c) Corinth; d) Argos; e) Epidaurus.

a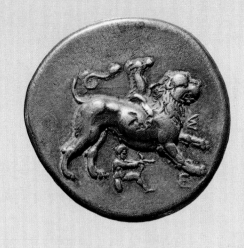

b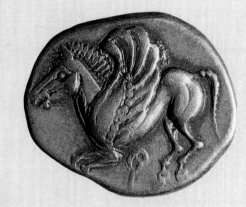

c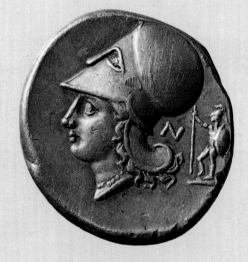

d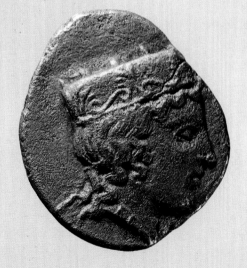

e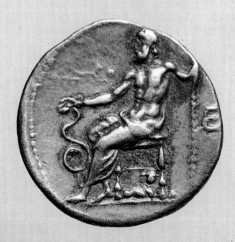

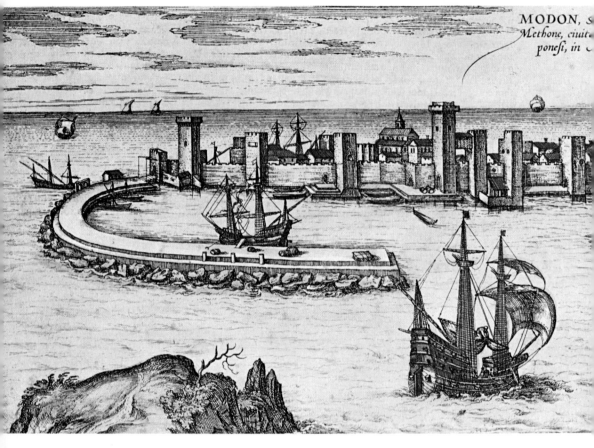

8. Copper engraving of the castle and harbour of Methone as it appeared during the

reforms of Diocletian and Constantine the Great. The barbarian incursions and the havoc they wrought came as a last straw. In the 3rd c. A.D. they ravaged the Peloponnese. In 375 there was a terrible earthquake, and in 395 Alaric's hordes carried out a catastrophic raid. It was at this time that Christianity was introduced to the Peloponnese and Christian communities were established at Corinth, founded by St Paul, Sparta and Patras, where St Andrew was martyred.

The Peloponnese under the Byzantines

From the time of Heraclius, Emperor of Constantinople (610-641), until the middle of the eleventh century, the Peloponnese was a province (theme) of the Byzantine Empire, consisting of forty cities ruled from Corinth. In the eleventh century the Peloponnese merged with the eastern region of central Greece into one province, referred to as Hellas. The capital remained Corinth, one of the most important towns in the Byzantine Empire, a bustling trading centre and the home of a thriving

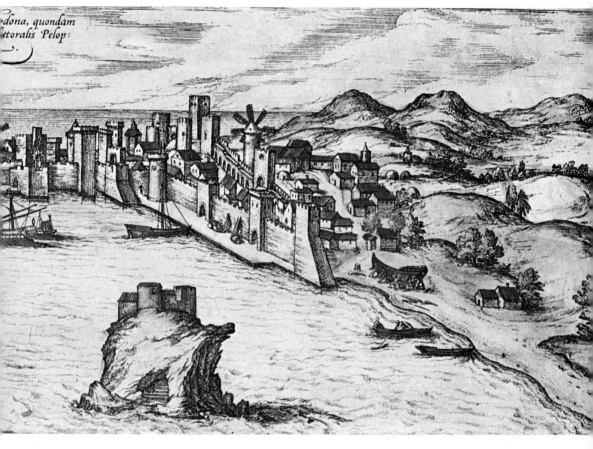

Venetian occupation. (Athens, Gennadeion Library).

silk industry, much frequented by foreign traders from both East and West. Other important towns include Patras, also a mercantile and manufacturing centre, Lacedaemonia, which had sprung up in the ruins of ancient Sparta, Monemvasia, with its export trade in silks and wines, Argos, Nauplion, Methone, Corone, Kalamata, Navarino and Arcadia (now called Kyparissia). One of the most important events of these centuries was the settlement of Slavs in the Peloponnese. Their extensive penetration of the peninsula has provoked much debate amongst ethnologists of many European countries. The German historian Fallmerayer even went so far as to assert that the entire Peloponnese had been peopled by Slavs. This theory has been vigorously refuted, and today is without supporters. It is now known that the Slavs were settled in the Peloponnese in the mid-eighth century in the reign of the Emperor Constantine V to augment its population devastated by a plague which first broke out at Monemvasia. They were quickly christianised and assimilated. Despite barbarian raids and pirate attacks, the Peloponnese enjoyed prosperity throughout the Byzantine period, thanks to the abundance of its agricultural produce, the vast production of silk and the resultant trade.

The Peloponnese under the Franks

After the capture of Constantinople by the Crusaders in 1204, the Byzantine Empire was partitioned between Western rulers. William Champlitte and Geoffrey Villehardouin, by mutual agreement which was also ratified by Boniface of Monferrat, King of Thessalonica, at Nauplia, undertook the reduction of the Morea (as the Peloponnese was then called). With the exception of the fortified towns of Methone and Corone, occupied by the Venetians, and invincible Monemvasia which stood alone as the sole bastion of the Byzantine forces, the rest of the peninsula was under Frankish control by 1212. William Champlitte was recognised by Pope Innocent as the ruler of the Principality of Achaea, the official title of the Frankish kingdom of the Peloponnese. William died in 1209, and was succeeded by Geoffrey Villehardouin. He drew up the feudal map of the Principality, dividing it into twelve lay baronies and seven ecclesiastical fiefs, while Argos and Nauplion were given as lordships to Otho de la Roche, Lord of Athens. Geoffrey II Villehardouin consolidated his power by building the castle of Chlemoutsi near Glarentza, and came to be considered as the most powerful of the Frankish barons. The Principality enjoyed the peak of its prosperity under his vigorous rule.

His achievement was maintained under William II Villehardouin (1246-1278), who occupied the fortress of Monemvassia after a three year siege (1246-1248), and the lands of the Tsakones and Mellingoi who inhabited the slopes of Mt. Taygetos. He built the citadel at Mystras, the castles at Maine and Beaufort and, with the consent of Louis IX, King of France, established a mint in the castle of Chlemoutsi where he struck Tournai coinage. However, in 1259, he embroiled himself in the civil war raging between the two Greek powers of Nicaea and Epirus. Defeated at the battle of Pelagonia in 1261 by Michael VIII Palaeologos, he was taken prisoner. In return for his freedom he was obliged to surrender his castles at Mystras, Maine, Beaufort and Monemvasia, which were thus turned into the baulk-heads of the Byzantine Emperors in their attempt to expel the Franks from the Peloponnese. The Frankish lands passed into the hands of the Palaeologoi Despots of Mystras. The last traces of Frankish suzerainty disappeared in 1430 when the entire peninsla was ruled by the Palaeologue family. Mystras had been the intellectual and artistic centre of medieval Greece. In its last days it was the home of the Platonist philosopher, George Plethon Gemistus. Its fortifications, palaces and churches testify even today to its wealth, and demonstrate the sumptuousness of Byzantine art.

The Peloponnese during the Turkish occupation

In 1443 Constantine Palaeologus became Despot of Mystras, having made himself master of the greater part of the Peloponnese and taken possession of the domains of his brother Theodore II, who became Despot of Selymbria. Constantine, fully conscious of the Turkish threat, immediately strengthened the Hexamilion, the powerful defense wall with its 153 towers that had been built across the Isthmus of Corinth by the emperor Justinian to protect the Peloponnese against the barbarian raids and later rebuilt by Theodore II when he was Despot of Mystras. However, the wall, for whose maintainance a special tax known as the «floriatic» had been imposed, proved unable to hold back the flood of the Turkish attack led by Tourahan in 1423, in the time of Murad II. But what Constantine had foreseen finally happened: in 1446 Murad himself mounted an expedition with a large army against the Peloponnese, and having broken through the Hexamilion in spite of the valiant resistance of the despots Constantine and Thomas, he divided his army into two parts, one of which

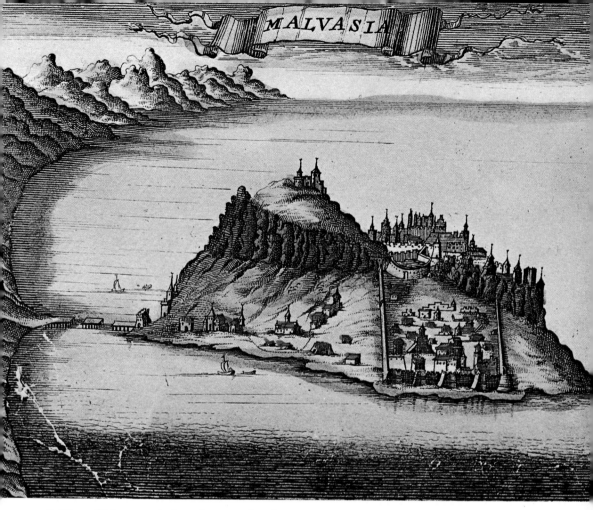

9. View of Monemvasia from the map of F. de Wit. (Athens, Gennadeion Library).

proceeded to Glarentza, burning the districts of Sicyon and Patras on the way, and the other pursued the two despots, who were forced in 1447 to acknowledge Murad as their sovereign. In 1449 Constantine left Mystras to be crowed Emperor of Byzantium in Constantinople, where he was slain in the heroic fighting before the City was captured in 1453. The Peloponnese was divided up between his two brothers Thomas and Demetrius, who however took up arms against each other immediately after the fall of the City. The Turkish general intervened and patched up a reconciliation between the brothers, but extorted a promise of payment of tribute to the Sultan. Because they failed to meet this obligation, Mohamet II attacked their kingdom in 1458. Thomas fled in panic to Mantinea, while Demetrios took refuge at Monemvasia. Mohamet occupied the whole Peloponnese, investing Omar, son of Turahan, as governor. Two years later, he returned to wipe out every remaining trace of Palaeologue rule: Demetrios handed Mystras over to the Sultan, Thomas escaped to Italy.

Soon after the last trace of Greek authority in the Peloponnese was obliterated, war between the Venetians and the Turks broke out (1463-1479). Lacedemonia, Arcadia, Monemvasia, Corinth, Patras and the Mani all joined in the struggle against the Turks. This was the first armed protest the conquered made against their conqueror. The Turks succeeded in capturing Pasava and Zarnata - the two castles

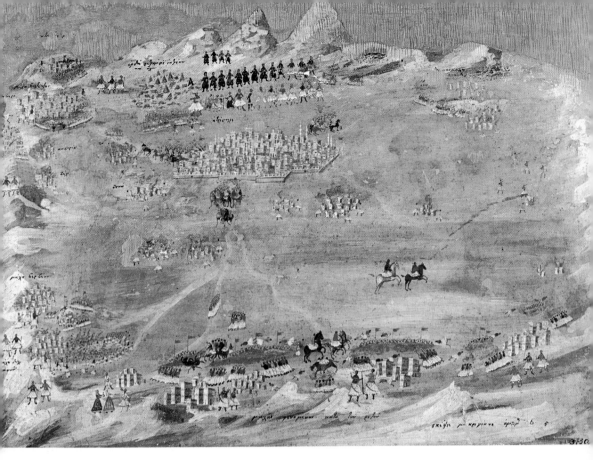

10. *Picture executed by P. Zografo and Y. Macryiannis, tempera on wood. It depicts the several stages in the struggle for Tripolis up to 1821 (Athens, National Historical Museum).*

which guarded the routes into the Mani. When the Venetians made a separate treaty with the Turks, they abandoned the Greek population to their fate. When fighting was renewed, between 1499 and 1502, and again between 1537 and 1540, the Maniots took no part in it, being disinclined to trust the Venetians as allies a second time.

At the beginning of the 17th c. (1605) the Maniots again rose against the Turks. In 1684 a new war broke out between the Turks and Venetians, in the course of which not only the Maniots but virtually the whole of the Peloponnese went over to the Venetian general Francisco Morosini. In 1714 war again broke out between the Turks and Venetians, resulting in the subjugation of the Peloponnese by the Turks for a second time, and this was followed by a massacre of the Christians. To show their acknowledgement of Turkish sovereignty, the Maniots were obliged to demolish their castles and pay 4000 grossi.

In 1769 Russian agitation caused the outbreak of a revolt. But despite her promises, Russia sent only a small force of men, led by Theodore Orloff. The revolutionary movement was crushed, and in order to avoid annihilation, many Christians of the Peloponnese were forced to seek refuge in the Ionian islands.

On the eve of the outbreak of the War of Independence the Peloponnese was administered by a Turkish governor with his headquarters at Tripolitsa (modern Tripolis). Six years earlier the Mani had been recognised as an independent territory

18

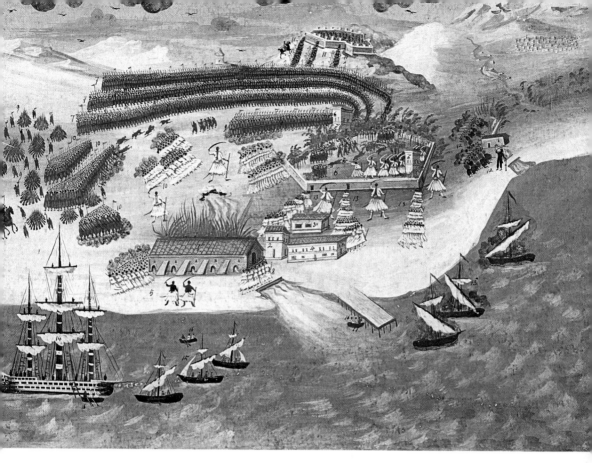

11. *Water colour by P. Zografou and Y. Makryiannis, depicting fighting before the gates of Nauplion. (Athens, Gennadeion Library).*

ruled by Petrobey Mavromichalis. In March 1821 revolt against the Turks broke out simultaneously in two areas of the Peloponnese, Achaea and the Mani. The forces of Theodore Kolokotronis marched against Kalamata which they captured and occupied on March 23rd. On March 25th, which has since been officially designated as the date when the Struggle for Independence began, Germanos, archbishop of Patras, raised the revolutionary banner in St George's Square, Patras.

The Battle of Valtetsi in Arcadia on May 13th-14th paved the way for the capture of Tripolitsa, thereby ensuring the spread of a full-scale revolution in the Peloponnese. This great success at so early a stage in the revolt is to be ascribed to the tactics of Kolokotronis. He also achieved the resounding victory at Dervenaki in 1822 which struck a decisive blow a Turkish strength. In 1825 Ibrahim and the Egyptian army landed in the Peloponnese, causing great losses. In October 1827 the victory of the allied fleets of England, France and Russia against the Turkish and Egyptian ships at Navarino marked the beginning of the liberation of the Peloponnese from Ibrahim, while the arrival of the French army under General Maison finally freed the area from Egyptian occupation.

From 1830, the time of its liberation, the Peloponnese has never ceased to play a leading part in the progress of the free Greek nation. Its subsequent history is interwoven with the development of the modern Greek state.

19

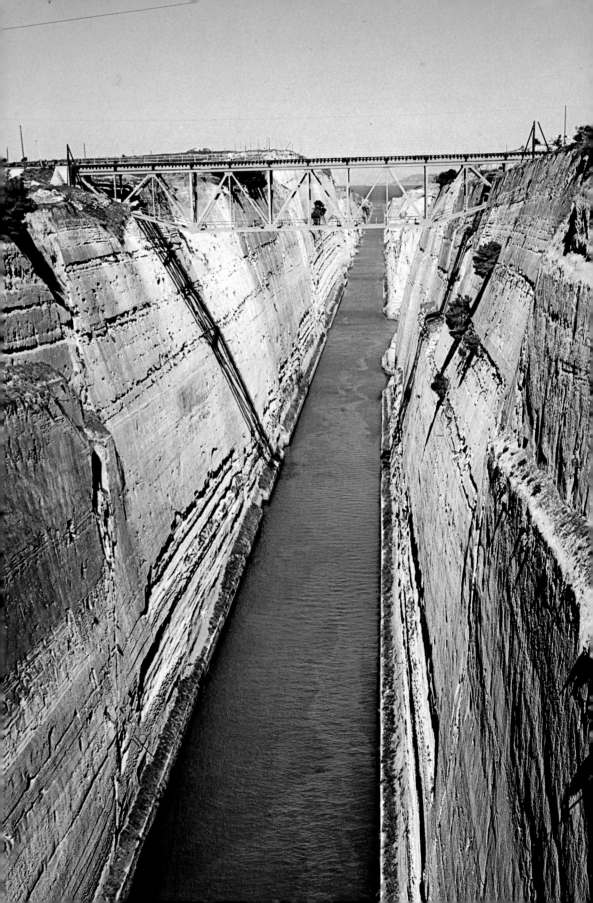

CORINTHIA

The district of Corinthia occupies the north-east part of the Peloponnese, inclu-
ding the Isthmus and the area beyond as far as Megarid. The modern boundaries
correspond almost exactly with the ancient ones. Amongst the few ancient sites
accessible to the visitor is the site of the **Heraion of Perachora**, some 20 kms. from
Loutraki. Excavation near the harbour uncovered the temples of *Hera Akraia* and
Hera Limenia, and the stoa of the port. Having crossed the Canal, the visitor may
take a road immediately to the left and visit one of the most important ancient
pan-hellenic centres of worship, the **sanctuary of Poseidon of Isthmia**, in the modern
village of Kyparissi where pan-hellenic games were held every two years. Excav-
ations conducted by the American School of Classical Studies have shown that the
temple was originally built in the seventh century B.C. It was destroyed a little before
the middle of the fifth century B.C., and was reconstructed almost immediately. This
temple was burned in 390 B.C. during the Corinthian War. It was again rebuilt, and
stood until the sack of Corinth by the Romans in 146 B.C.. On the rebuilding of the
city in 44 B.C. the temple, along with the other structures in its precinct, was re-
paired. In the time of the Emperor Justinian much of the material was robbed to be
used in the construction of the wall across the Isthmus (the Hexamilion, so xamed
because it was about 6 Roman miles long). Only the foundations and some few
architectural fragments were left. East of th temple parts of a narrow and elongated
altar were found. The most important building in the precinct after the temple was
the **Palaemonion** dedicated to palaemon, the patron of the games, and connected
with a secret cult. Scanty remains of the building were revealed by excavations at the
southern end of the old stadium. The finds also date the Palaemonion to the time
before the end of the 1st c. A.D. There was a stadium next to the Palaemonion on the
northwest in earlier times. In the Classical period a new temple was erected, but this
went out of use when the Palaemonion was built. The Hellenistic and Roman sta-
dium was situated southeast of the sanctuary at the foot of Rachi hill.

*12. The Isthmus of Corinth. The bridge which links the Peloponnese to the rest of
Greece. The canal, planned from ancient times, was cut between 1881-1893.*

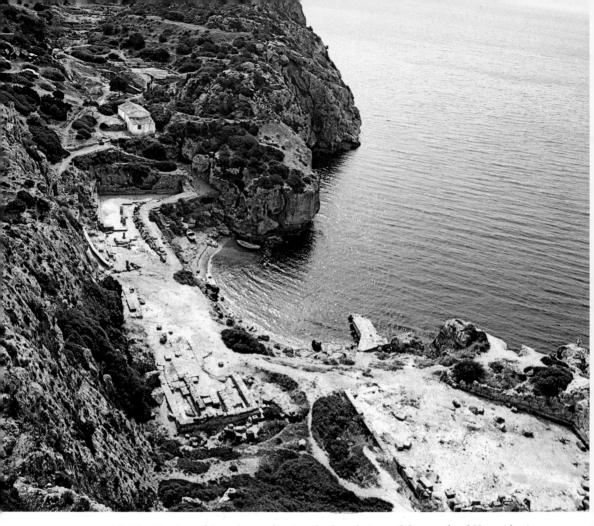

13. The Heraion of Perachora, showing the foundations of the temple of Hera Akraia, the altar and a stoa by the harbour.

The games, which took place every second year, were pan-hellenic, and included a variety of contests: running, jumping, the *pentathlon* (the contest of the five exercises), the *pangration*, equestrian events, chariot races and musical competitions.

Until the destruction of Corinth in 146 B.C. the organisation of the games was the responsibility of the Corinthians, after which date it was undertaken by neighbouring Sicyon. A theatre also existed, but only traces of the *skene*, the entrance passages and the seats of the Roman period remain. It too was robbed to its foundations to provide building material for Justinian's defensive wall across the Isthmus.

The Museum of Isthmia

The museum stands close to the ancient site, and houses finds from the excavations at Isthmia and Kenchreai. Especially noteworthy amongst the objects on display are the two *Perirrhanteria* or lustral basins, one of which, the archaic, was found in the Temple of Poseidon. Its supports are fashioned in the shape of maidens (*korai*) alternating with the heads of rams. Two ivory plaques from Kenchreai depict seated men (philosophers). Other exhibits include panathenaic amphorae, sports

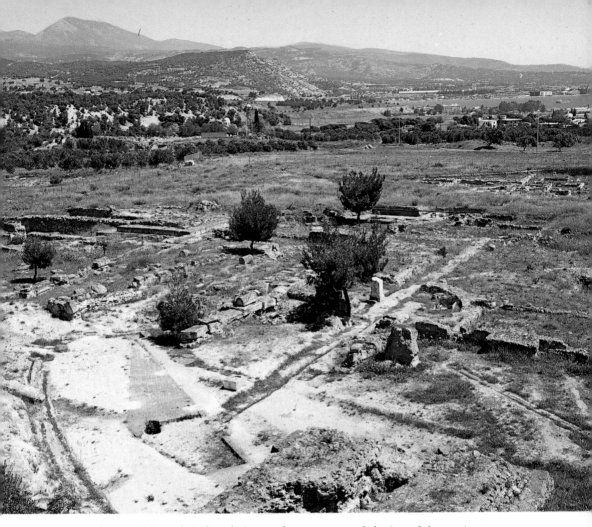

14. Partial view of the archaic foundations at the sanctuary at Isthmia and the starting line for the runners in the old stadium.

equipment, pottery and small finds from every period together with a large display of the votive lamps from the Palaimonion. Of outstanding interest are the panels of *opus sectile* which were dredged up from the jarbour of Kenchreai. They depict plants, birds, ornamental motifs and human figures. They also show harbour and seashore installations with harbour structures.

In the first bay south of the Isthmus was the eastern harbour of Corinth, *Kenchrai*, important for trade with the islands and the East. Building foundations have been excavated on both of the harbour moles, but the grater part of the structures are today below the surface of the sea. Most of the builgings are Roman in date.

Various building foundations have been excavated on the south mole, chiefly warehouses. There was also a temple of Isis, on the site of which there are now the remains of an Early Christian basilica that was erected later. Long walls linked Corinth to its second harbour, *Lechaeum*, the point of communications with the West and its colonies. According to Pausanias there was a sanctuary of Poseidon at Lechaeum with a bronze statue of the god, and Plutarch mentions a sanctuary of Aphrodite. On the harbour front the remains have been found of a large Early Christian basilica measuring 179 m. in length. It was destroyed by an earthquake shortly after it was built.

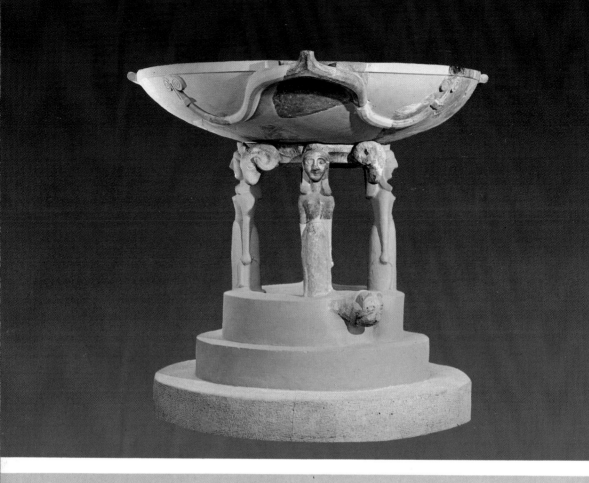

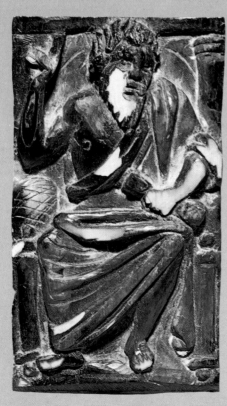

15. *Archaic marble per-rirhanterium from the temple of Poseidon at Isthmia. Kores alternating with heads of rams form its supports. 7th century B.C.*

16-17. *Two ivory plaques bearing representations of male figures, probably philosophers. They were found at Kenchreai and were used as decoration on chests.*

18. *Glass mosaic in opus sectile depicting a philosopher, perhaps Plato. This is one of the many pictures recovered from the harbour of Kenchreai. These pictures of glass and gypsum were probably made in Egypt and were intended as wall decorations. Subjects depicted include various representations of birds, plants, human faces and sea-shore installations. A disaster which struck this region is probably the cause for their not being used, and for their being discovered still in their boxes by the excavators. Others, however, must have been lost in the sea.*

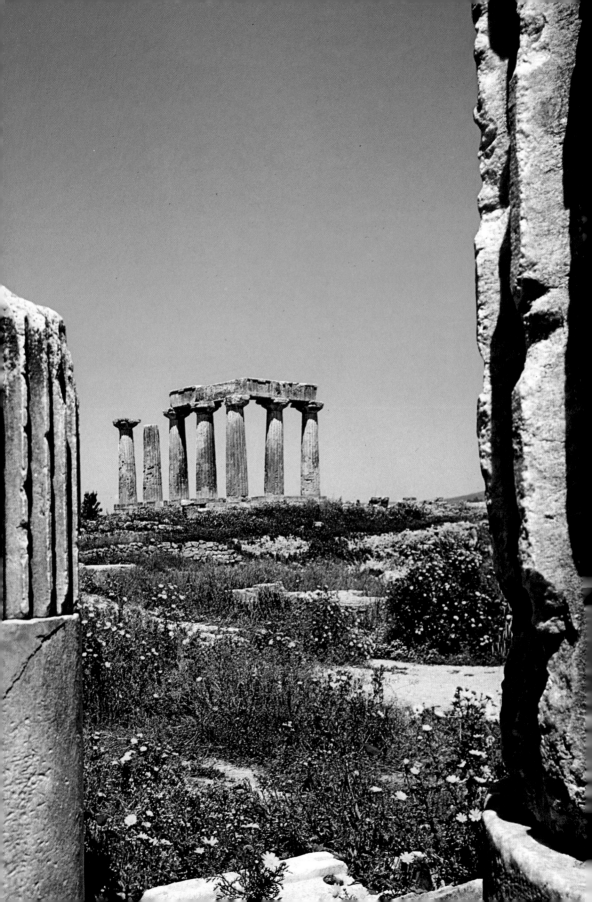

CORINTH

Ancient Corinth was one of the most important cities of ancient Greece. Homer refers to it as «thriving», an indication that the place was wealthy as early as the Mycenaean period. The region was inhabited in prehistoric times, at least from 4000 B.C., when there existed a small neolithic settlement on the site of Ancient Corinth. Small settlements appear in the next period, the Bronze Age. scattered between Isthmia, Kenchreai and Corinth. Some have been excavated, such as Korakou (between New Corinth and Lechaeum), which in the Mycenaean period was a settlement of greater importance than Corinth itself.

Groups of invaders crossing the Isthmus and passing through Corinth at the end of the Mtcenaean period unsettled the area and disrupted its political and economic development. The Dorians arrived from the ninth century onwards, coming from Argos, and began to impose their own customs. The power of Corinth reached its height in the eighth century B.C., and at this time she founded two colonies in the west, Syracuse and Corcyra. The establishment of these colonies contributed to the wealth of Corinth, because her products reached new markets in the West; her naval power, of necessity, became stronger. This increased economic and maritime power is to a certain extent mirrored in the developments in the arts, particularly marked in pottery, but noticeable also in bronze and metal working. The Corinthians were particularly skilled in nautical matters, and it was they who perfected the design of the warship, the trireme. To assist commerce by making direct communication between her eastern and western ports, the Corinthians had planned the cutting of

19. The Archaic temple which crowns the level summit of the market place of Ancient Corinth.

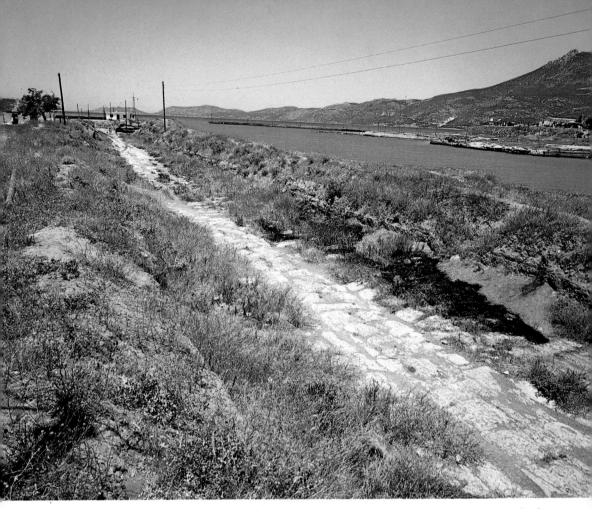

20. Remains of the ancient diolkos with the parallel grooves which guided the wheels of the platforms onto which ships were loaded for transport across the Isthmus.

the Isthmus as early as the period of the tyrants. The project was not carried out, partly because it required vast sums of money, partly because at the time technical difficulties were too great to be overcome. Instead, to avoid the circumnavigation of the Peloponnese, construction of a paved road was undertaken, the *diolkos*. Two parallel grooves cut in each block guided the wheels of the platforms onto which the empty ships were loaded.

Corinth reached the height of her power in the fifth century B.C. She took part in the wars between the Greeks and the Persians, fighting in all the battles on both land and sea. After the defeat of the Persians, her trade began to be adversely affected by the increase of Athenian power, the latter's vigorous navy engaging in trading activities and thus boosting the Athenian economy. It was inevitable that the two cities should clash. Their mutual hostility was the chief cause of the Peloponnesian war (431-404 B.C.), from which the Corinthians emerged victorious, but much weakened. Thereafter, Sparta became the leading power amongst the Greek cities, and Corinth was obliged to abandon her dream of naval supremacy. Displeased by her former allies, the Spartans, she ranged herself with the Athenians, Thebans and Argives and declared the Corinthian War (395-387 B.C.).

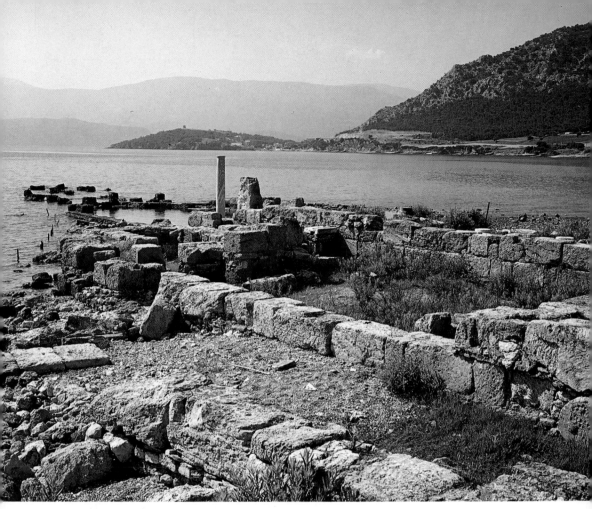

21. Partial view of the ancient foundations and the Early Christian church on the southern mole of the harbour of Kenchreai, Corinth's outlet to the East.

However, she failed to gain the expected independence from Sparta. Mean while, Philip II, king of Macedonia, began to intervene actively in Greek affairs, uniting the Greek cities against him. After Philip's victory in 338 B.C., he established a fortress on the Acrocorinth. It was later captured and occupied by the Antigonides until 243 B.C., when Aratus, commander in chief of the Achaean Confederacy, captured the fortress and delivered it to the Corinthians who were thus drawn into the Confederacy. Her participation, indeed her outstanding role, and even more, her status as capital of the Confederacy after 196 B.C. provoked the hostility of the Romans. In 146 B.C. the city was captured by the general Mummius, who razed it to its foundations. The town was set on fire, its foundations ploughed under the soil, the walls pulled down and its treasures (*necro-corinthia*) trasported to Rome and sold in the market place. Part of its surrounding territory was declared public property, part of it was bestowed on neighbouring Sicyon. The city remained desolate and uninhabited for a hundred years.

In 44 B.C. Julius Caesar founded a Roman colonia in the ruins of the old city. In his homour it was named *Colonia Laus Julia Corinthiensis*. The first inhabitants were foreigners, most of them Roman freemen. However, their numbers were soon in-

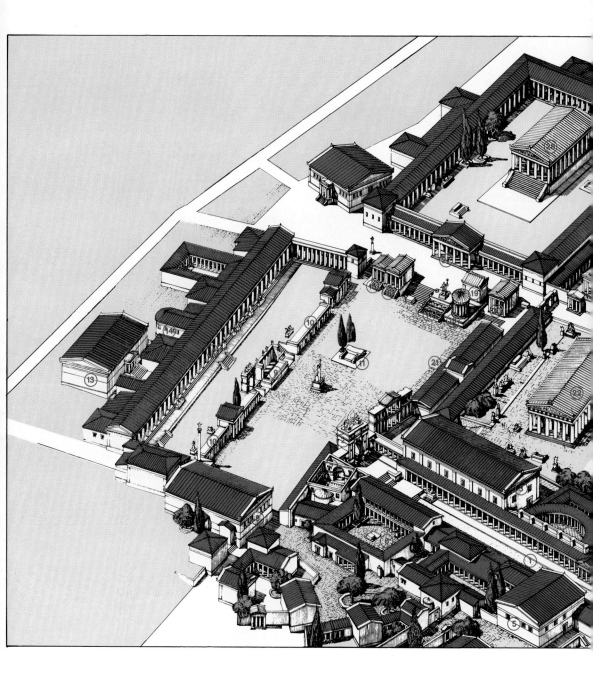

ANCIENT CORINTH - RECONSTRUCTION

1. Lechaion Road
2. Propylaia
3. Basilica
4. Semicircular building
5. Baths of Eurycles
6. Peribolos of Apollo
7. Peirene Fountain

8. Julian Basilica
9. Bema
10. Central shops
11. Altar
12. South Stoa
13. South Basilica
14. Bouleuterion

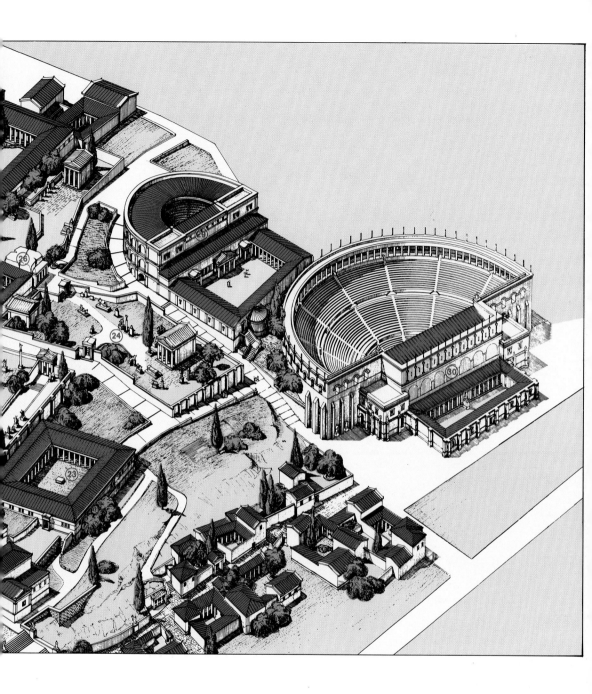

15. Temple F
16. Temple G
17. Statue of Poseidon and Fountain
18. Babbius Monument
19. Temple K
20. Temple D
21. Northwest shops
22. Archaic temple

23. Northern market
24. Sanctuary of Athena Chalinitis
25. Temple C (of Hera Akraia?)
26. Glauke Fountain
27. West shops
28. Temple E (of Octavia?)
29. Odeion
30. Theatre

creased. both by Greeks and by large numbers of merchants, entrepreneurs and sailors from the East, attracted by the commercial opportunities offered by the two ports of Kenchreai and Lechaeum. When the traveller Pausanias visited the area in the second century A.D. he found a bustling and prosperous city.

The new inhabitants of Corinth included many Jews. This contact with the East perhaps explains the very early appearance of Christianity here, the visit of St. Paul in A.D. 52 and his two letters to the Corinthian community.

Several emperors, as well as many rich individuals, were to beautify the city. In the second century A.D. the Emperor Hadrian made provision for the construction of an aqueduct which brought water to the city from the Stymphalian Springs: at the same time Herodes Atticus embellished the market place, repairing the Peirene fountain. Amongst other benefactors were Euricles, who constructed the public baths, and Babbius Philinus who added a small circular monopteral building to the attractiveness of the market place.

Earlier, in the first century A.D., the Emperor Nero had enthusiastically adopted the idea of cutting a canal across the Isthmus to facilitate trade. In A.D. 67 he ordered several thousand slaves to start digging a wide trench at the narrowest point of the Isthmus, on the same line where the Canal now runs. Work began simultaneously from both shores, the teams planning to meet in the centre. The attempt was interrupted by the death of Nero, and the scheme thereafter abandoned. The Canal was only finally cut at the end of the last century, 1881-1893.

During the second and third centuries A.D., Corinth was a flourishing centre, surpassing Athens in size and wealth. It was not only the busiest and most prosperous commercial centre of the Roman province of southern Greece, Achaea, but its administrative capital. From the middle of the third century, however, the beginning of the barbarian invasions of the Roman Empire spelled its decline. The raids of Herulians (267) and of the Goths led by Alaric, who set fire to the city in 395, brought its prosperity to an end. During the reign of the Emperor Justinian, (527-565), it enjoyed a brief resurgence.

Corinth never fully recovered from the effects of the earthquake of A.D. 551. Only in the eleventh century did it regain something of its former splendour when it became the headquarters of the governor of the Byzantine theme of the Peloponnese. During the middle and late Byzantine periods, Corinth underwent a series of vicissitudes because of the strategic importance of the fortress on the Acrocorinth. In 1447 it was sacked by the Normans and in 1210 captured by the Crusaders, in spite of the resistance offered by the Nauplion leader Leon Sgouros, who had captured Acrocorinth with its garrison. In 1358 Corinth passed into the hands of the Florentine prince Nicolas Acciajuoli, but was returned to Byzantium in 1395, only to be sold in 1400 by Theodore Palaeologus to the Knights of Rhodes. In 1458, after a heroic resistance conducted from the Acrocorinth, the city surrendered to the Turks. The Knights of Malta laid claim to it in 1612, and seized it from the Turks; in 1687 it passed to the Venetians. The Turks recaptured it in 1715, Holding it until 1822, shortly after the outbreak of the War of Independence. The site of the Acrocorinth, placed right in the middle of rebel country, made it a strong candidate for the capital of Greece. Athens, however, was preferred, and the capital was established there in 1834. After the liberation of Greece, Corinth began to recover some of its past vitality, cut short by the earthquake of 1858 which destroyed the city. The town was not rebuilt; instead New Corinth, closer to the Isthmus, was laid out. Its original buildings were destroyed by the earthquakes of 1928 and 1930, but reconstruction

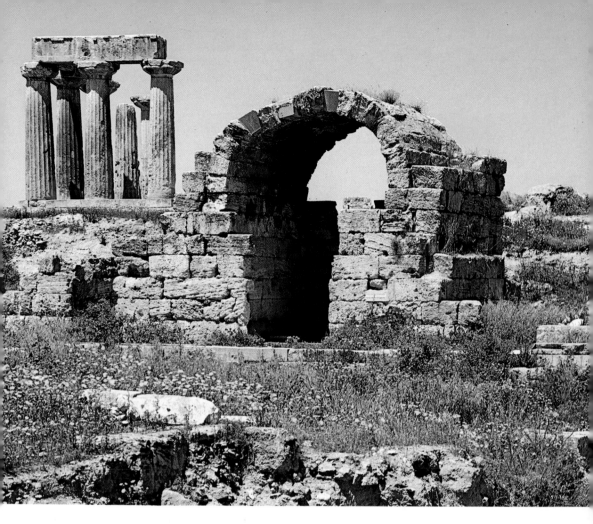

22. *Part of the market place of Ancient Corinth showing the vaulted building and the seven monolithic columns of the Temple of Apollo.*

was quickly put in hand, and today Corinth is one of the most important towns in Greece, and the centre of a network of communications.

The archaeological finds in ancient Corinth

Excavations to uncover the remains of Ancient Corinth were begun in 1886 by the German Archaeological Institute of Athens; They were continued in 1892 by the Greek Archaeological society without spectacular results. Systematic exploration of the site was first undertaken in 1896 by the American School of Classical Studies at Athens, whose excavations still continue.

Most of the remains brought to light are of Roman date, belonging to the rebuilding of the city in 44 B.C., and a small number belong to the Hellenistic period.

One of the most outstanding monuments of the pre-Roman period to have survived, is the **Temple of Apollo**, whose ruins stand on a bluff overlooking the ancient market place. The temple was built in the Doric peripteral style in the middle of the

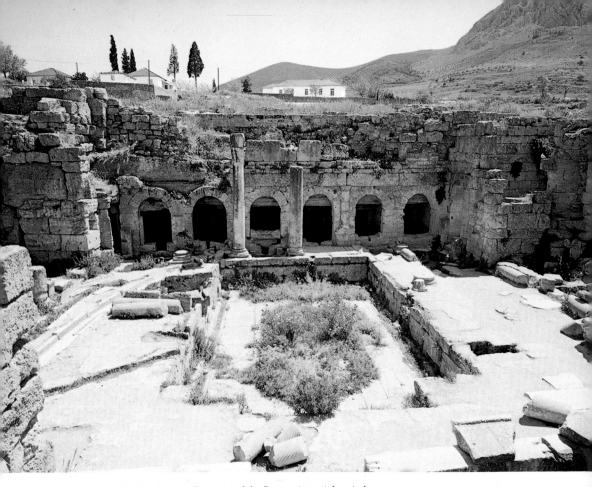

23. The Peirene Fountain of the Roman imperial period.

sixth century B.C. Today, only seven monolithic columns survive. Originally two rows of internal columns supported the roof; in both the *pronaos* (porch) and *opisthodomos* (rear porch) two columns stood *in antis*. The temple was rebuilt during the general reconstruction of 44 B.C.

The market place was entered from its northern side at the termination of the **Lechaeum Road** - the road which connected the city to its port of Lechaeum on the Gulf of Corinth. It had a paved surface and narrow paved sidewalks with gutters to carry off rain-water. On either side the road was lined by stoas divided into shops. At the point where the Lechaeum road debouched into the market place stood an imposing monumental gate, above which there originally stood gilded bronze chariots in one of which rode Helios, in the other Phaethon. East of this gate, at a lower level, was the **Peirene fountain** which was approached by a flight of steps. The earliest fountain is dated to the seventh century B.C. when the water flowed from spouts in the southern wall bounding an open courtyard. At a level still lower than the courtyard were three basins. Those who wished to draw water from them descended by means of a few steps beyond the openings on the southern side. The rectangular space to the north of the Peirene fountain was occupied by the **Peribolos of Apollo**, a space suitable for public and perhaps religious gatherings. Further north, beyond this precinct, a building used as a bath-house has been identified as the bath of Eurycles.

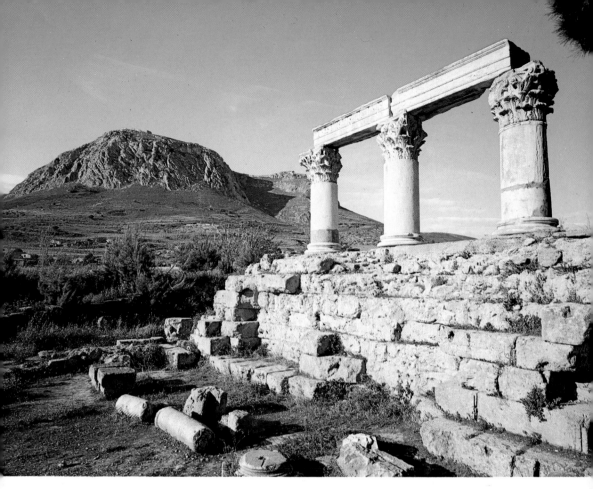

24. The ruins of the Temple to the Empress Octavia; in the background is Acrocorinth.

On the west side of the Lechaeum Road the finest building was the large **Roman basilica**, known as the North Basilica: the facade was decorated with colossal statues of captive barbarians. A little further north of this was the earlier square **market place**, above which was later erected a semicircular building. To the west of this a new rectangular market place was laid out in Roman times, closed in by an internal colonnade. To the same date belong the six **temples** to be seen on the western side of agora, and the small circular **peripteral building** whose inscription tells us that it was erected by Babbius Philinus, magistrate of the Roman province of Corinth. To the Roman imperial period belong a row of sixteen **small shops**: the vaulted room the visitor today sees in their centre is Christian in date and was used as a church. There were also shops in the centre and on the southern side of the agora. In the middle of the central shops stood the **bema** (rostrum). Here the Roman proconsul delivered his public addresses, and here St Paul defended himself before the Roman governor Lucius Julius Gallio against the charge that he "persuadeth men to worship God contrary to the law" (Acts of the Apostles, XVIII, 12-13). The central area of the agora was closed on the east by the **Julian Basilica**, so called because of the statues of Julius Caesar, Augustus and other members of the Julian family placed there. Another basilica stood in the south-east corner of the agora and west of it a row of shops. Of the **temples** built by the Romans the most notable is that which stands south-west

of the modern museum, assumed to have been that dedicated to the deified Roman Empress, Octavia. West of the Temple of Apollo, and at a lower level are the remains of the rock-cut Glauke Fountain, named after the daughter of a king of Corinth. Medeia, to avenge hrself because Jason wanted to leave her and marry Glauke, sent Glauke a magic cloak which burst into flames as soon as she donned it. To save herself, she leapt into the fountain, which was close by, and which has borne her name ever since.

Beyond the agora, north-west of the temple of Apollo, at a lower level, lie the remains of the **theatre.** It was originally built at the end of the 5th century B.C. and altered in the Roman period, when the **Odeon** to the south of it was constructed. On the level ground to the north of the theatre the Shrine of Asclepios has been excavated. The area included the temple to the god and the Fountain of Lerna.

ACROCORINTH

A rocky outcrop, some 575 m. high, towers above the ancient city. On it stand the imposing remains of the Acrocorinth, the fortress of Archaic, Classical and medieval times. The enceinte, which preserves its Franko-Byzantine and Venetian character, was in many places built on top of the ancient fortifications or was created by renovating them. The only side which can be scaled lies to the west: greater protection here was afforded by a triple wall, itself strengthened by three successive gateways which lead to the broad summit of the fortress. In antiquity many shrines and temples stood on the slopes. According to an old tradition Poseidon quarrelled with Helios as to which of the two should possess the Acrocorinth, and which the Isthmus. Acrocorinth fell to Helios, and the ancients dedicated an altar to him, as they did to other gods, including Egyptian and Phoenician deities. The principal temple was that of Aphrodite on the summit of the hill. Its remains have since been obliterated by medieval and Turkish buildings. A little below the temple in antiquity there was a spring known as the Upper Peirene, about which there were many traditions. Pausanias writes that Peirene was a woman who was transformed into a spring by the tears shed by Artemis for her son Cechrias, who was killed. The magnificent view from the top of Acrocorinth is unique for the variety of the landscape.

25. Part of the fortifications of Acrocorinth.

26. The three successive gates across the ascent to Acrocorinth constructed in the medieval period.

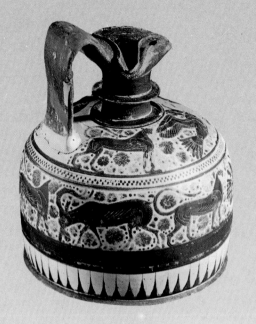

27-28. Corinthian vases. The first is an oinochoe with painted decoration (c. 600 B.C.), the second an aryballos showing a dance scene. Six figures form three couples. It bears the inscription "ΠΥΡΓΙΑΣ ΠΡΟΧΟΡΕΥΟΜΕΝΟΣ". 600 B.C.

29. Amphora with a stopper decorated with a representation of two cocks with a double anthemion in the centre. c. 600 B.C.

THE CORINTH MUSEUM

In the south-west part of the site, close to the Glauke Fountain, stands the museum, erected by the American School of Classical Studies. The finds, mostly vases and statues, are displayed in four large rooms opening off a central court. Specially noteworthy amongst the pottery exhibits are the tall Mycenaean *kylikes* of the thirteenth century B.C. (first room left of the entrance), an *oenochoe* with a tripod base decorated in the Geometric style of the eighth century B.C.; two *aryball-oi*, one of the seventh century B.C. decorated with fighting warriors about to engage in battle, the other, dated to *c.* 600 B.C. showing a dance sequence. The show cases contain an abundant display of Proto-corinthian and Corinthian vases painted either with floral designs or with red and black decoration, and also terracotta sphinxes, on whose wings traces of colour remain. The statues recovered by excavation have been put on display in an oblong room; they include statues of the Roman rulers, together with reliefs and busts, also of the Roman period. Some Roman mosaic floors are also to be seen. The show-cases house metal, bronze, glass and ivory small finds and some Byzantine pottery. A "Modiolus" from Kenchreai with a green finish is of particular interest, (1st century A.D.). Reliefs representing the Gigantomachy, the Amazons and the Labours of Heracles are to be found in the courtyard; a separate room contains the finds from the Asclepieion.

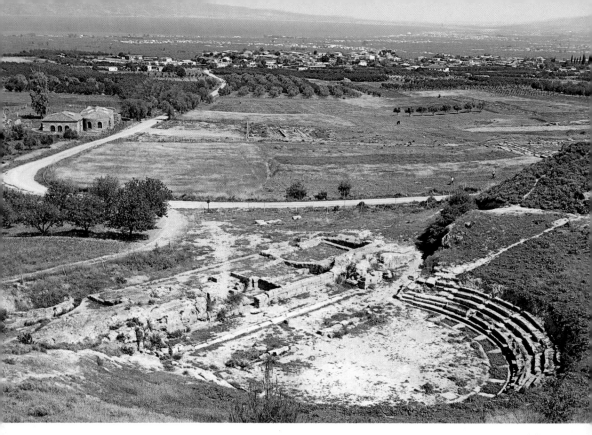

30. *Partial view of Sicyon, showing the upper rows of seats of the theatre, and the remains of the skene. To the left are the Roman baths (now the Museum).*

SIKYON

The road west of Corinth runs through a fertile plain. A little before Kiaton, at a crossroads, a left turn leads to the ruins of ancient **Sicyon**, a little way beyond the village of Basilica which today has been renamed Sicyon.

The city began to prosper under the rule of Orthagoras in the 7th c. B.C. The highest point of its development was achieved under the Orthagorids and especially the tyranny of Cleisthenes. During the fifth century B.C. the city erected a Treasury at Delphi, an indication of its wealth and power at the time. Soon after, however, decline began. In 303 B.C. Demetrios Poliorcetes became master of the region, and moved the town higher up the slopes to the site of the earlier acropolis. This he re-fortified, re-settling the inhabitants in new houses within its walls. These ruins - Hellenistic Sicyon - are those which the visitor sees today. The most important building, however, is the **Roman bath-house** which has been restored. It is now used as a museum, in which statuary (some few Archaic pieces, many more Hellenistic and Roman), pottery of all periods, statuettes and mosaics with griffons and floral motifs are displayed.

To the south extend the ruins of the Hellenistic market place of the city with the foundations of a temple and the **bouleuterion** (senate house). A large stoa and a **gymnasium** have also been excavated, and one of the fountains of the latter has been restored. Northwest of the gymnasium lies the **theatre** with two well preserved vaulted passages and northwest of the theatre the site of the Stadium can be seen.

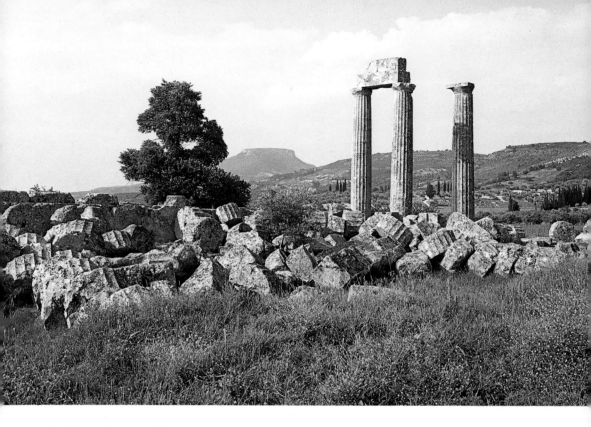

31. Column drums and the three standing columns of the Temple of Zeus at Nemea; two are columns of the pronaos, the third of the peristyle.

NEMEA

Leaving Sicyon, the visitor has the choice of continuing northwards to the Stymphalian Lake, the mythological site of the Labours of Heracles - the Slaughter of the Stymphalian Birds - or of turning southwards via the Corinth road to Nemea on the borders of Corinthia and the Argolid. Mythology furnishes two explanations for the name of the site: either that it was called after the daughter of the god of the river Asopos, or After Nemea, daughter of Zeus and Semele. The king of the region was Lycurgos, whose wife was Euridice, the mother of the local hero Opheltes, in whose honour panhellenic games were held at Nemea every two years, the victors receiving a crown of wild celery as their prize. The sanctuary of Zeus was the most important building in the historical period; and excavations have uncovered the prehistoric settlement on the hill of Tsoungiza. In the sanctuary there was a Doric peripteral temple of Zeus measuring 22 X 42.55 m., with six colums at the ends and 12 on the sides. Erected in the decade 330-320 B.C., the temple had a pronaos (porch), cella and underground crypt (adyton) instead of an opisthodomus (rear porch), where Opheltes was probably worshipped. South of it the foundations were uncovered of a hospice, basilica, tile kiln, houses and baths, and, 400 m. southeast of the sanctuary, the Nemea Stadium. Recent excavations have brought to light buildings indicating that Nemea chiefly served as a place where the athletes and visitors stayed during the performance of the games.

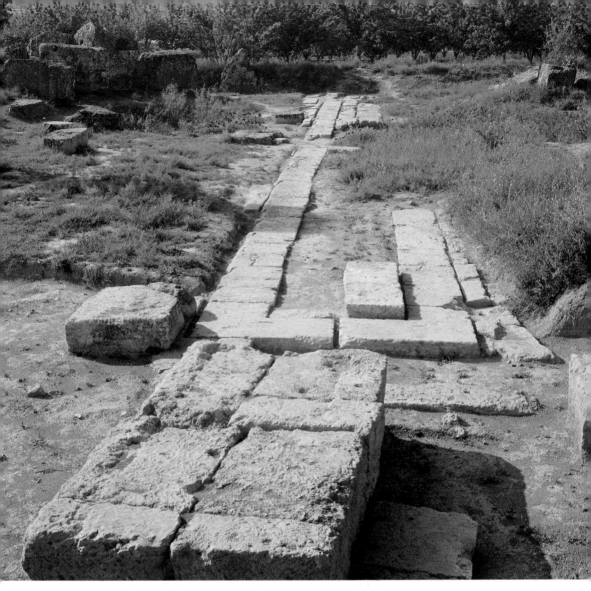

32. The foundations of the long altar to the east of the temple of Zeus at Nemea.

THE NEMEA MUSEUM

Since 1974 the University of California at Berkeley, under the auspices of the American School of Classical Studies and the supervision of the Archaeological Service of the Ministry of Culture, has been conducting large-scale excavations at Nemea.

The finds from these investigations are housed in the Nemea Archaeological Museum, built thanks to a generous gift from Rudolph A. Peterson and several other private citizens, which was inaugurated in 1984. Exhibits include finds from the valley of Ancient Nemea, as well as from the sites of Cleonae and Phlius.

Incorporated in the museum lobby are commemorative plaques bearing the names of Rudolph A. Peterson and the other donors, as well as those of the workmen and local people who gave of their time and toil to the Nemea excavations between 1974 and 1983. Displayed in the middle of the hall are various views of Nemea, captured for posterity by earlier travellers from 1766 onwards.

Housed in the central gallery are finds from the Sanctuary of Zeus and the Stadium of Nemea, the prehistoric settlement on Tsoungiza hill, the Mycenaean settlement at Aghia Irene and from the Mycenaean cemetery at Aidonia. The large windows of the gallery, which offer a vista of the Sanctuary of Zeus, and the large model of this (made by Robert Garbisch), enable the visitor to associate the objects in the museum with the corresponding sectors of the sanctuary and thus acquire an overall picture of Nemea and the area in which the games were held.

A large wall map to the left of the entrance and the cases containing silver and bronze coins from numerous Greek cities indicate the regions of the ancient world from which visitors came to Nemea (cases 1-3). Also exhibited are objects relating to the pythological traditions of Nemea and cult practices connected with the worship of the hero Opheltes (cases 4-6). To the right of the model of the sanctuary is one of the stadium. The objects displayed to the right of that are connected with the stadium and athletic activities at Nemea: stones from the starting line of the stadium, clay water conduits of the Roman period, statue bases and bronze strigils, javelin tips, a lead dumb-bell and part of a stone one, an iron discus, iron spits, vases, fragments of bronze statues and a bronze plaque with votive inscription, which was attached to a statue of a horse dedicated to Zeus (case 7).

The finds in the centre of the gallery were discovered in wells and reveal many interesting details of the history of Nemea (cases 8, 9, 18). This information is complemented by architectural members from the original temple of Zeus, tools, materials and equipment from the workshops of a bronze founder and a carver of Pentelic marble (the stone used for the sima of the fourth-century B.C. temple of Zeus), as well as a model of the system of sloping roofs applied to the temple of Zeus (cases 19, 20).

The east end of the gallery is devoted to prehistoric finds: vases, figurines, tools and weapons covering the Early Neolithic to the Late Helladic period, mainly coming from the hill of Tsoungiza (cases 12, 13).

There is an abundance of finds from the rich cemetery at Aidonia and the Mycenaean settlement at Aghia Irene: vases, figurines, gold finger rings, necklaces of glass paste beads or of gold, gold rosettes, sealstones, imitation scarabs, ivory rosettes, spindle whorls, a bronze dagger and arrow heads (case 14-17).

Displayed in the atrium are architectural members, sculptures and inscriptions from the fourth-century B.C. temple of Zeus, House 9 and other buildings at Nemea, as well as from other regions in the vicinity, such as Phlius and Petri.

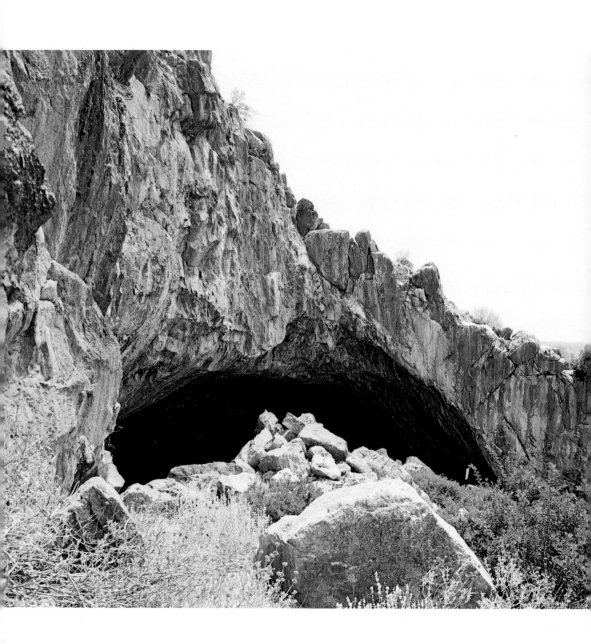

33. The cave of Franchthi at Ermionis where excavations (1967-1969) brought to light an entire cultural phase of prehistoric man (8th millenium B.C.).

THE ARGOLID

The region known as the Argolid consists of a small triangular seaside plain in the north-east region of the Peloponnese. It is hemmed in by a solid wall of mountains which divide it from Corinthia to the north and Arcadia to the west. The waters of the Saronic Gulf lap its eastern shore, the Gulf of Argolid its southern. Its eastern part, surrounded on three sides by the sea, is a true peninsula, scored by bays of great natural beauty. In antiquity, only the area around Argos itself was thought of as the Argolid. Pausanias employs this name for the plain of Inachos and the surrounding highlands, including the ancient cities of Mycenae, Tiryns and Midea. In late antiquity, the Argolid was understood to be the entire eastern part of the Peloponnese as far as Laconia in the south-west. The configuration of the land and the presence of many subterranean springs (the plain has no surface water) determined the economy of the countryside.

The Argolid was inhabited very early in the prehistoric period as mesolithic finds from the 8th mill. B.C. made in the cave at Franchthi at Ermionis show. Evidence for the Neolithic period (c. 3000 B.C.) has been found at several sites in the plain - Mycenae, Tiryns, Prosymna and Lerna - all of which were more densely populated in succeeding centuries. New settlements were also established, and in the 15th and 14th c. B.C. the Argolid was the centre of Greek civilisation under the rule of the Mycenaeans, after whom this period has been named. In the twelfth century B.C. the Argolid began to feel the effects of the migratory upheavals of the period, and was considerably weakened by repeated invasions. New settlers, the Dorians, established themselves on the plain, using Argos as their centre, and from the 9th century B.C. until the Roman occupation Argos was the capital of the area. Under Roman rule it enjoyed a period of peace, only interrupted by the incursions of the Heruleans in A.D. 267 and of the Goths under Alaric in 395. In the Byzantine period it was part of the theme of the Peloponnese. At the beginning of the thirteenth century it was occupied by the Franks, despite brave resistance offered by the ruler Leon Sgouros. The Argolid became one of the fiefs of the Peloponnese under the overlordship of the Duke of Athens, Otto de la Roche, until 1460, when it was conquered by the Turks like the rest of the Peloponnese with the exception of Nauplion, which was retained by the Venetians until 1540, and held by them again from 1686 until 1715. In the revolution of 1821, the area was frequently the theatre of war. Nauplion became the headquarters of the revolutionary government in 1822, and capital of Greece after the cessation of hostilities until 1834, when its place was taken by Athens.

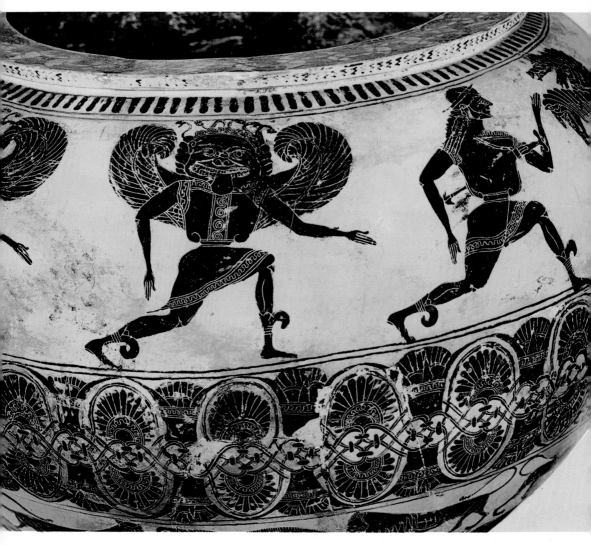

*34. Depiction of Perseus, founder of Mycenae, on a vase of the 6th century B.C. Perseus is
pursued by the sisters of Medusa, whom he had beheaded. (Paris, Musée du Louvre)*

MYCENAE

Shortly after the descent into the Argive plain from the Pass of Dervenakia a turn to the left leads to the ancient citadel of Mycenae, "rich in gold". It stands on a low hill (278 m.) wedged between the sheer lofty peaks of Mts. Zara and Profitis Ilias, separated from them by two deep ravines. Here at the northern erge of the plain of "horse-pasturing Argos" the citadel of Mycenae was built on a site that commanded both the greater part of the plain stretching southwards to the sea, and the exit from the Pass of Dervenakia. A continuous supply of water was ensured by the Perseia Fountain close to the entrance of the acropolis, while the proximity of the fertile plain ensured food supplies. The site's natural advantages thus enhanced its strategic position, and it was inhabited very early on in Neolithic times. The period of its greatest power, however, came at the close of the Late Helladic period (1600-1100 B.C.) which is also known as the Mycenaean period, and with which many tales and legends are associated.

The mythological founder of Mycenae was Perseus, son of Zeus and Danae. The Perseid dynasty gave many rulers to Mycenae. The last of them, Eurystheus, is famous for the Labours he imposed on Heracles, for which the Heracleides later took revenge, killing him when he visited Attica. After his death, the Mycenaeans chose Atreus, son of Pelops and Hippodamia, as their ruler. Atreus, however, hated his brother, Thyestes and went so far as to offer him his own children to eat, for which Atreus incurred the wrath of the gods. Thyestes pronounced a fearful curse on Atreus and his progeny. Atreus' heir, the renowned and energetic Agamemnon, who fought in the Trojan War, was murdered on his return home by his wife Clytemestra and her lover, Aegisthus. The children of Agamemnon, Orestes and his sister Electra, took vengeance for this murder, and Orestes became king of Mycenae. During the rule of his son, Tisamenus, the final catastrophe which destroyed Mycenae took place. About 1100 B.C. the citadel was destroyed by fire. Although excavation has

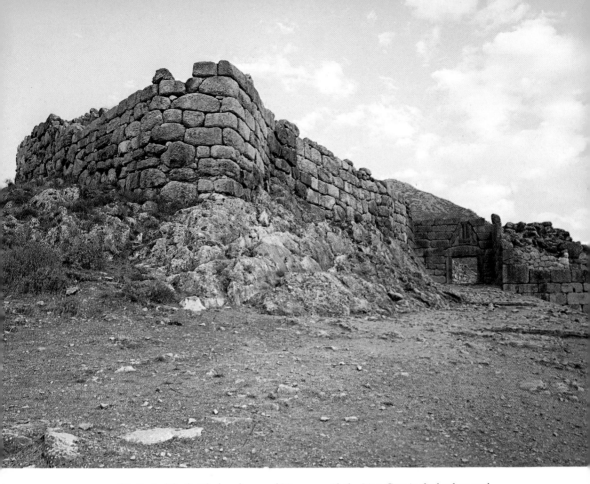

35. Part of the fortified enclosure of Mycenae with the Lion Gate in the background.

shown that it never ceased to be inhabited, the city dwindled into insignificance, becoming dependent on Argos, which replaced it as the political and religious centre of the Argolid. The Mycenaeans sent a contingent of eighty men to fight the Persians at the battle of Thermopylae and, together with Tiryns, some four hundred men to the battle of Plataea. For this noble deed their names were inscribed on the roll of honour on the tripod erected at Delphi by the cities which had taken part. The Argives, however, who resented the distinction conferred on their neighbours, seized the citadel in 468 B.C., forcing the inhabitants to surrender and then to destroy their fortifications. The city recovered sufficiently in the third century B.C. to repair its defences, but it was a short-lived spurt of activity. Under the Romans the city again slipped into oblivion. The last information about the site that we have comes from the traveller Pausanias who in the second century A.D. saw neither men nor animals on his visit. From that date until the beginning of the excavations only parts of the cyclopean walls and the relief of the lions, after which the Lion Gate is named, remained to bear witness to the former glory and grandeur of the city.

Excavations

In 1841, soon after the establishment of the Greek state, excavations started by the Archaeological Society uncovered the parts of the Lion Gate which lay below the surface. Three decades later, in 1874, Schliemann began explorations, discovering Grave Circle A in 1876, five of whose graves he excavated. In the following year the

then Ephor of Antiquities, Stamatakis, excavated the sixth grave in the Circle. Christos Tsountas undertook systematic exploration of the area between 1880 and 1902. His excavations laid bare the palace on the summit of the acropolis, foundations of two-storeyed houses, the underground spring and many tombs outside the defensive walls. Work was continued by the English archaeologist A.J.B. Wace with only a few intermissions until 1957; from 1952-1955 further work was carried out by the Ephor of Antiquities, J. Papadimitriou, and Professor G. Mylonas, who excavated Grave Circle B outside the citadel.

After 1955 Lord William Taylour and the Archaeological Society continued excavation. Professor G. Mylonas excavated a large area, completing the exploration of the ground inside the citadel and beyond.

STRUCTURES WITHIN THE CITADEL

The citadel of Mycenae was protected by a cyclopean wall, whose huge irregularly shaped blocks, some worked, some unworked, were placed in regular courses. The first and therefore the oldest defensive wall was built around 1340 B.C., enclosing only the summit of the hill. Grave Circle A lay outside it. The Lion Gate was erected c. 1250 B.C., together with the western and southern sections of the wall which now enclosed the Grave Circle. Only the northern section of the earlier wall was incorporated into the enlarged fortifications. The rest was demolished. A little later (c. 1200 B.C.), the defences were extended at the north-east to enclose and protect the subterranean spring.

The citadel is entered from the north-west through the famous **Lion Gate**. The relieving triangle above the lintel carries the oldest example of monumental sculpture. Two lions, whose heads, probably of steatite, are now missing, stand facing each other. Their forepaws rest on a high pedestal representing an altar, above which stands a pillar ending in a uniquely shaped capital and abacus. Above the abacus are four sculptured discs, interpreted as representing the ends of beams which supported a roof. The gate was closed by a double wooden door sheathed in bronze. The two halves were secured by a wooden bar which rested in cuttings in the jambs, still visible. The holes for the pivots on which it swung can still be seen in both sill and lintel.

Immediately beyond the gate to the right stands the **Granary**, a late structure which was in continuous use until the destruction of the citadel. Between it and the inner face of the Lion Gate a flight of steps used to ascend to the top of the wall.

Grave Circle A contains six royal graves, encircled by a row of stone slabs placed upright in the ground, interrupted on its northern side by the entrance. Above each grave stood a vertical stone stele. The dead were buried with a selection of personal belongings - the grave goods. These included gold face masks, gold cups and jewellery, bronze swords with ivory hilts and daggers with gold inlay decoration.

To the south of the Grave Circle lie the remains of several buildings of the Mycenaean era which today are known by various names - the **House of the Warrior Vase**, thw **Ramp House**, the **South House**, the **House of Tsountas**. Further to the south is the area of the **cult centre** of Mycenae. Returning to the inner face of the Lion Gate one sees a broad ramp in line with the gateway which ascends steeply, leading upwards to the site of the palace. The stairway now in use is modern. The **palace** complex of Mycenae covers the summit of the hill, and occupies a series of terraces. The entrance was in the northwestern side, controlled by a monumental gateway. Proceeding to the right beyond it one enters the great courtyard of the palace. The

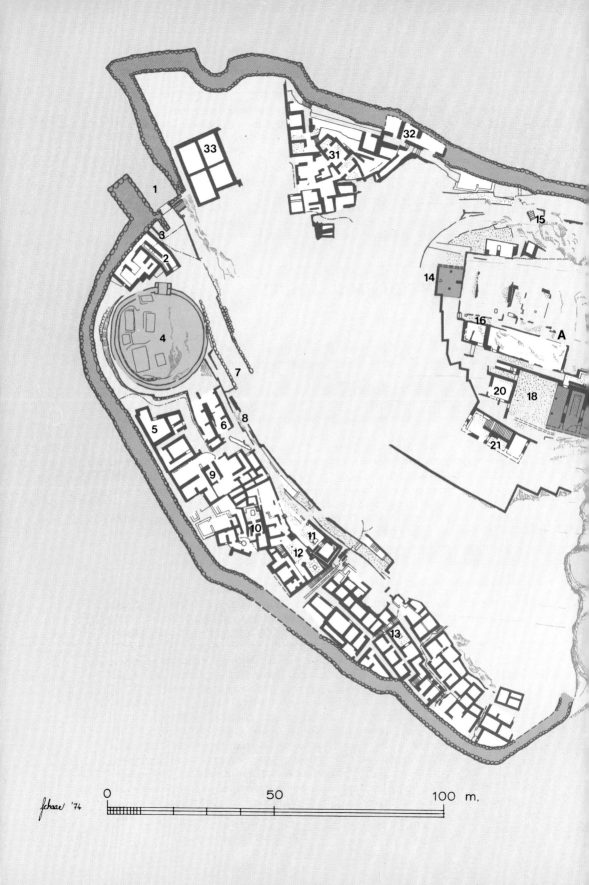

schaar '74

0 50 100 m.

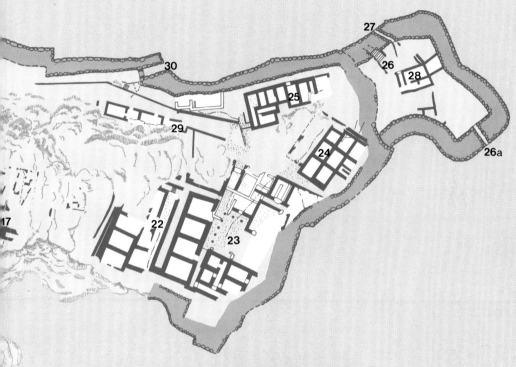

PLAN OF THE ACROPOLIS OF MYCENAE

1. Lion Gate
2. Granary
3. Staircase
4. Grave Circle A
5. House of the Warrior Vase
6. House of the Ramp
7. Great Ramp
8. Little Ramp
9. West House
10. Wace's House
11. Temple
12. Tsountas' House
13. Priests' Dwelling
A. Palace
14. Propylon of the palace
15. North Ramp
16. North Corridor of the Palace
17. Bath
18. Great Court

19. Megaron
20. Room (Guest Chamber)
21. Grand Staircase
22. Artists' Quarters
23. House of Columns
24. Building Δ
25. Building Γ
26. Entrance to the Underground
 Cistern
26a. Sally Port
27. North sally port
28. Buildings A and B
29. Storehouses
30. North Gate
31. Building M
32. Storehouses
33. Building perhaps for the guards
 of the fort

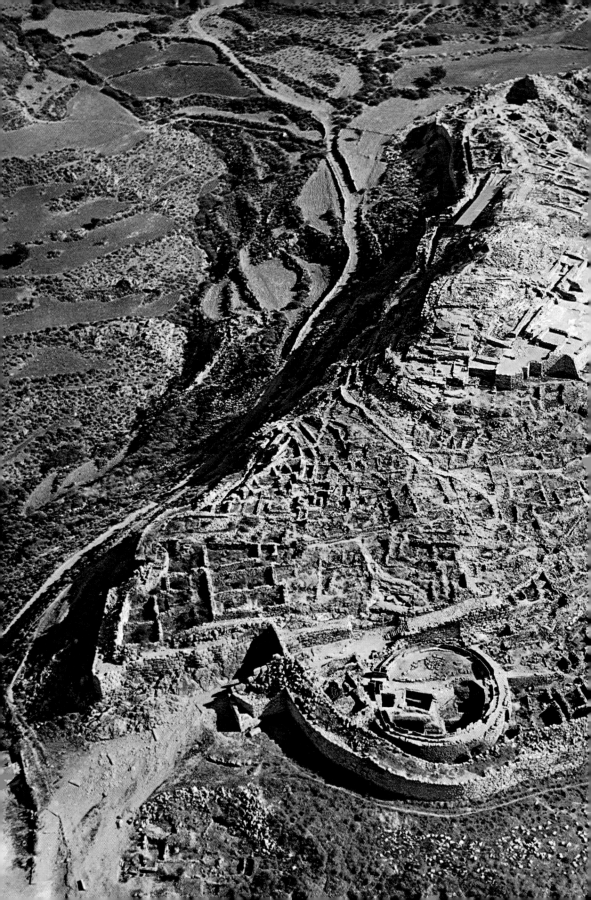

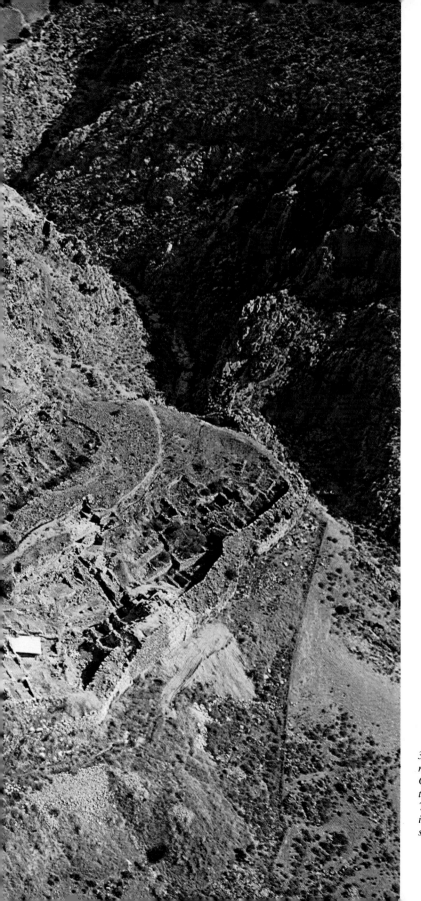

36. Aerial photograph of Mycenae, showing the fortifications, Grave Circle A with the houses to the south and the Cult Centre. The palace, surrounded by various complexes, occupies the summit.

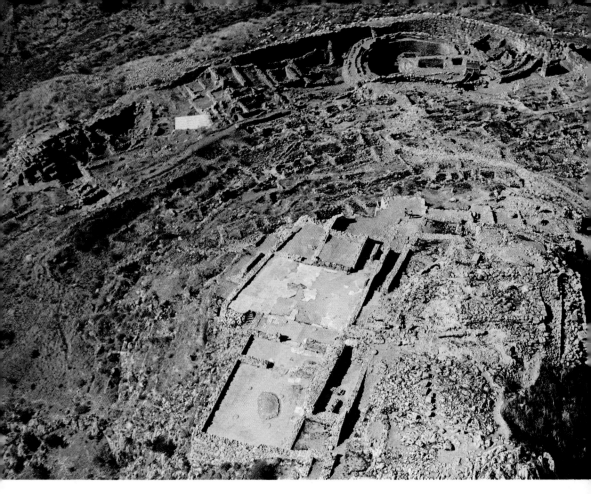

37. Aerial view of the palace complex of Mycenae.

ground was originally covered by a plaster coating above which was a layer of painted and decorated stucco. Some traces of the fire which destroyed the citadel can still be seen. The west side of the court was taken up by a succession of rooms, the east by the megaron complex. This consisted of a porch, a vestibule and a large room, the megaron itself. Homer's description suggests that the porch was open with two columns supporting the roof. It was paved with gypsum blocks and on its left an opening led to a flight of stairs and to the domestic quarters. A wooden door separated it from the vestibule, whose floor was also of painted and decorated stucco bordered by gypsum blocks, and another door connected it to the **megaron** proper. The throne room had four columns at its centre which supported the roof, and a circular raised hearth for the offering of sacrifices and the performance of ceremonies in which members of the royal family participated. Here too the floor was of painted stucco, and the walls were decorated with painted frescoes. The throne must have stood in the middle of the southern side, but it has not survived.

Remains of an **Archaic** and a **Hellenistic temple** can be seen north of the palace, and to the east on the right the visitor encounters the workshop of the artists and craftsmen employed by the king. The **House of the Columns**, which communicates both with the palace and with the workshops, received its name from the row of columns which surrounded its central court. Beyond it lie **Buildings Γ** and **Δ**, whose purpose is unknown, but which continued to be used until the citadel was abandoned. The remaining section of the fortification wall to the east consists of an

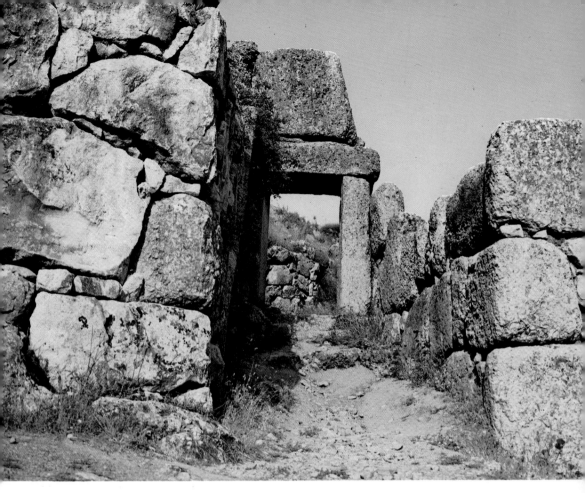

38. The North Gate of Mycenae, built on the same plan as the Lion Gate

addition made at the end of the 13th B.C. to ensure free communication from inside the citadel with the subterranean reservoir cut at the same time. This cistern, which was a storage tank for water brought some five hundred metres from a spring above, is one of the most impressive technical works of the Mycenaean period. Along the north cyclopean wall lie the ruins of another Mycenaean Building, Building M.

In addition to the Lion Gate which was the main entrance to the citadel, there was a gate of secondary importance in the north wall, west of the underground reservoir, the so-called **North**, or **Postern Gate**, built on the same plan as the Lion Gate. Beyond the gate are the ruins of the Hellenistic city.

STRUCTURES OUTSIDE THE CITADEL

Leaving the Lion Gate behind and descending to the area outside the citadel, the visitor comes across prehistoric remains, the most noticeable being those of tombs, whether shaft graves of the 17th and 16th c. B.C. or chamber and tholos tombs dated to 1500 B.C. and later. The tholos tombs were called "Treasuries" by the 2nd c. A.D. traveller Pausanias. The first of these tombs is the **Lion Tomb**, so called because of its proximity to the Gate. In the area between the Gate and the modern road are two other tholos tombs, the **Tomb of Aegisthus** and the **Tomb of Clytemnestra**. The former, which is the oldest of the tholos tombs, was constructed *c.* 1500 B.C. A long

narrow entrance passage (*dromos*) led into the burial chamber. The Tomb of Clytemestra was built *c.* 1220 B.C. with a long dromos. The entrance in the facade is covered by three lintel stones supporting a relieving triangle; only traces of the sculptured decoration which this bore remain. **Grave Circle B** contained fourteen royal tombs, of the shaft grave type, and twelve of individuals. Careful excavation assisted the understanding of the technique involved in their construction and in the study of burial customs. The dead were interred with their belongings which are, however, fewer and less striking than those found in Grave Circle A.

In addition to the mansions found within the citadel private houses were also discovered outside the protection of the fortifications. Examples of such dwellings can be seen south of Grave Circle B. The finest were uncovered by Wace; they covered a considerable area and were rich in finds. These houses are dated to the thirteenth century B.C. when they were burnt and consequently deserted. Much later, tombs of the Geometric period and houses of the Hellenistic epoch were built above them. The Mycenaean structures have been given names in modern times, for example the **House of the Oil Merchant**, the **House of the Shields** and the **House of the Sphinxes**. On the hill of Panagitsa lies another Mycenaean settlement, discovered by Professor G. Mylonas. Close by stands the most impressive building of those outside the citadel and the most imposing example of Mycenaean architecture, the **Treasury of Atreus**, also known as the Tomb of Agamemnon. Its construction is placed around

39. The facade of the famous tholos tomb known as the Treasury of Atreus with its monumental entrance and the relieving triangle above the lintel.

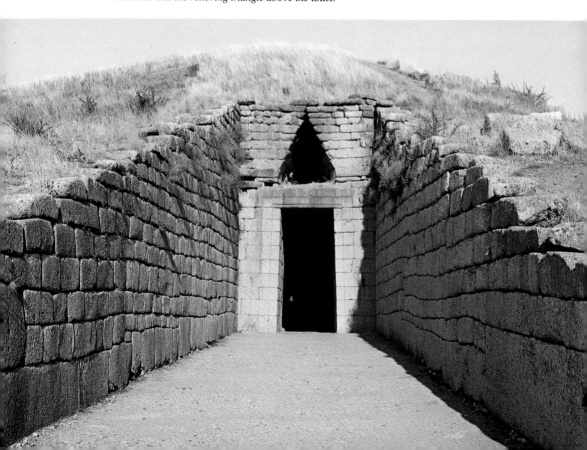

1250 B.C. contemporary with that of the Lion Gate. Just like the other tholos tombs, it consists of a passage way (36 m. long, 6 m. broad), built of huge squared stones, which leads into the domed chamber. The facade of the entrance had applied decoration, but only small fragments have been preserved they are exhibited in the National Archaeological Museum of Athens and the British Museum in London. Traces of bronze nails suggest that similar decoration once existed on the internal surfaces of the chamber. A square chamber opens off its northern side. The tomb was found empty, already robbed in antiquity. However, it must at one time have contained rich and valuable grave goods, since Pausanias tells us that the ancients considered it to be the Treasury of Atreus and his family.

From Mycenae a secondary road leads left to the slopes of Mt. Euboia, on which stands the shrine of the goddess Hera. It is known as the **Argive Heraion**. It is also possible to reach this site from Argos, passing through the village of Chonika. The Heraion was one of the most important shrines, not only in the Argolid, but also in the whole of Greece. It was regarded as the centre of the worship of the goddess Hera who was known as early as Homer's time as «Argeia», the Argive goddess. Excavation (Waldstein 1892-1895, Blegen 1925-1928, Caskey and Amandry 1947-1949) has shown that the site is to be identified with that of Mycenaean Prosymna, whose acropolis probably occupied the site of the later temple.

Today the sanctuary is much ruined, but the site is still impressive.

40. The ruins of the temple of Hera at the Argive Heraion. The sanctuary reached the peak of its prosperity in the 5th century B.C.

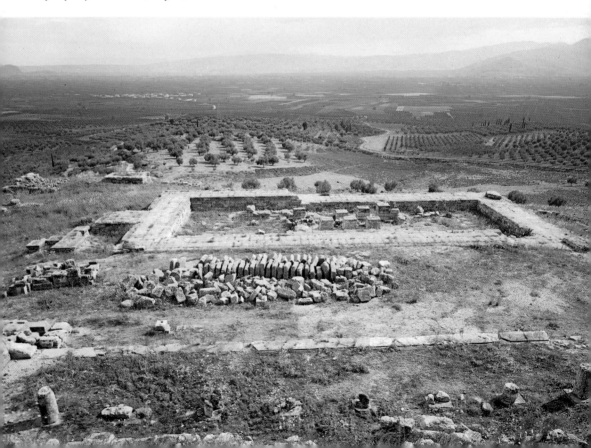

FINDS FROM MYCENAE
IN THE NATIONAL ARCHAEOLOGICAL
MUSEUM OF ATHENS

41. Most of the finds from Mycenae are to be seen in the National Archaeological Museum of Athens. Amongst them is the fresco depicting a woman, discovered by Professor G. Mylonas in a room in the Cult centre of Mycenae.

42. Plaster head of a woman; the features of the face are especially prominent and have been picked out in colour.

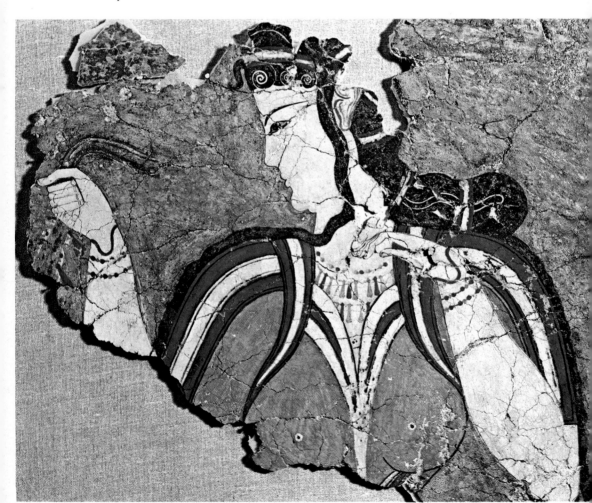

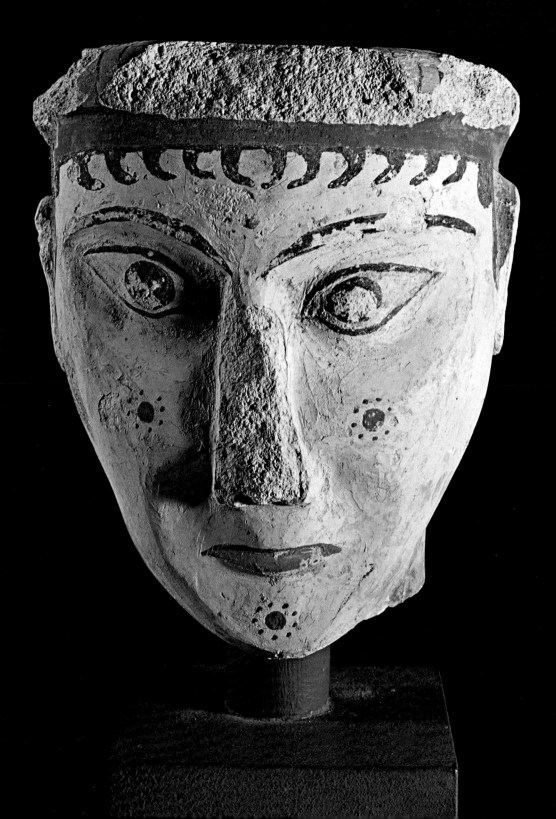

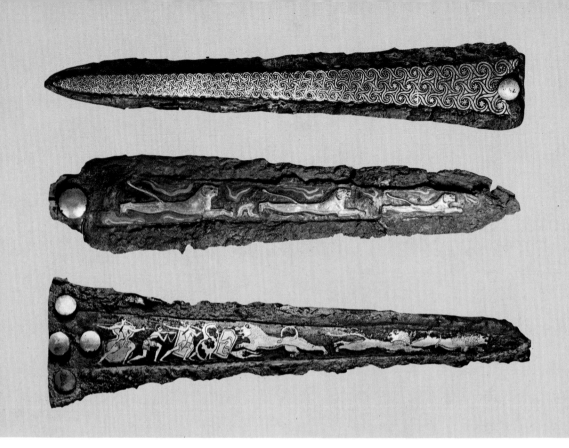

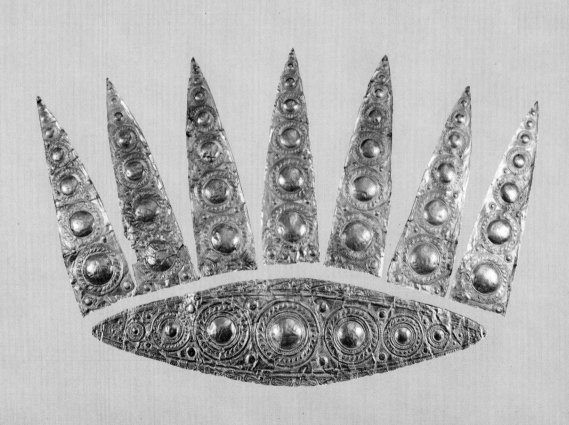

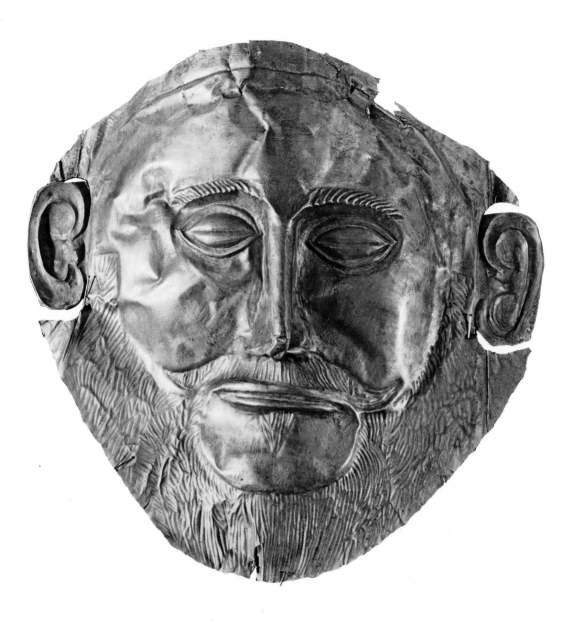

43. *Bronze daggers with inlaid decoration in gold and silver. They were found in graves IV and V in Grave Circle A.*

44. *Gold diadem fashioned out of rhomboidal sheets, found in Grave III.*

45. *Gold mask said by Schliemann to represent the face of Agamemnon. It is the most striking of the masks found in Grave Circle A. This one came from Grave V.*

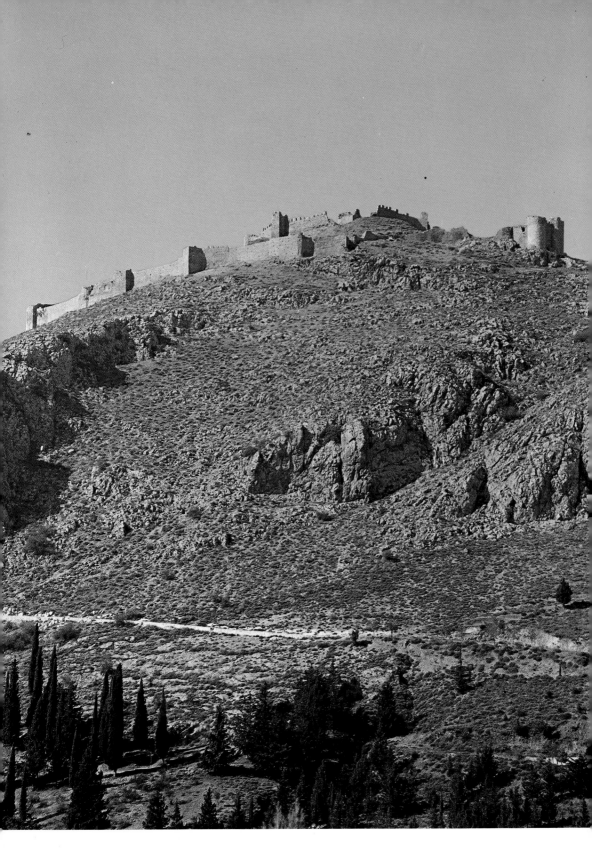

ARGOS

Argos (13 kms. from Mycenae) a historic city of the Peloponnese and today the agricultural and industrial centre of the region, has been inhabited since prehistoric times. According to tradition the founder of the town was the son of the river spirit Inachos, Phoroneus. He was later dethroned by Danaus, who came from Egypt. His descendants divided the Argolid between themselves. Akrisius remained as ruler of Argos, his grandson being Perseus, the founder of Mycenae. His grandson was Eurystheus and from him descended the Achaean rulers Atreus, Agamemnon, Orestes and Tisamenos. Legend therefore represents Argos as the oldest town of the Argolid, more ancient even than Mycenae and Tiryns. It was in Argos that Danaus took refuge with his fifty daughters, trying to avoid his fifty nephews, the sons of his brother Aeguptus. They nevertheless pursued him to Argos, marrying Danaus' daughters. Danaus, however, had given secret orders to his daughters to murder their husbands, and all but one, Hypermnestra, obeyed him. The murderesses were punished in the Underworld for their crime, condemned forever to fetch water in jars that leaked like sieves. In the Mycenaean era the most important settlements were Mycenae and Tiryns, and Argos occupied a secondary position. After the coming of the Dorians, however, political emphasis was transferred to Argos which developed

46. *The castle on Mount Larissa seen from the east. Little remains of this fortress, once one of the strongest in the Peloponnese, except for the outer defensive wall with a few towers. On the slope of the hill is the monastery dedicated to the Virgin Katakekrimeni or «tou Brachou». From here one has a panoramic view of the plain of Argos.*

into one of the most impostant centres of Doric culture. Its acme was reached at the beginning of the seventh century B.C. under the rule of Pheidon who extended the sway of Argos; power and minted coins to facilitate his trading operation. But at the same time Argive rivalry with Sparta came to a head and the long-drawn out war between the two cities began. The Spartans emerged victorious. In the fifth century B.C. it was only natural that the Argives should be found as the allies of Athens against Sparta, but, exhausted by the Peloponnesian War, their power thereafter was much diminished. Despite their unpropitious circumstances, they did not relinquish their hopes of dominating the Peloponnese. The Argives participated actively in all the many quarrels between the Greek cities, until the Macedonians became supreme, whereupon the Argives became their faithful allies. In 229 B.C. they were drawn into the Achaean League, and thus in 146 B.C. were treated as an enemy by the Romans, although not as harshly punished as Corinth. The subsequent history of Argos resembles that of the other cities in the Peloponnese.

The cultural development of Argos ran parallel to its political fortunes. There is considerable evidence for the flourishing of artistic skills early on, notably in pottery manufacture. Its products of the Geometric period were particularly distinguished. Special emphasis should be laid on Argive skills in metal working and sculpture in bronze, its most famous masters in the latter being Ageladas and Polycleitos.

During the Byzantine period Argos, otherwise insignificant, retained some importance because of its metropolitan church and bishopric. A little before the Sack of Constantinople by the Franks in 1204, Argos passed into the possession of the ruler of Nauplion, Leon Sgouros, to be taken in 1212, together with Nauplion, by Otto de la Roche. In 1463 it was conquered by the Turks. Captured by the Venetians in 1686, it was re-occupied by the Turks in 1715. It was freed in the War of Independence, in which the town played an important role. It was here that the first post office was established.

The modern town to a large extent covers the ancient one. Remains of the latter have been brought to light by the excavations of the French School of Archaeology. On the south-west slopes of Mt. Larissa, also known as Kastro, by the side of the modern road to Tripolis, lie the remains of the ancient **agora** (market place) laid out in the fifth century B.C. Foundations of a building of the fifth century B.C. were uncovered in the agora over which a bath house and small shops were constructed in the Roman period. Also dated to the 2nd century A.D. are the impressive **public baths**, or Thermae, northeast of the theatre, restored in the 4th century A.D. while a few metres further north is a large villa whose mosaic pavements can now be seen in Argos museum. The most impressive of the excavated monuments, however, is the **Theatre**, on the south-east slopes of Mt. Larissa and built towards the end of the 4th or the beginning of the 3rd century B.C. According to an inscription it was remodelled in the time of the Emperor Hadrian. Most of the eighty-nine tiers of seats are cut into the rock of the mountain side. It has been estimated that twenty thousand spectators could be accommodated, which makes it the largest theatre in Greece.

South of the theatre stands a similar building, the **Odeon** or concert hall. A building on the site was in use from the fifth century B.C., probablu serving as the assembly place of the Argives; the present structure dates to the Roman imperial period (first and third centuries A.D.). A little beyond the skene of the Odeon to the south-west, a **shrine to Aphrodite** was excavated. The sacred area was enclosed by a stone wall. The temple, a building of the fifth century B.C., perhaps deteable to the decade 430-420 B.C., was divided into the cella *(sekos)* and *pronaos* or porch; there was no *opisthodomos* (rear porch). Only its stone foundations remain. In this sanctuary worship of Aphrodite continued until well into the Christian period, ceasing only with the persecution of paganism and the destruction of the shrine by the incur-

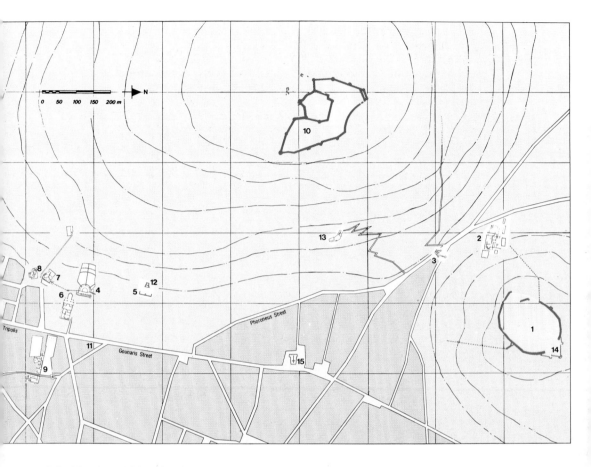

PLAN OF ANCIENT ARGOS

1. Aspis
2. Sanctuary of the Pythian Apollo
 and Athena Oxyderkes
3. Mycenaean tombs
4. Theatre
5. Kriterion
6. Roman baths
7. Odeon

8. Sanctuary of Aphrodite
9. Agora
10. The fortifications of Mt. Larissa
11. Villa where the mosaics were found
12. Cistern
13. Virgin of the Rock
14. Fortification wall
15. St John's Chapel

sions of the Goths. Two other buildings which beautified Argos should be mentioned: the **Kriterion**, northeast of the theatre, where according to tradition Danaus brought his daughter Hypermnestra to trial for refusing to kill her husband Lynceus: and a little higher up the slope, the apsidal **Nymphaeum** where a Hadrianic aqueduct terminated. The conduit itself can be seen on the mountainside, extending as far as

the Church of the **Panagia Katakekrimenni** (well-hidden) or **«tou Vrachou»** - the Virgin of the Rock. This is possibly built on the site of the archaic temple of Hera *Akraia*.

The higher of the two mountains to the north-west of the town of Argos is Mt. Larissa, the modern **Kastro**. Its peak can be reached either by a steep and rugged path on the eastern side, by a more gentle track which starts above the Odeum, or by using the motor road from the plateau of Deiras. Mt. Larissa was turned into a fortress in the sixth and fifth centuries B.C. Poros foundations of the two temples which Pausanias tells us stood on the summit have been found: one was dedicated to Zeus *Larissaios* the other to Athena *Polias*. The Archaic walls were rebuilt in the middle ages, and kept in repair by the Franks in the thirteenth century and by the Venetians in the fifteenth. There is a double line of fortifications: an outer wall

47. *The impressive remains of the Roman baths built in the 2nd century* A.D. *in the market place of Argos.*

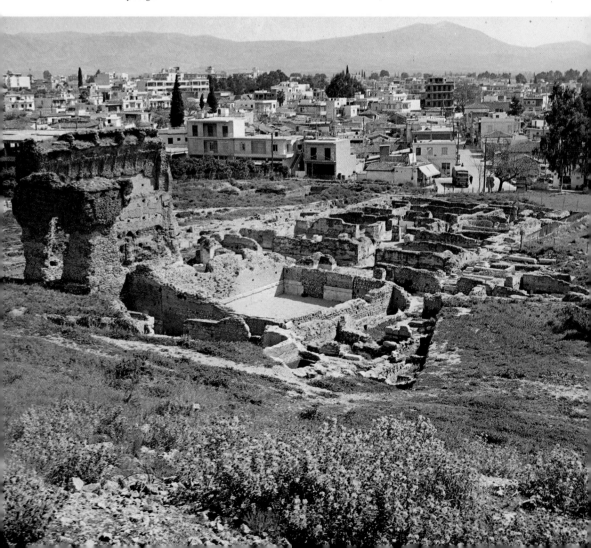

encircles the relatively flat top of the hill and an inner circuit protects a centrally placed tower. Older material, re-used, can be seen both in the defences and in the ruined church within the castle.

More modern buildings to be seen in the town include several neo-classical structures, for example the house of the general Tsocris and his brother; of general Gordon; of Constantinopoulos built to plans of Ziller; and market arcades and the barracks dating from the time of Capodistrias.

Eastwards from Argos a road leads to the village of **Merbaka** which has a Byzantine church of the twelfth century, and thence through the village of Manesi to **Dendra**, from which a footpath leads to the hilltop where the Mycenaean acropolis of Midea was sited.

48. The theatre at Argos, one of the largest of antiquity. The remains of the skene, the orchestra and some of the tiers of seats can be seen.

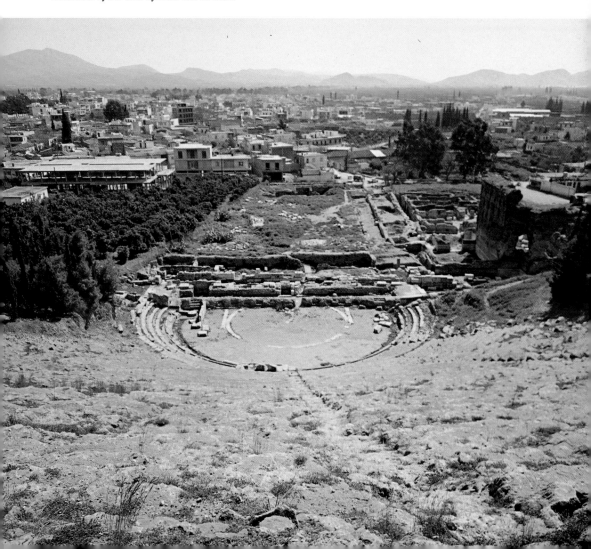

49. *Fragment of a clay krater of the 7th century B.C. It bears a representation of Ulysses and his companion blinding the Cyclops Polyphemus.*
50. *Large vase with three feet whose linear decoration depicts animals and birds. Beneath the handles are figures of wrestlers. 8th century B.C.*

THE MUSEUM

The museum of Argos, on Olga Street, is housed in a new building, the gift of the French School of Archaeology. The finds from the excavations are displayed on the first floor, to the right of the entrance. Some are displayed free-standing, others in cases, in chronological sequence. From left to right is a diplay of Middle Helladic and Mycenaean pottery and figurines, followed by Proto-geometric and Geometric pottery, a helmet and the breastplate and helmet of an Argive warrior. The second floor has a display of Roman remains, including sculpture, statues, busts and reliefs. In the basement of the Kallergeion, a neo-classical house incorporated into the museum, are the finds made at Lerna from the Neolithic, Early Helladic, Middle Helladic and Late Helladic periods. Of special interest is a Neolithic figurine and a circular Early Helladic altar. Mosaic floors found in the late Roman villa close to the theatre are to be seen in the courtyard outside. They bear representations of the Seasons, the months and of Dionysos and his retinue.

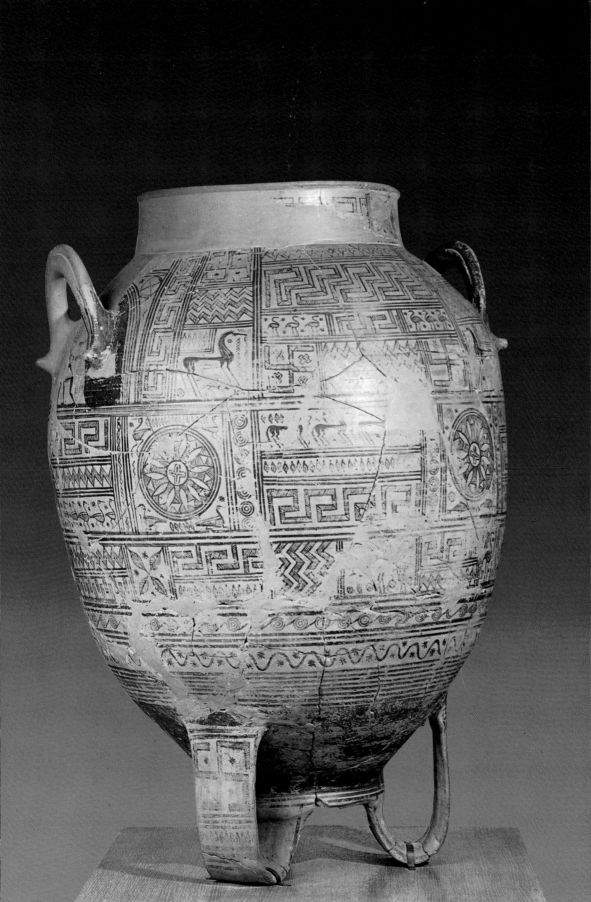

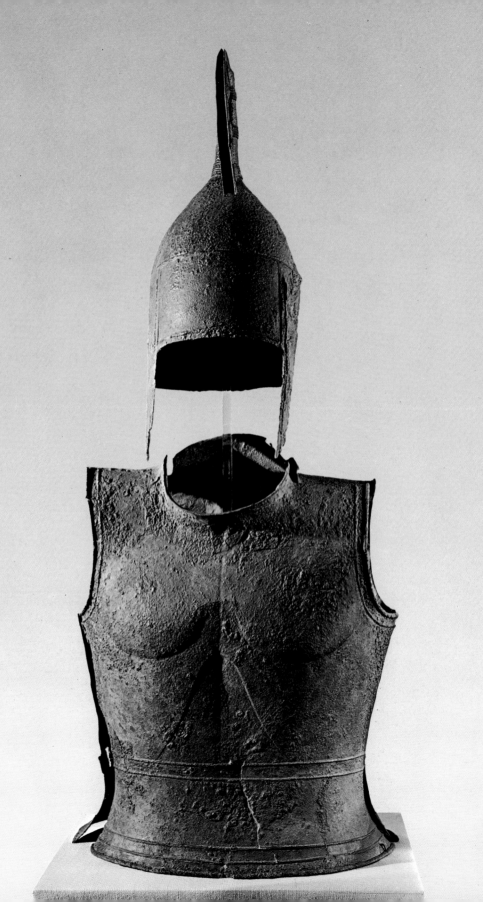

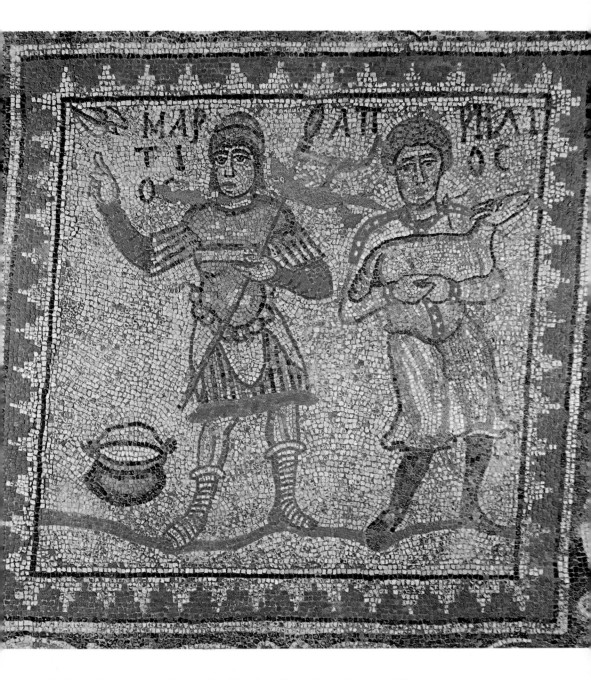

51. *Bronze breastplate and helmet, found in a Late Geometric tomb at Argos. 8th century* B.C.

52. *Roman mosaic depicting the months March and April as male figures - March is shown as a warrior, April as a shepherd with a lamb in his arms. The mosaic was found alongside others (bearing representations of the months, the seasons of the year, Dionysos with his retinue) in a late Roman villa close to the theatre.*

71

53. *One of the better preserved galleries in the east wall of the acropolis of Tiryns.*

54. *The entrance to the acropolis of Tiryns, reached through a gate built on almost the same plan as the Lion Gate of Mycenae.*

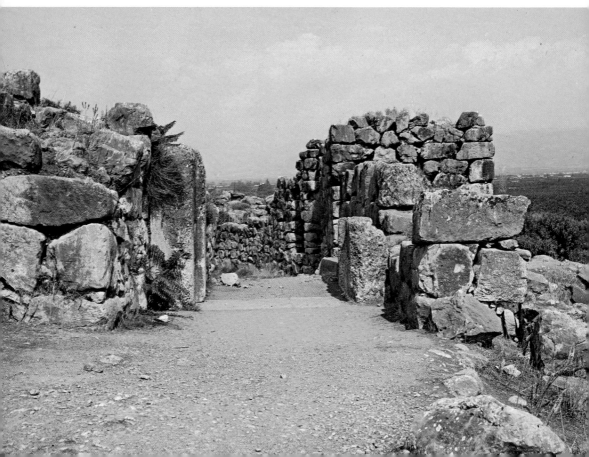

TIRYNS

Beyond Argos the road crosses the pleasant plain of Argonauplia, bounded by mountains on one side, the sea on the other. Twelve kms. from Argos, five before reaching Nauplion, are the ruins of the Mycenaean acropolis of Tiryns with its fortifications of cyclopean masonry that still stand to a low leight. The ancients attributed their construction to the Cyclops - beings with super-human strengt - who built them to help Proetus, king of Tiryns and brother of Akrisius king of Argos. Mythological sources suggest that Tiryns was fortified two generations before Mycenae - a fact which has been confirmed by excavation. Mycenae, Argos and Tiryns were all to some extent, not yet determined, inter-related. Homer describes Tiryns as "the wall-girt city", but that is the only literary reference to the city we have. About the end of the Mycenaean period the citadel was destroyed by fire, and abandoned. The vicinity never ceased to be inhabited, of course, but its former importance was lost for ever.

Archaeological exploration of the site was first undertaken in 1876 by Schliemann. Work was continued by Dörpfeld in 1884 and later by the German Archaeological Institute. Excavation still continues. The finds show that the acropolis was occupied in Neolithic times. It was not fortified, however, until a little after 1400 B.C. The defences were completed in three stages, assuming their final shape a little before 1200 B.C. The total length of the ramparts is 725 m., the thickness varying from 4.50 to 17 m. The acropolis is divided from north to south into three sections, *lower, middle* and *upper*. The site as we see it today consists of the walls, the palace and the elongated lower citadel. The **entrance** to the citadel is on the eastern side, and is approached up a ramp. Once past the entrance, a left turn leads to the main gate of the Upper Citadel, a right turn towards the Lower.

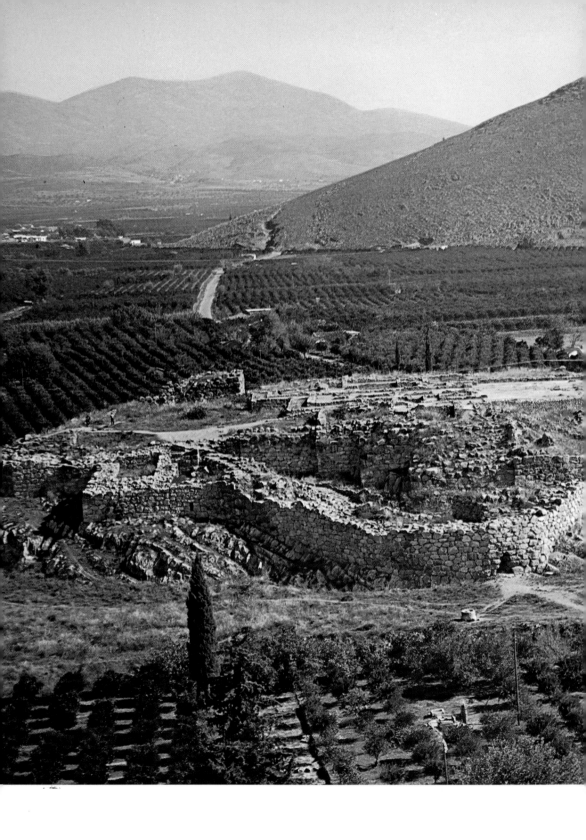

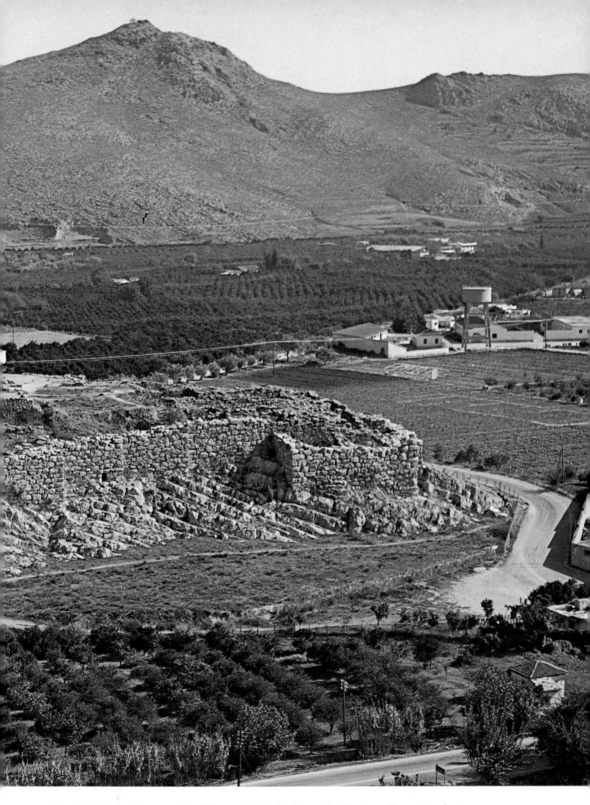

55. Aerial view of the acropolis of Tiryns with the Cyclopean fortifications. The western bastion, the postern gate and the palace complex on the summit can be seen.

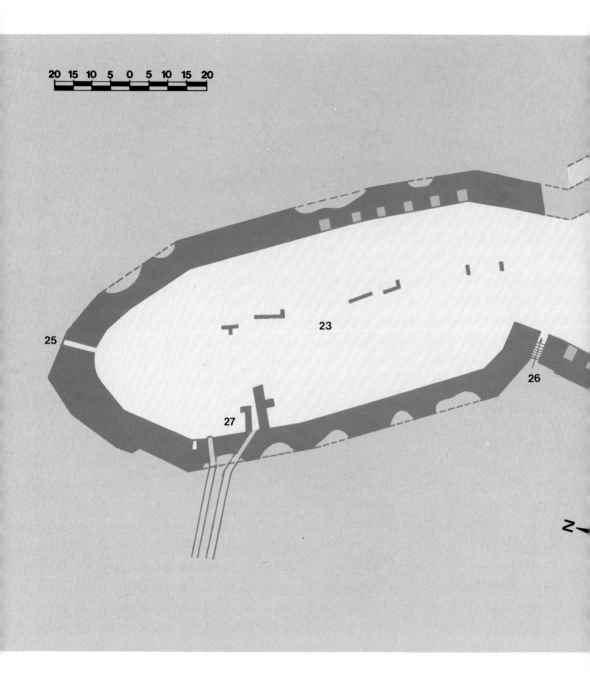

PLAN OF THE ACROPOLIS OF TIRYNS

1. Cyclopean Ramp	5. Courtyard	9. Gallery
2. Entrance	6. Galleries	10. Guard house or Archives room
3. Main Gate	7. Great Propylon	11. Propylon
4. Gate	8. Outer court of the palace	12. Central court of the palace

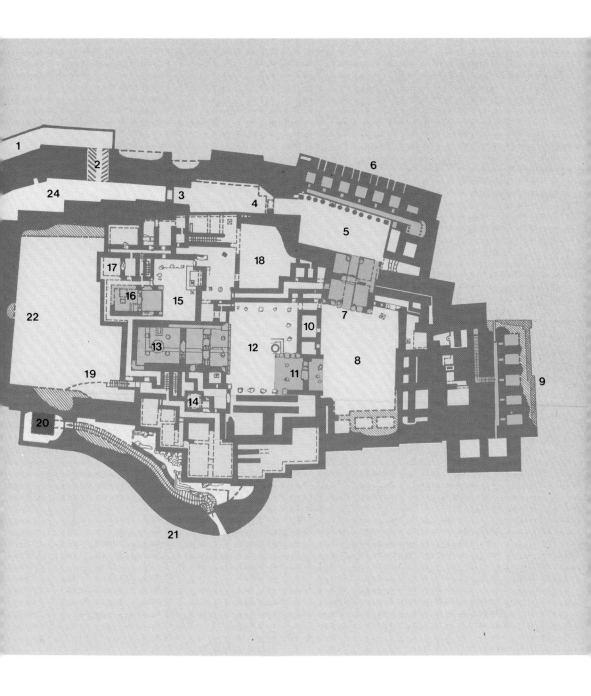

13. *Great Megaron*
14. *Bath*
15. *Court*
16. *Small Megaron*
17. *Megaron-like Quarters*

18. *Ruins of houses*
19. *Paved corridor*
20. *Tower*
21. *Western Bastion*
22. *Middle acropolis*

23. *Lower acropolis*
24. *Niche*
25. *Arched gate*
26. *Arched gate*
27. *Underground galleries*

The **main gate** closely resembles the Lion Gate at Mycenae in plan and dimensions, although here only the threshold and jambs have survived. Beyond the gate lies the first courtyard, which had an elongated portico on its eastern side. Below this, on the inner side of the defences is a row of small square rooms or casemates opening off a long narrow corridor roofed by a corbelled arch, one of the famous galleries of Tiryns. A second such gallery is to be found in the southernmost part of the acropolis. This second tunnel also communicates with a series of casemates whose and walls, today incomplete, were vertical and formed the external face of the enceinte. The galleries rank among the most interesting Mycenaean architectural achievements; they served as storerooms and would have been especially useful during long sieges.

The **palace** itself is sited at the highest point of the acropolis. Before arriving at its central court one had to pass through a succession of guarded entrances, emerging into the light to be dazzled by the splendour and richness of the palace, in whose central section, the *megaron* proper, stood the royal throne. Surviving fragments suggest magnificent decoration, both of the floors and of the walls: the latter were covered in frescoes. Such wall paintings were probably not limited to the megaron, but existed elsewhere in the palace. The frescoes, which today are on display in the National Archaeological Museum of Athens, depict a boar hunt, women riding in chariots and a procession of women. Over and above their artistic merit, they afford details of daily life in the Mycenaean kingdom. All the apartments of the palace lying between the megaron and the west wall are built with special care; amongst them is the bathroom, whose floor consists of a single immense limestone slab, weighing more than twenty tons. On its north-east side a runnel conducts the water to a T-shaped channel nearby which drained into a sewer designed to collect rainwater from the overhanging roofs. Four separate drains made up the drainage system which served the entire complex. Behind the megaron towards the east was a small courtyard with a colonnade on its eastern side and on its southern corner the **small megaron**. The palace, and indeed the entire megaron-like complex, faced the sea, communicating with the shore by means of an impressive flight of stairs which terminates at a small **postern gate**. The upper part of these stairs was protected by a watch-tower, and by a curved extension of the wall, the western bastion. This embodied the older fortifications. Against its internal face was the flight of steps, still preserved, from the top of which the modern visitor can see and appreciate the defensive strength of the entire fortified enclosure.

The middle citadel was also inhabited, but it awaits proper exploration, while the excavated part of the lower acropolis cannot be visited. Recent excavations in the acropolis show that the acropolis was damaged by an earthquake. At the north-west corner of the defences, however, a significant discovery was made; two tunnels, parallel to each other, start from within the acropolis, and proceed under the walls. Each served as a subterranean cistern. These tunnels, roofed in the same way as those on the eastern and southern sides, ensured a continuous water supply to the acropolis, even in time of sige. About 1200 B.C. the palace complex was destroyed by fire. A century later, the Argolid was invaded and settled by the Dorians. Tiryns, like Mycenae, at first enjoyed a brief spell of autonomy and then became subject to Argos.

56. Fragment of a wall painting from the palace of Tiryns. 13th century B.C.

NAUPLION

The town of Nauplion lies five kms. beyond Tiryns. The modern visitor is charmed by the dramatic setting of the city: the sheer mass of Palamidi, the rocky promontory of the Acronauplia, the picturesque and mysterious Bourzi island fort. According to mythology, the town was founded by Nauplios, son of Poseidon and Amymone. His special skill in nautical matters spurred the development of the town, and it quickly became a naval power. According to myth, it took part in the Argonaut campaign. Whether or not this is true, the archaeological finds testify that Nauplia (as Nauplion was originally called) was inhabited in the prehistoric period; chamber tombs from the Mycenaean era have been uncovered on the north-east side of Palamidi. Until the seventh century B.C., the town remained independent, although it was not one of the important centres in the area. A little before the end of the seventh century B.C. during the course of the Second Messenian War, the men of Nauplia allied themselves with Sparta, rival of Argos. The consequence of this was that the Argives attacked Nauplia, deprived its inhabitants of power, and took the city for themselves as a naval base and arsenal. The former inhabitants were expelled and moved to Messenia, establishing themselves at Methone. In the Hellenistic period Nauplia acquired considerable importance: in about 300 B.C. fortifications were built to surround the promontory of the Acronauplia which rises sheer from the sea on the southern side of the town, and was the acropolis. However, in the Roman period, the town was deserted. When Pausanias visited it in the second century A.D. he found it abandoned, and refers only to ruined walls and a temple of Poseidon. Nauplion recovered its vitality in the Byzantine period; in the twelfth century the Byzantines re-fortified the Acronauplia, incorporating the ancient walls. In 1210 the Franks captured the town, despite the brave resistance of its ruler Leon Sgouros. In 1389 it was ceded to

57. The entrance to the fortress of Palamidi. Above can be seen the emblem of the Venetians, the Lion of St Mark.

58. View of the Acronauplia from the fort of Palamidi. Its fortifications can be seen at several points. In the bay is the islet of Bourzi. The town of Nauplion extends picturesquely along the shoreline, its old houses and monuments a reminder of its past. ▶

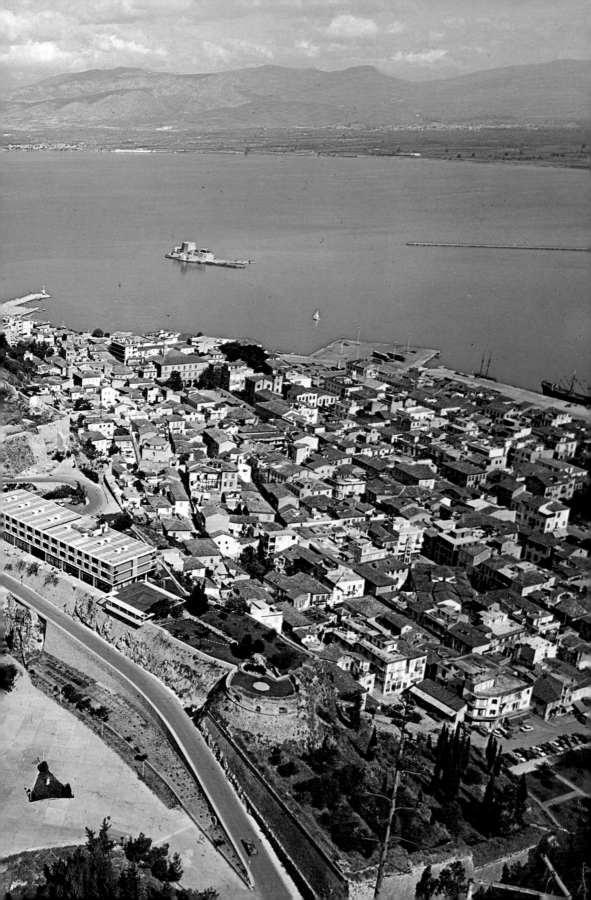

the Venetians who rebuilt the defences incorporating their emblem, the Lion of St Mark, at different points. The town was occupied by the Turks in 1540. Francesco Morosini occupied it in 1686, later building the stronghold which crowns the precipitous mass of Palamidi. 857 steps cut into the rockface, passing under a series of galleries, gave the defenders of Palamidi the opportunity to communicate in safety with the fort of the Acronauplia. In 1715 the Turks succeeded in recapturing the town, both forts and the tiny offshore Bourzi island, which had also been fortified by the Venetians. Nauplion was recognised as the capital of liberated Greece from 1829 until 1834 and as the seat of the first governor, J. Capodistrias. Here Otto, Prince of Bavaria and first king of Greece, was welcomed on landing in Greece in 1833. He later transferred the capital to Athens.

The town evokes strong memories of the past. The modern visitor can saunter through the narrow picturesque alleys with their old houses whose latticed balconies are nearly always adorned with flowers. Today the ruins on the Acronauplia represent only scanty traces of the four successive fortresses. Although parts of the ancient defences can be seen below the Venetian fortifications, the Byzantine walls were almost entirely obliterated by the Venetian extensions and alterations. The repair work of Morosini in 1686 is most clearly seen in the eastern side. The city also was walled; part of the north-west section, erected by the Venetians, can be seen at the small bastion called the Five Brothers. This bastion with five gun embrasures survives opposite the Bourzi, the small islet, originally called SS. Theodore, linked to the Acronauplia by an iron chain which blocked the entrance to the Harbour. After independence, the fort was used as a home for the executioners of those awaiting the death sentence in Palamidi.

Palamidi fort which towers impressively over the town was erected by the Venetians in the seventeenth century. It is now easily accessible by road from its eastern side, while the romantic can always ascend the steep stairs, partly covered over by galleries on the north-western side. The fortress is made up of eight self-contained batteries linked together by a curtain wall, decorated in many places with the emblem of Venice, the Lion of St Mark.

Of the historic buildings within the town, the visitor may see the **residence** of the regent Armansberg, the **house** of co-regent Professor Maurer, the **first gymnasium** in Greece, the **first ministry of defence**, the **first military academy** and the **first school** (*Allilodidactirion*) which was housed in the Turkish mosque on the east side of Syntagma Square. In another mosque on the south-west corner of the same square the first parliament of the free Greek state was held; hence the mosque was known thereafter as the **Vouleftikon**. At the entrance to the town is the **Lion of the Bavarians**, erected to commemorate the Bavarian soldiers who died in the plague epidemic of 1833-34. Amongst the many churches is **St George**, built by the Venetians in the Byzantine style during their first occupation and later converted into a mosque by the Turks. During the second period of Venetian rule it became a Roman Catholic church. At this date it was decorated with wall paintings, copies of works by famous Italian painters, such as the Last Supper of Leonardo da Vinci. **St Nicolas**, also erected by the Venetians, is in the central square. **St Spiridon**, built in 1702, is famous because it was here that Capodistrias, the first governor of free Greece, was murdered. The bullet which killed him is still embedded in the wall. A little higher stands the **church of the Metamorphosis**, built in Western style on the site of an older mosque, itself erected on the site of a Venetian monastery. It was presented by King Otto I to the catholics of Nauplion for use as their parish church. On the wooden arch of the entrance, erected by the Philhellene Touret, are inscribed the names of the Philhellenes who died in the War of Independence.

59. *The cliff on which stand the prehistoric fortifications of the acropolis of Asine.*

ASINE

Beyond the small picturesque bay of Tolon, some eleven kms. east of Nauplion, is the sandy shore of Asine, above which the ruins of the ancient acropolis stand on a rocky steep promontory. The area retains all its wild charm. Excavations carried out by the Swedish Archaeological Institute brought to light finds which demonstrate occupation of the site from the Early Bronze Age and which flourished both in the Mycenaean and in the Protogeometric and Geometric periods. Archaic remains were also found, and Asine seems to have remained prosperous as late as the Hellenistic era. However, when Pausanias visited it in the second century A.D. he saw only ruins. Today, only the walls and towers of the Hellenistic acropolis, their survival considerably assisted by medieval repair work, remain as indications of its former glory.

Beyond Asine you may progress to the Gulf of Drepanon, one of the most enchanting bays in the Peloponnese. If, however, one wishes to visit Epidaurus, one should retrace one's steps on the road towards Mesogeia some twenty-five kms. to the village of Ligourio which boasts a Byzantine church, St Constantine.

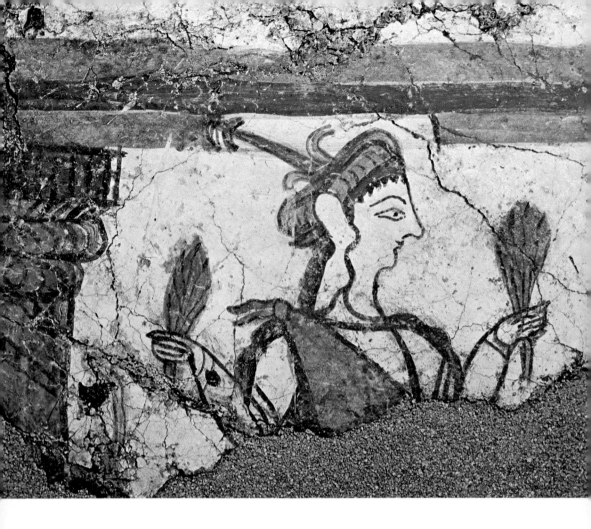

THE MUSEUMS OF NAUPLION

On the west side of Syntagma Square stands an imposing Venetian building, once a warehouse and now the **Archaeological Museum**. The exhibits are displayed in chronological order on two floors. On the first floor are finds from the prehistoric centres of the region: Neolithic vases from Franchthi, Early, Middle and Late Helladic pottery from Asine, Mycenae, Tiryns and Midea, and bronze objects, such as the unique bronze suit of armour with a boat's rusk helmet from a tomb at Midea, grave stelai, stone vases, cult figurines and frescoes from Mycenae and some frgments of wall paintings from Tiryns.

Outside the room are two stone megaliths (*menhirs*) from Midea. On the second floor are finds from the historic periods: a sub-Mycenaean helmet and grave goods from a tomb at Tiryns, Proto-geometric and Geometric vases and small finds, the terracotta masks and shields from Tiryns, examples of black and red figure pottery and statuettes of different periods.

Local costume together with weapons, tools and household goods, two old plans of the town and photographs of monuments now demolished make up the display of the Folk Museum which is in a neo-classical house in Vassileos Alexandrou Street.

60. *Fragment of a fresco depicting a female figure, perhaps a princess; she wears a typically royal style of head-dress and holds a stalk of corn in her hand. It was found at Mycenae and is dated to the 13th century* B.C.

61. *Mycenaean armour in bronze, unique of its kind. It was found in a tomb at Dendra (Midea) and consists of strips of bronze joined together by metal plates. The helmet was fashioned from boars' tusks. 15th century* B.C.

62-63. *Mycenaean figurines found at Mycenae and dated to the 13th century* B.C. *The facial features and jewellery bedecking both throat and hands are picked out in colour. The body is entirely stylized.*

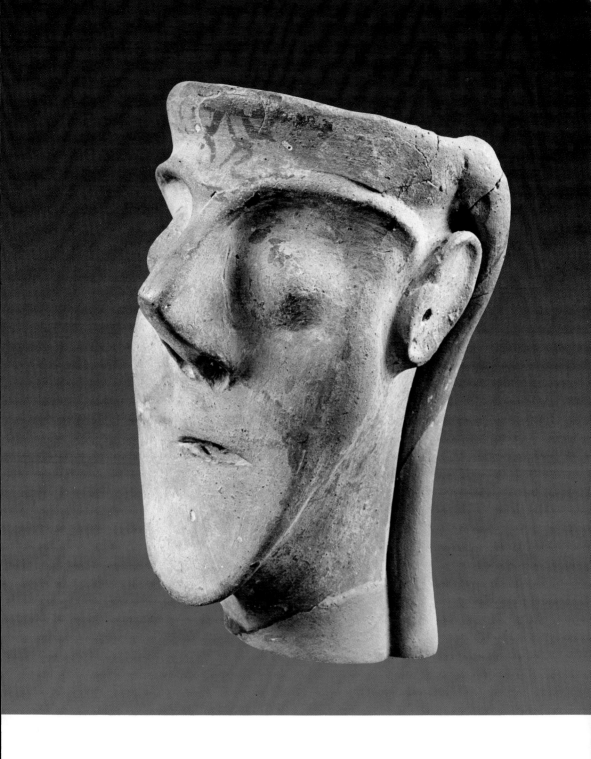

64. Clay head of a figurine from Asine; it may represent a nobleman and has thus been called the Lord of Asine. They way in which the facial features have been worked - the eyes, the nose and the chin - has produced an object of exceptional beauty.

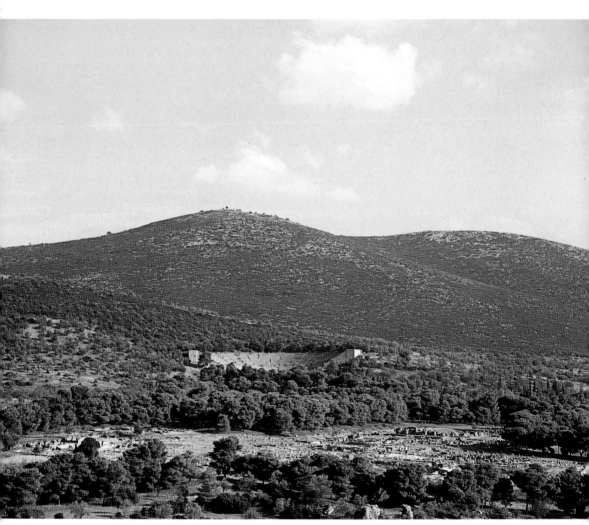

65. View of the site of Epidaurus showing the theatre and ruins of the various buildings attached to the sanctuary.

EPIDAURUS

Some five kms. beyond the village of Ligourio lie the ruins of the sanctuary of **Asclepios**, who was predominantly the god of healing. In his honour sanctuaries, known as *Asclepieia*, were founded throughout Greece. Myth has it that he was the son of the god Apollo and of the mortal Coronis, and that his birthplace was in Thessaly. However, when his cult spread, several variations of the tale about his origin were invented in attempts to make Asclepios a local god in places where his cult had in fact been newly established. At Epidaurus he was worshipped at first as a hero, and for a long time his worship co-existed with that of Apollo. It was only later that he was elevated to full divinity. The sanctuary entered on a long period of prosperity towards the end of the fifth century B.C. - a prosperity specially marked in the fourth century B.C. In honour of Asclepios a large and impressive temple was erected, in which the chryselephantine statue of the god was kept. The most splendid buildings within the precinct were also raised to honour the god. Prosperity continued until 86 B.C. when the sanctuary was desecrated by the Roman general, Sulla. A new era opened in the second century A.D. when the Roman senator Antoninus provided money to rebuild much of the sanctuary.

The sanctuary continued to function until the fourth century A.D., when it, along with other shrines in Greece, was closed by decree of the Emperor Theodosius. The severe earthquakes of A.D. 522 and 551 completed its ruin.

Excavations began in 1879 under the direction of P. Kavvadias on behalf of the Archaeological Society, continuing until his death until 1928. Sypplementary small-scale work was carried out by the French School of Archaeology in 1942. From 1948-1951 the then Ephor, J. Papadimitriou, undertook the excavation of the temple of Apollo Maleatas, where work began again in 1974.

THE MOST IMPORTANT BUILDINGS OF THE SANCTUARY

Today the Sanctuary is entered from the south, and not, as in antiquity, from the north. On the slopes of Mt. Kynortion lies the **theatre**, perhaps the best known and best preserved of all ancient theatres, where performances are still given. Its superb acoustics, admired by contemporary theatre-goers, reveal that the ancients knew

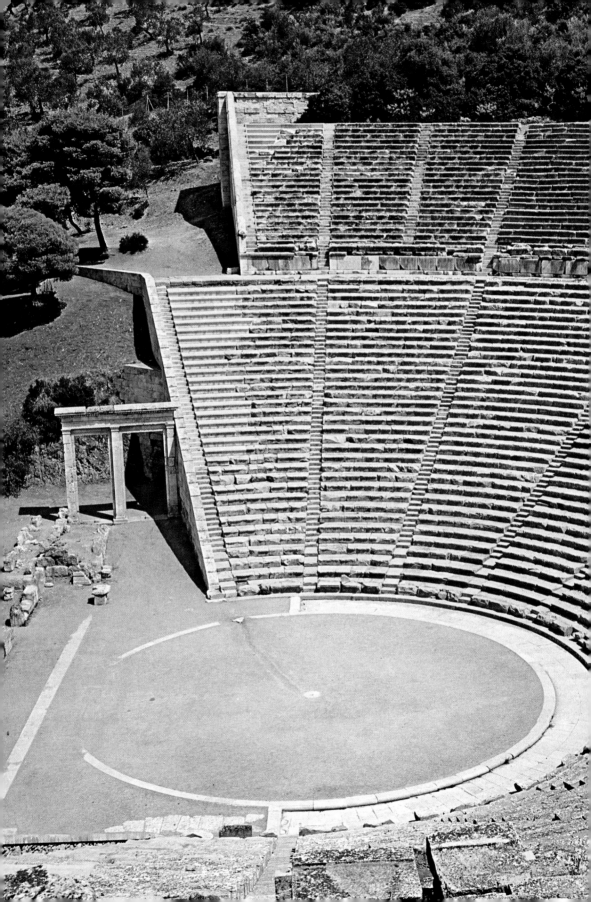

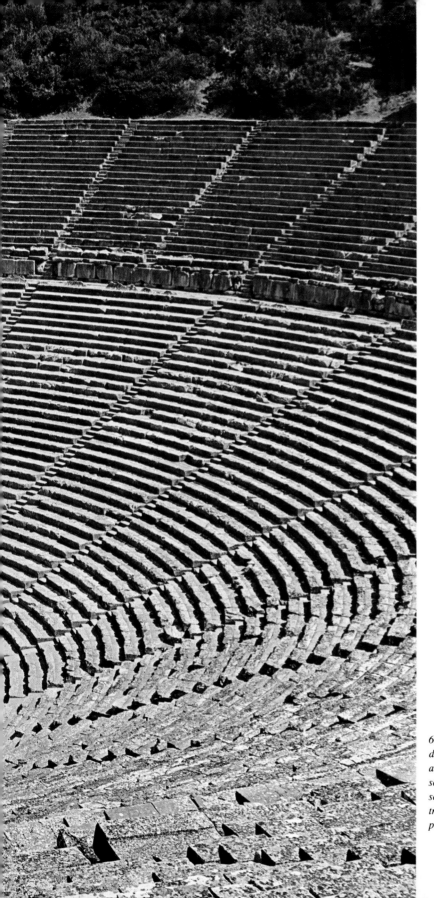

66. View of the theatre of Epidaurus, the best preserved of the ancient world. Note the rows of seats divided into wedge-shaped sectors, the gangways, the orchestra, one of the passageways and part of the remains of the skene.

93

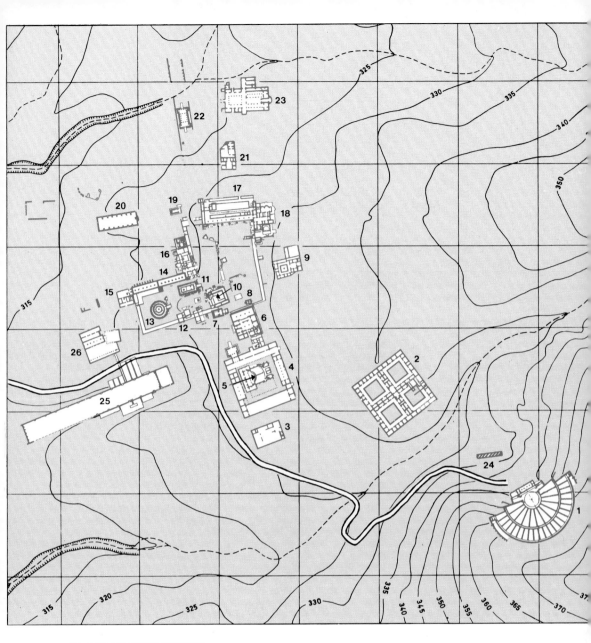

PLAN OF EPIDAURUS

1. Theatre
2. Katagogeion or Guest House
3. Baths
4. Gymnasium
5. Odeon
6. Palaestra, Stoa of Kotys
7. Temple of Artemis
8. Temple of Themis
9. Temple of Asclepios and of Apollo of the Egyptians
10. House of the Priests
11. Temple of Asclepios
12. Buildings
13. Tholos
14. Enkoimeterion or Abaton
15. Fountain
16. Baths and Library
17. Stoa
18. Roman baths
19. Temple of Aphrodite
20. Cistern
21. Buildings
22. Propylaia
23. Christian Basilica
24. Museum
25. Cistern
26. Palaestra and Hostel for the athletes

well how to make the most of the morphology of a site when building a theatre. Its proportions confer a harmonic symmetry on the entire structure. The theatre was built in the early third century B.C., a fact which makes its construction difficult to reconcile with the tradition that it is the work of Polycleitus the Younger. In its original design, there was a circular orchestra, the only circular one to have survived unaltered from antiquity. At the centre stood an altar. Thirty-four rows of seats, divided into twelve sections, could accommodate an audience of 6,200. In the second century B.C. alterations were made: the rows of seats were extended upwards, divided into twenty-four sections, and separated from the original tiers by an ambulatory. Capacity was thus increased to 12,300. The lowest and the highest row of the original tiers, and the lower row of the upper division were reserved for people of importance, and hence were not just benches, but were fashioned into thrones. Spectators reached the upper rows of seats by side corridors, thus avoiding crossing the *orchestra* which is about 20 m. in diameter. In front of the *orchestra*, facing the auditorium, was the *skene* which consisted of the main building with one room at each side, and the *proskenion* with a row of Ionian half-columns marking its outer edge or facade. In between these there were once paintings which could be moved about to block the gaps between the columns and change the scenery. In the beginning the actors performed in the *orchestra*, but with the enlargement of the theatre they moved on to the *proskenion* and only the chorus remained in the orchestra. Between the *skene* and the tiers of seats were two side corridors, the *parodoi*, from which the chorus, the messenger and the herald made their entries. Each passageway was graced by a stately monumental gate, adding charm to the whole structure.

Moving north from the theatre one progresses into the area containing the buildings attached to the shrine. The first is the guest-house (the Katagogeion), the largest single building within the precinct, erected in the fourth century B.C. to accommodate the steady stream of worshippers. It was a two-storey building, enclosing four square courtyards, off each of which rooms opened on all four sides. There were originally one hundred and sixty rooms, but today only the lower courses of the walls, door-sills, column bases of the colonnades and a few column drums remain. West of it are the remains of the square **bath-house** of the Hellenistic period, contemporary with the **gymnasium** to the north. This is also a large square building, its entrance in the north-west constructed as a Doric **propylaea**. In the Roman period, on the same site, a small **temple** to the **goddess Hygeia** was erected. In the inner court of the gymnasium was a small **Odeon** with a semi-circular *orchestra*. Another square building erected in the Roman period by Antoninus has been interpreted as a **palaestra**. The building itself had a monumental entrance, a hypostyle court in the centre with an open colonnade on the northern side and rooms opening off the other three sides. The colonnade to the north is thought to be the **Stoa of Kotys** to which Pausanias refers. To the north-west stood the Temple of Artemis, a building dated to the end of the fourth century B.C.; its foundations and assorted architectural fragments have survived, and can now be seen in the museum. The temple was small, with a cella (*sekos*) and porch, in front of which stood six Doric columns. Within the cella a row of ten Corinthian columns on the northern, western and southern side surrounded the cult statue. Contemporary with it is the **Temple of Themis** to the east, from which only the lower parts of the walls survive. On its north-east side sprawls a complex of buildings of the Roman period, probably including the **temples of Asclepios** and of **Apollo of the Egyptians** built by Antoninus to which Pausanias makes reference. According to the most recent excavations, however, this building is more probably the **temple** of the **Dioscouroi**. Progressing westwards one enters the area of the Sacred Grove delimited by boundary stones. Here birth and death were equally forbidden. The first building is the oldest building in the shrine, rectangular with

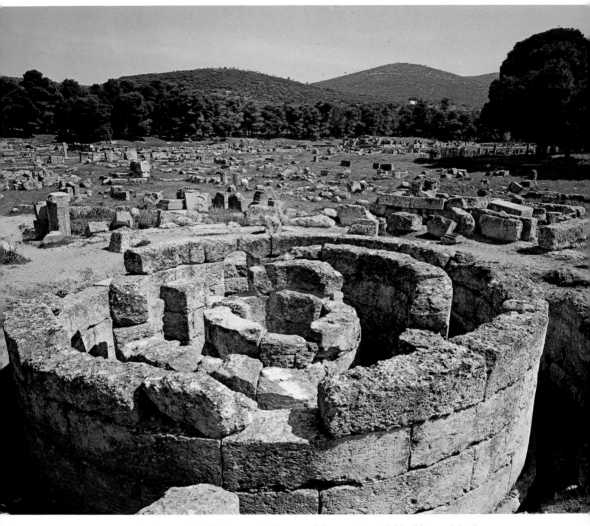

67. The ruins of the Tholos, originally one of the most beautiful buildings of the Sanctuary.

long narrow spaces at its sides, originally a **temple of Apollo**. However, from the sixth century B.C. onwards, when the worship of Asclepios alone triumphed, the place was altered to become the *"Enkoimeterion"* (dormitory). It ceased to be used for a period of time, and in the Roman period it was converted for use as the priests' residences.

To the north lies the most important building of the sanctuary, the **Temple of Asclepios**. An inscription of 380 B.C. informs us that it was first erected at the beginning of the fourth century B.C. designed by the architect Theodotos. The temple was in the Doric peripteral style, with six columns on the ends and eleven on the long sides, with a *sekos* and *pronaos* in front of which stood two columns *in antis*. The entrance, on the eastern side, was approached by a ramp because the entire structure stood on a three-

stepped platform. The cella housed the cult statue of Asclepios, the work of the artist Thrasymedes of Paros. According to the description of Pausanias (II, 27.2) it was fashioned of gold and ivory and represented the god seated on the throne, one hand clasping a staff, the other resting on the head of a serpent. A dog stretched out at his feet. The throne was ornamented with relief representations of Bellerephon with the Chimaera and with Perseus who cut off the head of Medusa. The same artist executed the big wooden door which led into the cella *(sekos)* decorating it with ivory plaques held in place by gold nails, while the sculptured decoration of the pediments and acroteria were executed by Timotheos. On the west pediment were scenes from the War against the Amazons (Amazonomachy), on the east the Fall of Troy. On the acroteria are Nereids or the *Aures* mounted on horseback and Victories. Some pieces of these sculptured compositions and of the acroteria have been preserved. The main altar to Asclepios stood on the east, opposite the entrance to the temple. The sick who came to the shrine hoping for a cure believed that the appropriate treatment would be revealed to them through a dream or perhaps by some other divine act. To this end they slept in the **Abaton** or **Enkoimeterion**, a colonnade some 70 m. long separated into two parts. That which lies towards the east is the older. Constructed in the fourth century B.C., it was a single storey structure with a double Ionian colonnade on its southern side, having sixteen columns on the exterior and seven on the interior. The western section was built in the third century B.C. at a lower level. It was therefore possible to make it two-storeyed, and it also had a double Ionian colonnade. On the east side of the enclosure is a well-head of the sixth century B.C. above a spring believed to possess healing properties. Close to its mouth inscriptions relating cures were found.

A little distance to the south-west of the **Temple of Asclepios** excavation revealed the foundations of the **Tholos** - the "Round House" of Pausanias. It was perhaps the most outstanding construction within the sacred precinct, a work of Polycleitos the Younger. It was a circular building, with an exterior colonnade, a round *sekos* (cella) and an internal colonnade. The entrance, on the eastern side, was approached by a ramp. The exterior colonnade consisted of twenty-six Doric columns and supported a Doric entablature with metopes which bore no decoration other than a small rosette sculptured in the centre. The internal colonnade consists of fourteen Corinthian columns, whose capitals are to be considered amongst the most beautiful in this style. A richly ornamented door opened into the cella *(sekos)* whose walls and ceiling were panelled in marble, each panel decorated with a spray of blossoms sculptured at the centre. Below the floor level of the cella was a crypt with three concentric circular walls, reached from the *sekos* by moving a white slab in the centre of the floor. The erection of the Tholos started around the mid-fourth century B.C. and a variety of materials was employed in its construction, ranging from limestone to wood and even white marble. Its purpose, however, remains obscure and has provoked much scholarly debate. It has been variously interpreted as a centre for the practice of secret rites, as a place where official busines was discussed or as the chapter house of the priests and dignitaries.

Beyond the enclosure of the Sacred Grove to the north-east are the foundations of a block of buildings of the second century A.D. The northern part is thought to be a **bath-house**, the southern a **library**. On the north-east was a second complex of colonnaded buildings, to the east of which in Roman times another large bath-house was erected. To the west of the complex was the **Temple of Aphrodite**, dated to the late fourth century B.C. Leaving the temple behind and descending the slope to the north one comes to the monumental **Propylaia** (gateway), the ancient entrance to the precinct, built around 300 B.C. The gate has two archways, each with six columns; those on the north are Ionian, those to the south Corinthian. They rested on a raised

stone foundation with steps in the middle of the narrow sides. East of the gate are the foundations of a large **Christian basilica**.

To the south-west of the sanctuary - today beyond the boundary of the archaeological site - is the **Stadium**, where a few tiers of stone seats have been preserved. In the Hellenistic period, a subterranean passage was excavated below the seats on the northern side which linked the arena with two buildings lying to its north. Above the theatre, on the southern side of the sanctuary, rises Mt. Kynortion where the **Temple of Apollo Maleata** was excavated by P. Kavvadias in 1928. It has been examined since by J. Papadimitriou and most recently by Professor V. Lambrinoudakis. Before the fourth century B.C. buildings of this sanctuary - a **small temple, stoa** and **cistern** - an **altar** dated to the seventh century B.C. stood on the same site.

Many of the finds from the Asclepieon are on display in the **museum** which stands close to the entrance to the site. In the *first room* are inscriptions of varying nature: a hymn to Apollo Maleatas and Asclepios by the poet Isyllos, an account for the various repairs carried out to the Temple and to the Tholos, and many ennumerating details of cures. One show-case is given over entirely to a display of surgical instruments, while in the *second room* are to be found plaster cast copies of statues and offerings the originals of which are to be seen in the National Archaeological Museum of Athens. Sculptured fragments from the Temple of Asclepios and of Artemis and others from the Tholos are in the *third room* together with drawings and reconstructions of the floor of the Tholos. Amongst the finest exhibits is the Corinthian column capital, the work of Polycleitos the Younger.

The town of **Ancient Epidauros** lay about ten kms. beyond the sanctuary, on the site of the modern village of Old Epidauros. Here a **theatre** dating to the time of Alexander the Great, some of whose stone seats survive, has recently been excavated. At **New Epidauros**, seven kms. further north, are the remains of a medieval stronghold, and four kms. beyond the village is a monastery, **Moni Agnountos**, with Byzantine wall-paintings.

LERNA

On the coast opposite Nauplion, about ten kms. from the modern village of Myloi, are the remains of ancient *Lerna*, excavated by Professor J.Caskey. The site was inhabited in Neolithic times (5th and 4th millenia B.C.); it reached an acme in the Pre-helladic period (*c.* 2500 B.C.), to which the most important building - the House of the Tiles - is dated. The site continued to be inhabited in the Mycenaean period. In the historic period it extended northwards: a settlement of the second century A.D. has been found, that mentioned by Pausanias.

68. One of the most beautiful exhibits in the Museum of Epidaurus, the Corinthian column capital said to be the work of Polycleitos the Younger.

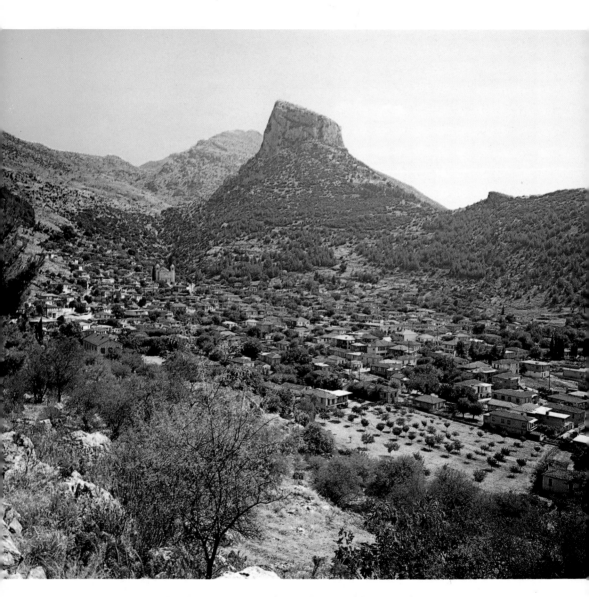

69. View of modern Nestani, built close to the ruins of the ancient city.

ARCADIA

Arcadia occupies the central area of the Peloponnese, and is a mountainous region, whose boundaries march with those of all the other provinces of the Peloponnese: its eastern side extends to the coast of the Gulf of Argolis and the Myrtoon Sea. In antiquity, however, because the Argolid had a common boundary with Laconia on the east Arcadia had no littoral. Seaside Kynouria, now Arcadia, was then part of the Argolid although the Spartans laid repeated claim to its possession.

The Arcadians are thought to be the oldest inhabitants of the Peloponnese (Herodotus, VIII, 73). The first king of the region was Pelasgos who succeeded in imposing some measure of civilisation on the Arcadians, who had lived until then in a state of barbarity. Originally the Arcadians had been divided into several separate tribes; they appear for the first time as a united people when they took part in the Trojan War (Iliad, II, 603-604). Because they were not a seafaring people, but trained as warriors, they reached Troy in ships allotted to them by Agamemnon himself. Later, they fought in the struggles of the Messenians against the Spartans. The latter initiated intense and prolonged pressure to acquire supremacy over Arcadia, without, however, any measure of success, since the Arcadians, despite their internal differences, had acquired a consciousness of common descent and religious unity. At the beginning of the historic period the various settlements united to form the large cities - Mantinea, Phygalia, Tegea and Orchomenos. Following the Peloponnesian War, they came under the control of Sparta. After the battle of Leuctra and the collapse of Spartan rule, their tendency to unity is again revealed. They founded the Arcadian League, centred on Megalopolis, and entered into alliance with the Thebans. A little later they made overtures to the rising power of Macedonia, but decided to remain neutral at the battle of Chaeroneia (338 B.C.). Eventually, and with some eagerness, they joined the Achaean League, and thereafter followed the common fortunes of the Peloponnesian states. After the destruction of Corinth in 146 B.C. by Mummius, and despite the foundation a little later of the fifth Arcadian League, Arcadia began to decline. Slowly the region sank into insignificance, and was almost

70. Entrance of the fortified acropolis of ancient Nestani and part of the walls.

entirely deserted after the raids of the Goths under Alaric in A.D. 395. Several centuries later, the region was easily conquered by the Franks, who met with only feeble resistance, such as the vain stand of Boutsaras Doxapatris at the castle of Araklovo. The Franks divided Arcadia into five baronies, making provision for its safety by the construction of many castles. In 1330 it was freed from Frankish occupation by Andronicos Palaeologos. In the last years of Byzantine power many Albanians settled there. In 1458, it was captured by the Turks. During the Turkish occupation some slight increase in prosperity can be traced, interrupted by the advent of the Venetians (1687-1715) who imposed heavy taxation and exacted forced labour. In the subsequent period, an unaccustomed level of wealth was reached. Tripolis became the commercial and political centre of the Morea, although challenged by Dimitsana as the intellectual centre after the foundation of a famous school there in 1764. During the revolution of 1821, Arcadia was the scene of bitter fighting. Greek soldiers under Theodore Kolokotronis won many spectacular victories over the Turks.

The modern capital of Arcadia is **Tripolis**, which was completely rebuilt after its destruction by the army of Ibrahim Pasha in 1827. The first reference to the town occurs in 1467, when it was called Droboliza. It rapidly developed into a large settlement, becoming the capital of the Turkish Pashalic of the Peloponnese. At the outbreak of the War of Independence it was the first target of the Greek forces, and was captured after a six month's siege which ended in September 1821. Throughout

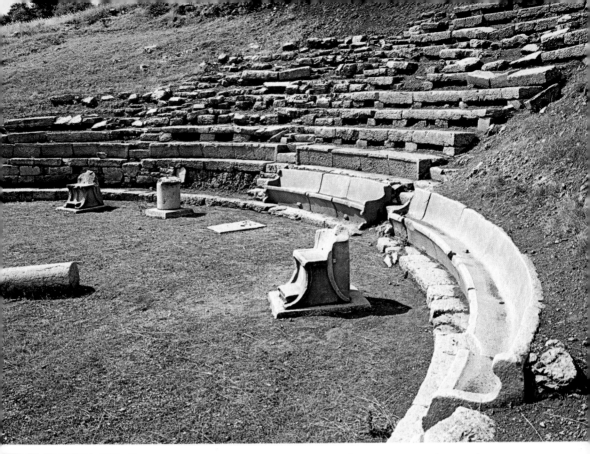

71. Part of the auditorium of the theatre of Orchomenos, some of the surviving tiers of seats and the two stone thrones.

the subsequent struggle it played an important role, suffering many reversals of fortune, which culminated in its total destruction when the troops of Ibrahim burnt it to the ground in 1827. After the liberation it was rebuilt on a new plan, and it is today the centre of a network of communications for the whole Peloponnese. Placed against a breath-takingly beautiful mountain back-drop, it is an excellent base from which to explore the surrounding region rich in archaeological sites and picturesque glimpses of local colour.

Tripolis lies in the district of Mantinea, which takes its name from the ancient city and its surrounding territory. The sities of the Arcadian state lay on a high enclosed plain; from north to south they were Kaphyes, Orchomenos, Nestani, Mantinea, Tegea and Pallantion.

Fourteen kms. north of Tripolis on a side road lies the picturesque village of **Nestani**, built near the ruins of the ancient city which was one of the five demes of the Mantineans. Close by is the monastery of Gorgoepikos, dating to the tenth century, which possesses many treasures. **Mantinea** itself lies some thirteen kms. north of Tripolis. Known to Homer as "pleasant Mantinea" (Iliad, II, 607) by historic times it consisted of five demes or villages which united to form the settlement close to the low hill at present-day Gortzouli, where some remains can still be seen. Sometimes the ally of the Athenians, sometimes of the Spartans, the town suffered from the effects of war on many occasions. Excavations carried out by the French

103

School at Athens brought to light ruins of the defences, whose circumference was some four kms. The walls were 4.20 m. thick with 122 towers and 10 gates astride the ten approach roads. Some public buildings in the vicinity of the market place were uncovered, most of which belong to the Roman period. They include the **Bouleuterion** (senate house), a **theatre**, the **exedra** of the Epigoni and the **Stoa of Eurycles.**

Twenty-five kms. further north is the village of **Levidion**, to the north-east of which lay ancient Elymia with a **temple to Artemis Hymnia**, close to a Byzantine chapel of the Virgin. In the village there is a **museum** in honour of Alexandre Papanastasiou, who proclaimed the first Greek Republic, with a collection of his personal belongings.

From Levidion a right turn leads to the ancient acropolis of the Arcadian **Orchomenos** which was on the summit of the hill north of the village Kalpaki. From its fortified position the kings of Orchomenos "rich in sheep" could control their territory. After the Persian War the decline of the city began, since as the ally of the Spartans, it bore the brunt first of the Athenian attacks and later of the Achaean. The latter captured it in 223 B.C., led by Antigonos Doson. It is still possible to see large sections of the fortifications and remains of the **temple of Artemis**, the foundations of a colonnade, of the **bouleuterion** and **theatre** excavated by the French School in the upper Town. The lower town was not only inhabited, but thriving in the Roman imperial period.

Returning to the village of Levidion one can visit the village of Vlacherna, at a

72. The village of Dimitsana which spreads over the summit and the slopes of a hill.

height of 940 m., where there are two Byzantine monasteries: the *Agia Eleousa* and the *Panagia Vlacherna*.

From Vlacherna a road leads south-west, where on the fir-covered slopes of Mt. Menalon stands **Vytina**, one of the most famous winter resorts in Greece. Beyond, the road divides on the summit of Karkalou.

A left turn leads to **Dimitsana** (67 kms.) which, built amphitheatrically above the river Lousios on the ruins of the ancient city Teuthis, played an important role in the War of Independence. Birthplace of the patriarch Gregory V and of the bishop of Old Patras, Germanos, it boasts a library containing many rare books. The same building also houses a *Folk Museum*. There is also a small archaeological collection. In the neighbourhood of Dimitsana the spectacularly beautiful gorge of the river Lousios, in which legend recounts that the infant Zeus was washed, conceals threee monasteries: Aimialou, Philosophou and St John the Baptist. Here the unrivalled beauty of the canyon exerts an irresistible attraction on all those who love solitude, for nothing distracts the solitary from his reflections.

A few kms. further on is the village of **Stemnitsa**, built on the site of ancient Hypsous. There are many beautiful churches and traditional stone houses in the Byzantine style.

Returning to the cross-roads at Karkalou and continuing on the main road some 70 kms. one comes to **Langadia** whose cobbled lanes and medieval houses make it one of the most picturesque villages of Arcadia. A right turn some 14 kms. beyond

73. *The Monastery of St John the Baptist situated in an idyllic spot between Dimitsana and Hypsous (Stemnitsa).*

Langadia leads to the attractive hamlet of Tropea from which an hour's walk east-wards takes one to the medieval castle of Akova. From Tropea a road leads to the dam which contains the man-made lake of Ladon. Returning to the main road a drive through astoundingly beautiful countryside into the prefecture of Elis takes the visitor to the site of ancient Olympia.

The traveller who follows the road south-west from Tripolis passes *Pallantion*, an ancient Arcadian city. The acropolis can be seen on Ai Yannis hill, with notable re-mains of the Archaic period.

A few kms. beyond Pallantion southwards are the ruins of the acropolis of ancient *Asea*. The remains of the town fortifications have been investigated by a team of Swed-ish archaeologists. Between Asea and Pallantion are the foundations of a Doric temple dedicated to Athena Soteira and Poseidon. 34 kms. from Tripolis lies **Megalopolis,** built in a small plain surrounded by mountains. The remains of the ancient city lie about one km. north of the modern town. Recent excavations conducted by the Vth Ephorate of Prehistoric and Classical Antiquities, in collaboration with the German Archaeological Institute at Athens, have brought to light extensive remains of the Philippion Stoa and the Myropolis Stoa. Megalopolis was founded by the Theban ruler Epaminondas, fol-lowing his victory over the Spartans at Leuctra (371 B.C.). The inhabitants of forty vil-lages, augmented by the populations of other Arcadian towns, were transferred to live in the new foundation. It quickly developed into the most important town in Arcadia, and thus provoked the enmity of the Spartans who destroyed it in 222 B.C. The city was later re-built, but it never regained its former consequence. Its ruins lie on both banks of the river Elisson. The surviving remains of the many temples, shrines, market place and other buildings of the "great city" are not such as to convey its splendour. Excava-tions conducted by the British School of Archaeology uncovered the foundations of the **temple of Zeus Soter** in the south-east corner of the market place; traces of the **Sta-dium** and of several altars; the **Thersillion,** one of the meeting places of the Arcadian League and various Roman structures. The *orchestra, proskenion* and the lowest row of seats survive from the **theatre** which was one of the largest in the ancient world. It could seat twenty thousand spectators, for it served a dual purpose. It was used both for the meetings of the representatives of the Arcadian cities and for theatrical performances in the presence of many Arcadians who gathered in the city for one purpose or another. Hence in had a movable wooden skene. In the past few years a project to enhance the monument, which includes excavations and restoration work, has been underway.

The Archaeological Collection of Megalopolis, which is found at the center of the town, contains sculptures, architectural members, inscriptions and ceramics from Megalopolis and the surrounding region.

16 kms. beyond Megalopolis, the road leads to the site of **Lycosoura** one of the oldest Arcadian cities, but of interest only to archaeologists. According to tradition, it was built by Lycaon, son of Pelasgos. Excavation revealed the famous **Sanctuary of Despoina** to the east of the acropolis, remains of **altars of Despoina and Demeter,** together with a large stoa and an extensive complex of buildings ot the west of the main temple. On the western edge of the sanctuary was the temple of Despoina, a prostyle building with six Doric columns in the pronaos and two circular bases for statues. The local museum contains a display of sculptured fragments from the sanc-tuary and copies of originals (colossal heads, goddesses' garments) now exhibited in the National Archaeological Museum of Athens.

74. *The theatre of Megalopolis showing the auditorium, the orchestra and the prostoon of the Thersilion.*
75. *The picturesque region of Stemnitsa, the site of ancient Hypsous.*

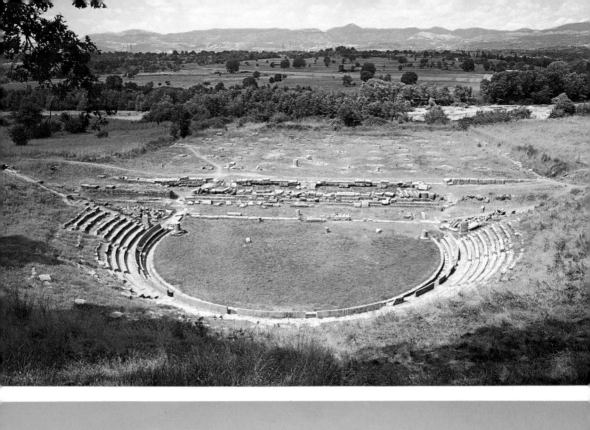

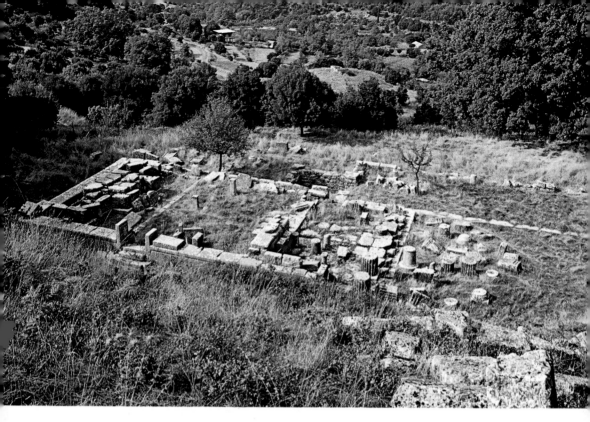

76. The foundations of the Temple of Despoina at Lycosoura.

A road to the north leads out of the plain of Megalopolis to **Karytaina** (16 kms.). Its Frankish castle perched on a massive rocky outcrop (700 m. high) is hemmed in on all sides by the Arcadian mountains. It is thought that Karytaina occupies the site of ancient Brenthe, deserted when Epaminondas founded Megalopolis. Karytaina was important during the Frankish Occupation, when the castle was built (A.D. 1245) by Jugues de la Bruyere. Nicknamed the "Toledo of Greece" it was considered as one of the most important castles in the Peloponnese because of its strategic position. In 1320 the castle was purchased from its Frankish castellan by Andronicos Palaeologos, after which Byzantine churches and monasteries were erected. In the mid-fifteenth century it fell into Turkish hands, and was occupied in 1685 for a short while by the Venetians. It passed again to the Turks in 1715, who held it until the revolution of 1821 when, with the rest of Arcadia, it became one of the bases from which the liberation of the Peloponnese was organised. Theodore Kolokotronis established himself here. He repaired the fortifications of the castle and built a house and church within their protection. Not even the forces of Ibrahim could harm him. After 1830, when Dimitsana replaced Karytaina as the capital of the region (the district of Gortynia), the town fell into decline. The ascent to the castle is by means of a short, but very steep, path. The outer walls stand almost complete, but within the enclosure the ruins of buildings lie in confusion.

Of interest in the town is the Byzantine bell-tower attached to the church of Zoodochos Pigi of the foorteenth century. Below the town flows the river Alpheios, crossed by the many-arched Frankish bridge which probably replaced a Byzantine structure. Repairs to the bridge carried out in 1441 by Manuel Melikis are recorded in an inscription. The road from Karytaina leads to the province of Elis, and thus permits the traveller to visti Bassae with its temple to the Epicurean Apollo.

The visitor who wishes to proceed southwards from Tripolis has a choice of itiner-

aries. The road south takes him to Agios Petros, a mountain village with lush greenery. Beyond, to the east, lies the Byzantine monastery of Malevi, one of the three famous monasteries of the district Kynourias. The alternative route takes him south-east and passing through Kato Doliana leads to **Astros** (31 kms.). Between them, on the roadside, is the *monastery of Loukou*, whose *Katholikon* dates to the twelfth century. The monastery occupies the site of the ancient temple of Polemocrates, grandson of Asclepios, who ruled as a god. Part of the rod, with a coiled snake, from a statue of Asclepios and an important bas-relief of the fourth century B.C. of Asclepios and his family, the Asclepiades, were found within the monastery. In the Roman period the name of Herodes Atticus was associated with the shrine, for it is thought that he owned a country estate nearby Excavations over the last twenty years have revealed a large building complex comprising a courtyard, a man-made river, porticoes with mosaic floors, Herodes Atticus's villa, the nymphaion, the exedra as well as a host of sculptures. Outstanding among the last are the groups in the Pergamon style, such as that of Menelaos and Patrocles, known as Pasquino, and of Achilles with the Amazon Penthesilea. The statues are housed in the Astros Museum. The walls of the katholikon and the various monastic buildings incorporate architectural and sculptured fragments; they include a Roman copy of a statue of a seated Athena, now headless.

Astros, over which the Spartans and the Argives quarrelled in antiquity for possession of its fertile lands, is divided into two settlements, one inland, the other on the sea. At the latter, on a bluff by the sea, are remains of a large building of the Classical period and on its summit a medieval castle in a fairly good state of preservation. The Museum of Astros is housed in a building of 19th-century popular architecture, which was built by Karytsiotis for a school and it contains interesting finds: sculptures, inscriptions, architectural members, ceramics and miniatures from the villa of Herodes Atticus at Loucou, from Hellenikon and from other sites in Kynouria. From inland Astros the road descends along the coast through a strange and peculiarly beautiful landscape. On the left the limpid sea of Kynoura stretches away, with its smooth beaches and deep bays, while on the right the lofty peaks of Mt Parnon rise up. Thus through the midst of a constand alternation of blues and greens the traveller arrives at *Agios Andreas* on the coast where, on the top of the hill Nisi, remains of polygonal walling are to be seen. The road continues to **Tyros**, the name of an ancient town: in the locality of Kastro are remains of an ancient acropolis. The road ends at **Leonidion**, some ninety-two kms. from Tripolis. Close by stand the ruins of the ancient acropolis and sections of pelasgian walls. From here you can visit the monastery of Ayios Nikolaos Sintzas northwest of Leonidion, built into a cliff face, and Moni Elonis southwest of Leonidion, built on top of a red rock and seeming to float in midair.

However, the most important town in ancient Arcadia before the founding of Megalopolis was **Tegea**, which lies on the road from Tripolis to Sparta. In antiquity the south-eastern part of Arcadia was known as Tegeatis; in historic times the region was composed of nine *demes*. In mythology Tegea is referred to as one of the areas which sent men to participate in the Argonaut Expedition and soldiers to the Trojan War. Later on, it sent a contingent to the Persian War and during the Peloponnesian War it was an ally of Sparta. After the battle of Leuctra (371 B.C.) the Tegeans changed sides, deserting Sparta and swearing allegiance to the Thebans. Eventually they became members of the Achaean League. When the Romans conquered Greece, Tegea shared the fate of the other Greek cities. In 31 B.C. Augustus sought to punish the Tegeans for the help they had offered to his rival Antony: Pausanias tells us that he removed both the ivory statue of the goddess Athena and the teeth of the Calydonian Boar from the Temple of Athena Alea, taking them to decorate the market place he had recently laid out in Rome. The region was plundered by the Goths in A.D. 395. From the tenth century it ceased to be referred to as Tegea and became known as Amyclion, which

by the twelfth century had been abbreviated to Nykli. At this time it was a thriving town, and continued to flourish during the Frankish occupation, when it was the centre of the baronies of the Principality of the Morea. In 1296 it passed under the suzerainty of the governor of Mystras, Andronicos Palaeologos, who razed it to the ground because its location, in the middle of a plain, required a large garrison to protect it Many of the inhabitants of Nykli either on the capture of the town by the Franks in 1209 or after its destruction in 1296 - it is not certain which - took refuge in the Mani. There they established the powerful families known as the Nyklians or "Megalogennites" who domineered over the locals. In Alea are the ruins of the **temple of Athena**, once one of the most beautiful in the Peloponnese. It was built in the south-west angle of the fortified enclosure of the ancient town. Exacavation has made it clear that even in Mycenaean times there was a sanctuary on this site, and that the cult of a goddess had been established. The remains which can be seen today belong to a later, Doric peripteral temple (4 X 14), the work of the Parian architect, Scopas. According to some it was erected in 370 B.C., according to others rather later, in the second half of the fourth century B.C. It was built of local marble from Doliana, and had a *prodomos* (anteroom), *sekos* (cella) and *opisthodomos* (rear porch). The interior of the *sekos* was decorated with Corinthian pilasters; at its centre stood the ivory statue of Athena Alea and marble statues of Asclepios and his daughter Hygeia. The external decoration depicted themes from local legends.

Today the village has a **museum** where sculptured fragments chiefly in the style of Scopas are on display.

Close to the agora of ancient Tegea, where there were temples and dedicatory statues, was the **theatre;** the south-east corner of its *proskenion* has been preserved because the church of Palaia Episcopi stands over the auditorium. The church was built in the second half of the eleventh or in the early twelfth century. In Episcopi remains of medieval walls and the mosaic floors of the Early Christian basilica may also be seen.

THE TRIPOLIS MUSEUM

The Tripolis Archaeological museum was founded in 1986 and is housed in the lovely, two-storey Neoclassical building of the former Panarkadian Hospital, The Evangelistria, (1895-1911), designed by the architect Ziller and donated by Anastasia Demesticha. The exhibit, covering all periods from Neolithic to Early Christian times, comprises finds from the region of Arkadia.

Displayed on the first floor, where the main entrance to the building is located, are interesting inscribed marble stelae, including the stele bearing an excerpt from the Diocletian Edict defining the maximum prices for agricultural produce and craft products from Thelpousa, Gortynia (fourth century A.D.); that from Arkadian Orchomenos regulating the boundaries of Arkadian cities (fourth century B.C.); stelae with various decrees, funerary stelae and herms, as well as reliefs from Loukou. Of the sculptures, the most noteworthy are the two headless, marble statues of a seated goddess (Athena). The first, from Asea and in the type of Endoios' Athena, is an outstanding work of the Archaic period (sixth century B.C.), and the second, which is reminiscent of an earlier mother-goddess, is a copy of an unknown work of Late Classical times (second century A.D.).

The prehistoric gallery, on the same floor, contains one of the most representative collections of Late Mycenaean artefacts in Greece. There is a host of cases of different types: amphorae, hydries, stirrup jars, small kraters, jugs, pyxides, alabastra, as

77. Female head found east of the Temple of Athena Alea. Some say that it represents Atalante, others Hygeia, the goddess of health. (Athens, National Archaeological Museum).

well as numerous minor objects of bronze: fibulae, pins, links, weapons et al., from the wealthy cemetery at Palaiokastro, Gortynia. Also exchibited are finds from the prehistoric settlement on the S(f)akovouni-Karvouni hill in the community of Kamenitsa, where excavations conducted between 1983 and 1986 revealed an important fortified site, occupied in Late Neolithic times and during the Bronze Age (circa 3000-1200 B.C.).

The exhibition of vases on the first floor is completed by pottery of the Geometric, Archaic, Classical and Hellenistic periods from Mantineia, Palaiokastro, Tegea and Helleniko, Kynouria, as well as the unique wooden vases from Megalopolis.

Displayed on the ground floor are funerary and hermaic stelae, reliefs, statues, pedimental acroteria from the temple of Despoina at Lykosoura, as well as bronze ex-votos of Classical and Hellenistic times from various sanctuaries, clay and bronze vases and figurines, sealstones, coins, weapons and minor objects of bone.

Architectural members, reliefs and inscriptions have been set up in the museum garden.

78. *The snow covered peaks of the Taygetos mountains which tower above Laconia, most impressively at Sparta.*

LACONIA

In the south-east of the Peloponnese, between Arcadia, Messenia, the Gulf of Laconia and the Myrtoon Sea, lies the region known as Laconia. Its boundaries have remained almost unaltered since antiquity. Inhabited since the Palaeolithic Age (6000-3000 B.C.), Laconia had a turbulent history whose repercussions had far-reaching effects on the entire ancient Greek world.

According to mythology, its first inhabitants were the Leleges, who were later absorbed into the Ionian and Achaean tribes. Plentiful remains excavated from villages and cemeteries reveal the density of settlement in the Mycenaean period: around Sparta, at Amyclae, Molaoi, Neapolis Boion, Monemvasia, Geraki, the villages on Mt. Taygetos and Mt. Parnon and many sites in the Mani. The Dorians invaded the area c. 110 B.C. Later, their strongest settlement, Sparta, annexed the whole of Laconia. Established in the district where numerically the pre-Doric tribes were dominant, the Dorians in Sparta faced either the danger of extermination or, at best, fusion, with the indigenous population. This threat resulted in the creation of institutions designed to enable the Spartans to assert their authority over the conquered natives, the Helots, who remained a permanent problem.

In the Early Christian period Laconia, suffered from the barbarian invasions, chiefly from the Goths who under Alaric ravaged the area in A.D. 395. In the Byzantine period, Laconia formed one of the eparchies of the theme of the Peloponnese, ruled from Corinth. Slav tribes settled on the slopes of Mt. Parnon and Mt. Taygetos; the best known are the Mellingoi and the Ezeritai. They were finally hellenised between the tenth and the thirteenth centuries.

The Turks marched against Laconia in 1458, but without subjugating it entirely since many pockets of resistance remained, especially Mani, which stayed independent until 1540. Although Mohammet exploited the quarrels of the Despots of Mystra in order to capture several fortresses in the region, such as Zarnata and others, the conquest of Laconia was not completed until the middle of the 16th century. Even then Mani retained a certain degree of independence and many privileges. In 1685, the area was occupied by the Venetians, under whose control it remained until 1715 when it was re-occupied by the Turks. Successive risings staged there resulted in reprisals by Turco-Albanian forces. During the War of Independence Laconians took an active part.

79. The plain and the town of Sparta as it appears from the heights of the Menelaion.

The modern centre and capital of Laconia is **Sparta**, laid out in 1834 in the reign of King Otto I on the site of the ancient town, of which only scant remains are preserved. This is only partly due to the severe earthquakes and the raids during the Roman era; more is owed to the fact that Sparta never developed fully into a city state, but throughout its history much resembled an army camp, and thus never acquired massive public buildings. One must assume that its rulers never showed any interest in a "building policy". The region was furthermore constantly beset by earthquakes which, along with the depredations that occured in the Roman and later periods, resulted in almost nothing left standing in its place. Archaeological finds are insufficient to suggest the existence of an important settlement in the area in either the prehistoric or the Mycenaean period. The Dorian invaders were almost certainly the founders of the town of Sparta, which consisted originally of four distinct settlements around an acropolis in the Eurotas valley. These settlements were Pitane, Limnai, Mesoa and Kynosoura; Amyclae was a later addition. Though politically united and communally governed, each village long retained its separate identity. From the very beginning, the town of Sparta was governed by a Council of Elders (*Gerousia*), composed of one member from each of the thirty leading families. Two representatives, descendants of the royal line of the Agiad and Eurypontid kings, held supreme political and military authority and were called *archagetai* or kings. The office was abolished at the end of the third century B.C. The office of Ephor was

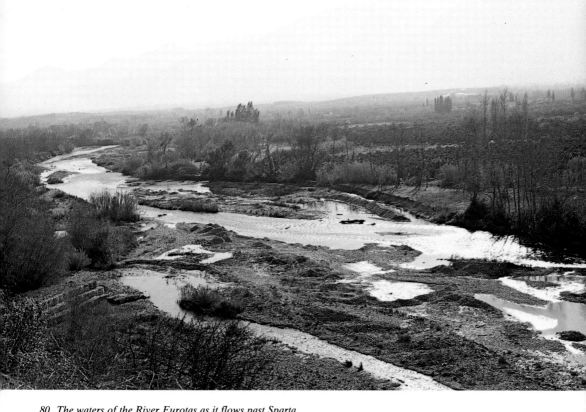

80. The waters of the River Eurotas as it flows past Sparta.

apparently instituted after the middle of the eighth century B.C. The Ephors, five in number, were elected every year, one from each of the five communities which made up the town of Sparta. They became not only the moderators of Spartan life, but also the arbiters of her external policies, acting as a counter-balance to the power of the kings. The people were represented by the *Apella*, in which every citizen over the age of 30 participated, shouting his approval of war or peace. The institutions of Spartan government were strictly aristocratic, orientating the citizen towards the ideals of the warrior life. By the mid-fifth century B.C. the entire mode of Spartan life and government was attributed to the legislator, Lycurgus, who may have lived in the middle of the eighth century B.C. His work, preserved in the Great *Rhetra*, marks the change-over from feuding separate communities to a more settled society.

By the end of sixth century B.C. Sparta was recognised as an important power throughout the Greek world. Croesus, king of Lydia, appealed for Spartan aid in his struggle against Cyrus, king of the Persians, and the Ionian cities of Asia Minor. When, at the beginning of the fifth century B.C., the Greeks were facing the Persian danger, the military strength and the moral authority of Sparta contributed decisively to repel the enemy. Sparta abandoned her policy of isolation, joining the other Greek states to overcome the external threat. But after the war was over, jealousy of the increased power of Athens entangled her in the catastrophic Peloponnesian War, from which she emerged the triumphant leader in Greek affairs. But the victory itself

had drained her of strength. Her resources were exhausted, and her power diminished significantly after the Boeotian and Corinthian Wars. Sparta was defeated at the battle of Leuctra (371 B.C.) by the rising power, Thebes. In the period of the Macedonian ascendancy, despite her ambivalent attitude to Macedonia, and her efforts to revitalize her strength, nothing was really accomplished.

The two attempts made in the third century B.C. by the kings Agis IV and Cleomenes III to reform the political system failed, because they ran counter to the interests of the ephors and the wealthy. The establishment of the Tyrants brought no amelioration of the situation, and eventually the city was brought into to the Achaean League by Philopoemen (192 B.C.). In an attempt to break away from the Confederacy, Sparta invited Roman cooperation and intervention, thus giving the Roman republic the pretext it needed to meddle in Greek affairs, and eventually to impose its rule (146 B.C.).

In the Roman period Sparta existed in peace, still governed by the laws of Lycurgus, but with some additional privileges and freedoms conferred by Rome. However, some seaside towns and some of the subject territories formed the League of the Free Laconians and became independent of Sparta. When Pausanias passed through the town in the second century A.D. he found it relatively prosperous, and

81. The ruins of the Roman amphitheatre built within the sanctuary of Artemis Orthia.

this prosperity continued until the barbarian invasions started in the mid-third century A.D. Habitation continued on the site, known as Lacedaemonia, until the mid-Byzantine period. In the earliest years of the Frankish occupation, William II Villehardouin adopted Mystras as his capital, although after his defeat at the battle of Pelagonia he was obliged to cede it to the Greeks (1261). At that time the inhabitants of ancient Sparta migrated to Mystras, which became the Palaeologue capital. Slowly the site of ancient Sparta was abandoned, and was only re-settled early in the reign of King Otto I when modern Sparta was built on top of the ancient town.

Excavations conducted by the British School of Archaeology and continued by the Greek Archaeological society have brought to light some remains in the area of the **acropolis**, but study has been concentrated mainly on the area of the **Sanctuary of Atremis Orthia** on the right bank of the river Eurotas.

The best preserved section of the defence wall of the town built after 320 B.C. runs close to the bridge over the Eurotas and over the hill of Kastraki. Elsewhere its course can be traced only by its foundations. Another wall enclosed the acropolis, built much later, perhaps even after the barbarian raids of the third and fourth centuries A.D. Only scanty remains of the many temples which Pausanias saw on the acropolis have been brought to light by excavation. The best preserved is the **sanct-**

82. Ruins of the Menelaion on the left bank of the River Eurotas.

uary of **Athena Chalkioikos**, which stood on the north-west side of the hill above the auditorium of the theatre. The remains of a theatre which have been discovered date to the Roman period: traces of an older stone structure are insufficient to permit reconstruction of its original dimensions. The later theatre, whose orchestra had a diameter of 24.50 m. seems to have been in use as late as the fourth century A.D. On the east of the shrine are the ruins of the large church of Christ Soter, which was built in the lifetime of St Nikon (10th century A.D.), and the monastery of this famous and holy missionary, who preached Christianity in Laconia and spent his last years in Sparta.

Leaving the acropolis and proceeding eastwards to the main road from Tripolis to Sparta one comes to the **temple of Artemis Orthia**. The foundations of the archaic temple of the sixth century B.C. have been preserved, measuring 17 X 6.60 m. Successive repairs and alterations were carried out, even as late as the third century B.C. In front of the temple traces of two altars can be seen: one dates from the ninth century B.C. and the other to the 3rd c. A.D. The remains of the Roman amphitheatre, erected at the beginning of the third century A.D. when the peculiar sacred ceremonies in honour of the goddess were still performed, lie to the east. Only insignificant traces remain of other monuments which stood within the ancient city.

It is, however, worth visiting the so-called **Tomb of Leonidas**, north of the modern town. This is a temple-like structure, consisting of two divisions built of well-worked rectangular blocks. According to tradition, the bones of the hero Leonidas were brought back for durial at this spot. Pausanias remarks that games were founded in his honour.

South-east of Sparta, beyond the Eurotas river, stand the remains of the **Menelaion**, the shrine of Menelaus and Helen, which belonged to the prehistoric settlement of Therapne. The temple, on the hill of Profitis Ilias, with its large pyramidal shape is thought to date to the fifth century B.C. Excavations conducted by the British in 1975 brought to light votive objects which demonstrate that the peak of the hill had been a cult place since Mycenean times. A bronze *aryballos* of the Archaic period is inscribed "to Helen of Menelaus" and a bronze tool "to Helen".

Some five kms. south of Sparta, on the small eminence of Agia Kyriaki, was the **Temple of Apollo of Amyclae**. Amyclae was an older settlement than Sparta, inhabited from the earliest years of the Bronze Age, and the capital of the Achaean rulers. After the Dorians had established themselves in Sparta, Amyclae preserved its independence, and only much later became one of the settlements which made up the town of Sparta. On the hill, which was also the acropolis of Amyclae, was the sacred precinct of Apollo. On the south-east side are traces of the enclosure wall. Within the temple stood the famous colossal statue of Apollo, known to us from Spartan coins on which it was engraved.

A short distance from Amyclae, at **Vapheio**, are the remains of a tholos tomb. Its method of construction and the finds date it to the second half of the Mycenaean era. Amongst the gold and silver grave goods were the two superb gold cups which depict bulls and cows grazing and being captured. They are to be seen in the National Archaeological Museum of Athens.

83-84. The two hammered gold cups found at Vapheio. They bear bulls worked in relief, presented in two constrasting scenes. The first shows the trapping with nets of three half-wild bulls, the second a tranquil scene where two wild bulls graze.

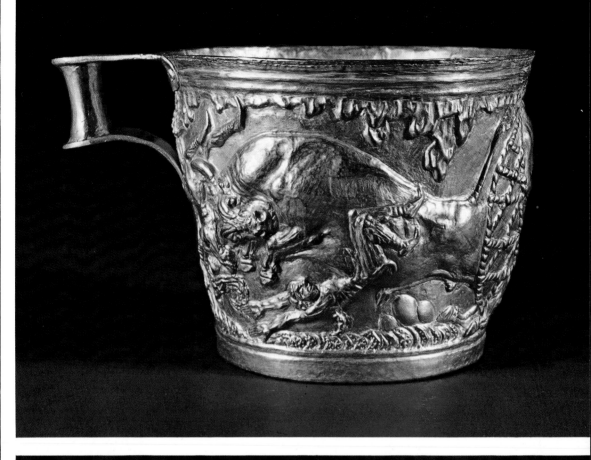

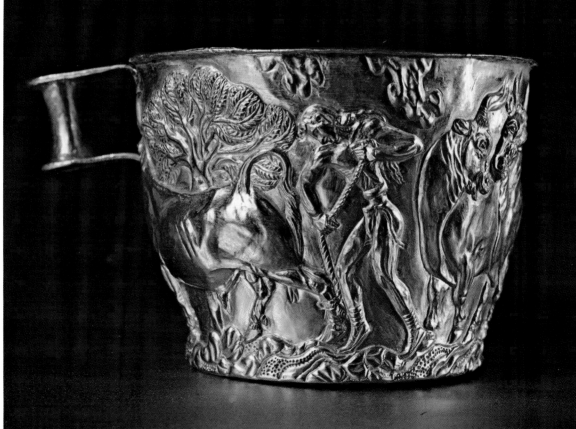

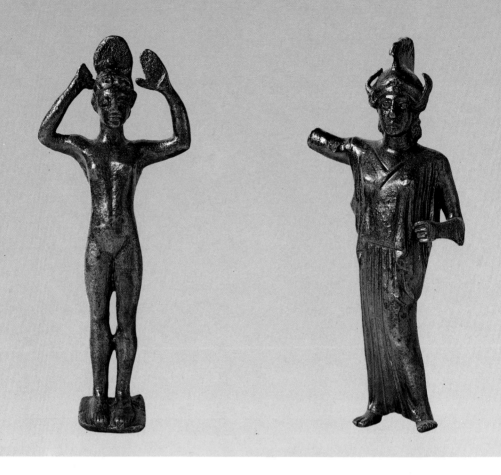

THE MUSEUM OF SPARTA

In the centre of modern Sparta is the museum, a neo-classical building designed by
Hansen in 1875-76 to house the finds from the region. The central block has since
been enlarged, and now contains five display halls and an entrance hall. There are
displays of pottery from the Mycenaean, Geometric and Archaic periods; assorted
votive offerings made of pottery, lead and bronze from the shrines of Artemis Or-
thia, Athena Chalkioikos, the Menelaion and Apollo of the Amyclae; striking terra-
cotta dedicatory masks; noteworthy sculptures of the Archaic and Classical periods
and, of special interest, the plaques decorated with the votive scythe, laid as offer-
ings at the shrine of Artemis Orthia by victors of various contests. The *stelai* and
bas-reliefs with representations of heroic figures and chthonic deities are the most
characteristic examples of Spartan art, the best example of which is that depicting a
seated couple. A series of reliefs depicts the Dioscouroi, the sons of Leda by Zeus
and Tyndareus, the protective gods of the household, travellers and sailors. A strik-
ingly expressive work is the upper part of the torso of a hoplite; its arms are missing.
The so-called statue of Leonidas, of Parian marble, was found near the Sanctuary of
Athena Chalkioikos. It is dated to *c.* 490 B.C.

85. *Bronze handle of a mirror in the shape of a naked girl. The raised arms served to hold the mirror disc in place. 5th century* B.C.

86. *Bronze statuette of Athena from the Temple of Athena Chalkoikos. c. 450* B.C.

87. *Bronze figurine of a seated figure, conventionally depicted, from the Temple of Artemis Orthia. End of the 8th century* B.C.

88. Large earthenware amphora with relief scenes; in the first band is a hunting scene, in the second a procession of men and chariots. It is an outstanding example of the kind of amphora placed above graves as monuments in the Archaic and Classical periods. Last quarter of the 7th century B.C.

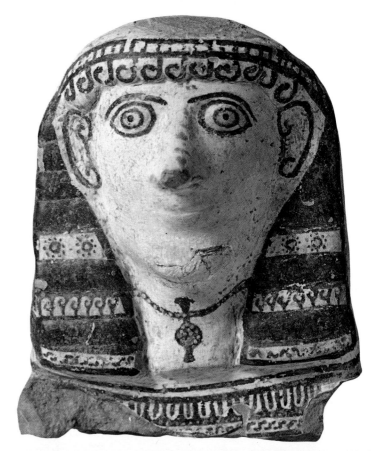

89. *Clay head of a woman from the acropolis of Sparta. The details of her expressive face are picked out in colour. 7th century* B.C.

90. *Marble bust of a Spartan hoplite found on the acropolis of Sparta, said to be Leonidas the defender of Thermopylae.*

91. *Laconian relief representing a couple seated on a richly ornamented throne. Behind the throne is a snake, on the lower right a man and a woman approach, bearing gifts. c. 540* B.C.

123

92. *Mosaic floor from a Roman villa depicting the Abduction of Europa. Early 4th century A.D. In the house of the mosaics at Sparta.*

93. *Mosaic from a Roman villa with a representation of Sappho. Late 3rd or early 4th century A.D.*

94. *The head of Medusa from a Roman mosaic floor. 5th century A.D.*

95. *Mosaic depicting the Sun. Early 4th century A.D.*

96. *Alcibiades, depicted on a mosaic floor.*

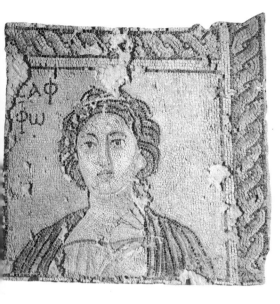

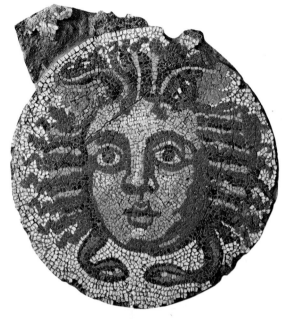

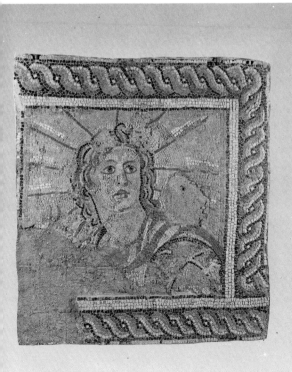

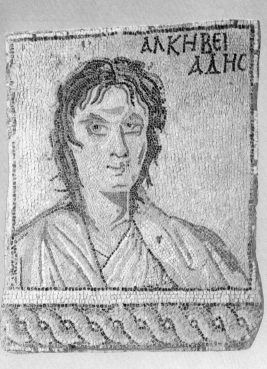

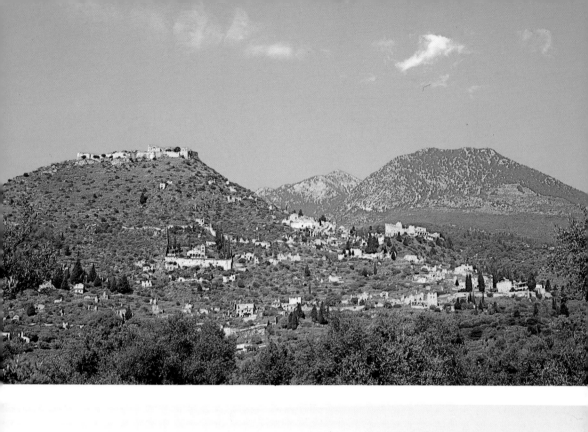

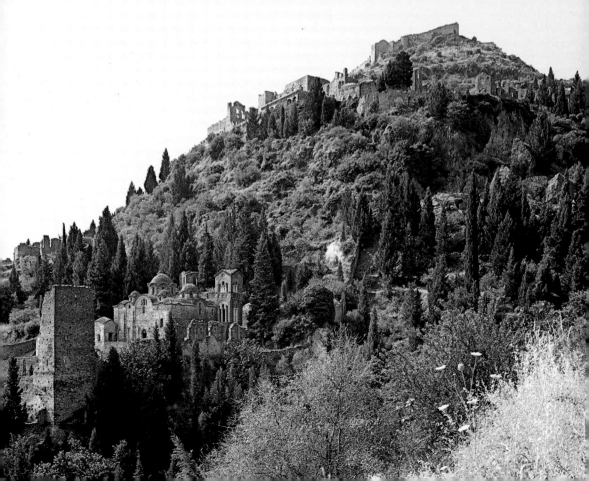

MYSTRAS

On the lower slopes of Mt. Taygetos, a short distance from Sparta, stands the silent, ruined city of Mystras. So much has remained unharmed by time that wandering along the grass-covered streets, between churches and noblemen's houses to reach the citadel crowning the summit, the visitor has the feeling that he re-lives part of the story of Byzantine hellenism. The original name of the area was *Myzithras*, (cheese-maker) the name, perhaps also the profession, of some now forgotten landowner of the site. The steep slopes and easily defensible position of the hill on which the city stands caught the eye of the Frankish ruler William II Villehardouin. In 1249 he erected the citadel. It did not, however, for long remain in Frankish hands. On the defeat of William at the battle of Pelagonia (1259), he exchanged Mystras, together with his castles of Monemvasia and Maina for his Freedon (1262) and thus Mystras passed under Byzantine rule.

The palaces occupied the extensive plateau on the north side of the hill. A defensive enceinte encircled the city, starting from the west side of the citadel. It continued along the steep northern side and along the eastern above the site of the later Pantanassa. The circuit was broken by two fortified entrances; the eastern, known as the *Monovasia gate*, the western as the *Anaplon gate*. They were linked by a road which divided the *Upper City* into two parts; in the northern quarter lay the palaces and houses of the nobles, and in the southern the dwellings of the townsmen, which staggered up the slopes of the hill as far as the central square, where the later **monastery of Zoodotos** stood. At the close of the thirteenth and the beginning of the fourteenth century several churches and monasteries were built outside the wall – the **Brontochion monastery** to the north with churches dedicated **to SS. Theodore** and the **Odigitria** (the *Afentiko*). Further east stood the **Metropolis** of St. Demetrios, and to the south-east the monastery of the **Peribleptos** and the church of the **Evangelistria**. Gradually houses also sprawled beyond the defences, and a second wall was erected to enclose them. The new suburb was known as the *Lower Town*, to distinguish it from the older habitation, the Upper Town. In this area, in addition to the monasteries, stand various noblemen's houses (notably those of the Lascaris and the Frango-

97. *The town of Mystras seen from a distance.*
98. *View of Mystras; the castle crowns the summit, below are part of the fortifications and the church of the Odigitria.*
99. *The palaces of Mystras.* ▶

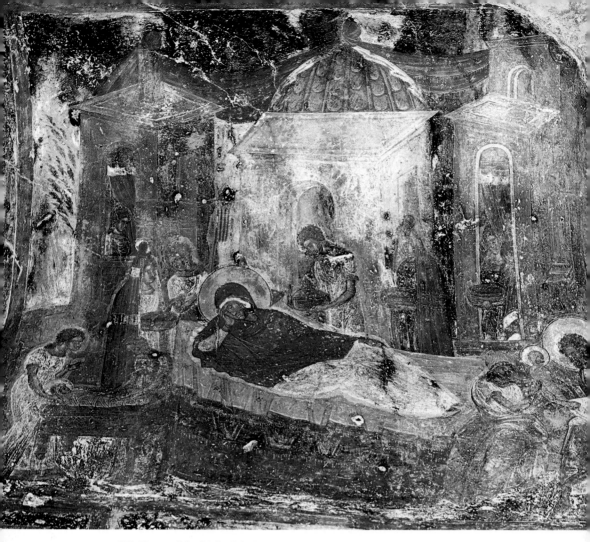

100. Fresco of the Birth of the Virgin in the Peribleptos.

poulos families). But even this extension was not sufficient to allow for Mystras' growth, and for a third time houses extended outside the fortifications, the *Outer Town*. Mystras' importance continued to grow unchecked throughout the fourteenth century. After 1308, the office of *strategos* or governor, previously an annual appointment, became a permanent tenure, the first holder being Kantakuzenos (1308-1316) followed by Andronicos Palaeologos Asan (1316-1321). External attack and internal strife caused difficulties, and the Emperor John VI Kantakuzenos was obliged to send his son Manuel to take charge of the situation. This action resulted in the creation of the Despotate of the Morea, which was governed by the Kantakuzenoi from 1348 until 1384, when the last king was expelled by the Palaeologue family. They ruled the Despotate from 1384 until 1460, and succeeded in extending its power over almost the entire Peloponnese. The ceaseless hostilities with Franks and Venetians, the political dissensions between the Palaeologan Despots and the mounting Turkish threat led to a weakening of authority and growing anarchy. The struggles between the three brothers, Constantine, Thomas, and Demetrios, exhausted the

101. An angel holding a scroll; detail from the wall painting of the Second Coming in the Metropolis.

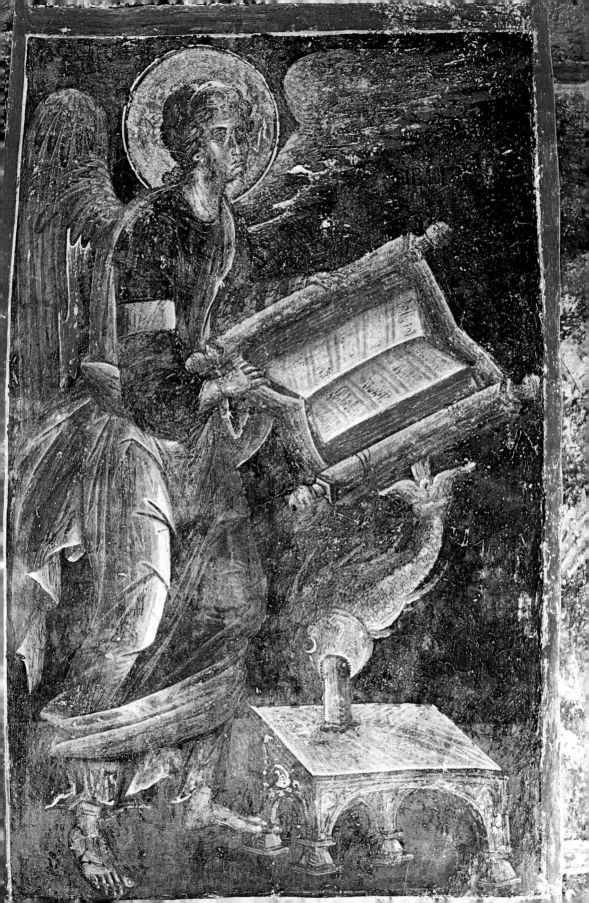

Morea, and invited Turkish intervention, with the result that Demetrios surrendered Mystras on May 30th 1460, seeking asylum for himself at the Sultan's court. During the Turkish occupation Mystras did not retain the importance it had enjoyed in the preceding centuries. Repeated attempts by the Venetians to re-occupy it failed until 1687 when the town surrendered to Morosini. At this time silk production appears to have been flourishing, and consequently Mystras enjoyed extensive commercial contacts. In 1715, however, the Turks recaptured it. It was liberated for a short period by the forces of the Russian general Orloff in 1770, but was sacked by the Albanians. Early on in the War of Independence, Mystras was freed, to be burnt down later by Ibrahim. Thereafter it was never completely re-inhabited. When the new town of Sparta was founded in the plain by King Otto I, most of Mystras'; inhabitants moved there, although some remained in the village of Mystras built below the old town. Today only ruins of the extensive city remain.

The ruined Kastro dominates the summit of the hill. The ascent is steep and laborious, but is rewarded by the splendid view from the top. Large parts of the walls, palaces, streets and vaulted alleys are preserved. Everywhere are the ruined houses of the Byzantine period and the Turkish occupation before 1821. Where, however, one can best see the spirit of Mystras and admire its art is in the beautifully painted churches like Agios Demetrios, the Odigitria, SS Theodore, the Pantanassa, Peribleptos and the Evangelistria.

Forty-five kms. to the east of Sparta, historic **Geraki** stands on a small outcrop on the south-west slopes of Mt. Parnon. The modern village occupies the site of ancient *Geranthrai*, finds from which show it to have been inhabited from at least the Bronze Age and perhaps even as early as the Neolithic period. Traces of Late Helladic walls exist, while remains dating to the historic period in the lower town are more plentiful. Geraki continued to be inhabited in the Early Christian and medieval periods; from the latter survive a number of churches with interesting wall paintings, and fragments of older material incorporated in the walls. The best preserved churches are the *Evangelistria*, a cruciform church of the eleventh and twelfth centuries; *St John Chrysostom*, a single-aisled basilica of the twelfth century; *St Nicholas*, built as a domed basilica in the fourteenth century; *SS. Theodore* and *Profitis Ilias*.

A considerable distance from the modern village, on the summit of the hill which rises to the east, are visible the ruins of the Frankish **castle** built in the thirteenth century by Guy de Nivelet, the holder of one of the baronies of the Principality of the Morea. Only scant traces remain of the castle and the palace from which de Nivelet could keep watch over the plain of *Helos* and defend himself from the raids of the *Tsakones*. Most of the Byzantine churches and noblemen's houses built within the fortress both before and after the Frankish occupation are in ruins (6th to 14th century). The few churches still standing are in poor condition. One exception, however, is the church of St George on the summit, where assorted emblems, such as the arms of de Nivelet on the iconostasis, testify to Frankish influence. Its ruined walls, churches and houses are the only indications of a glorious past.

102-103. Two views of the castle of Geraki with the ruined houses and churches.

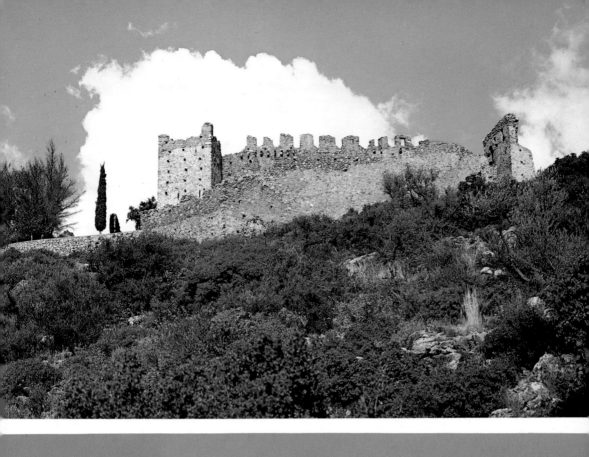

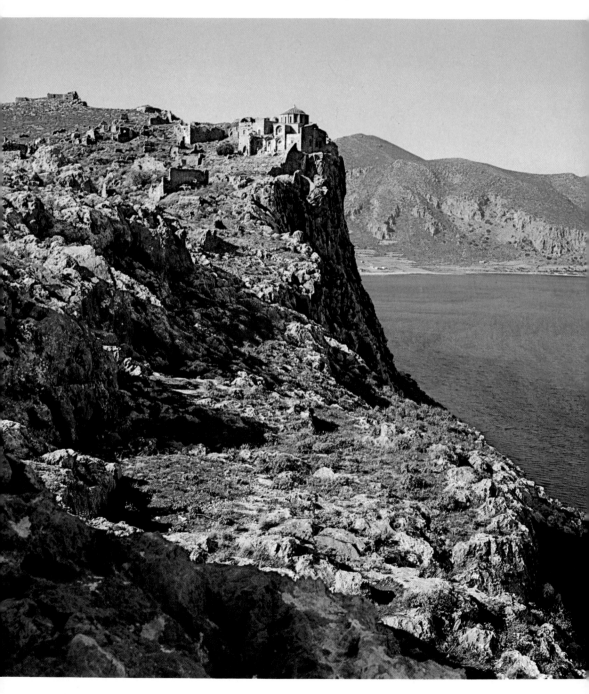

MONEMVASIA

Monemvasia has claim to a unique place amongst ruined medieval cities. Built on a distinctively shaped rock which rises from the sea, it is connected to dry land by a bridge, the sole approach ("moni emvasis"). From the mainland the rock appears to be deserted. However, as one makes one's way along the causeway, one sees first the entrance to the castle, and then the walls which snake upwards to the peak of the rock. Enough remains of these fortifications, even though in places they are ruined, for the impression to be breathtaking. On the eastern edge of the rock is the small settlement of the Lower City, the houses huddled together and rising high above streets so narrow that only two persons abreast can pass along them. The town was first laid out in the sixth century A.D., when many of the inhabitants of Laconia sought refuge here from the raids of the Arabs and the Slavs. Despite many sieges, it served its purpose well, so well that in the mid-fifteenth century the historian Phrantzes could justly observe that "it was an unshakeable bastion, unconquerable and unassailable by any war machine". Local pride, no doubt, permitted him to slide over the brief period of Frankish occupation (1249-1262) and the three year siege which preceded it. Under the Byzantines Monemvasia flourished, developing into a trading centre of considerable importance. In 1446 the "famous town" was captured and occupied by the Venetians until 1540. After a period of Turkish occupation, the Venetian Morosini recaptured the town in the mid-seventeenth century. It passed back to the Turks from 1715 until 1821. They surrendered it to the Greeks only after a terrible siege. Today, both the Upper and the Lower Cities bear the mark of Venetian overlordship – the fortifications, the shields bearing the Venetian emblem of the Lion of St Mark and the foreign-looking chimney pots. Strolling along the paved lanes one is surrounded by ruined houses and Byzantine churches, few of which remain undamaged today. An exception is the church of *Christ Elkomenos* (= dragged to the Cross), which serves now as the cathedral church. It was originally built by Andronicos II Palaeologos in the thirteenth century in the style of a domed basilica. In the years of the Venetian occupation alterations were made. Inside, immediately beyond the narthex both right and left, stand two imperial thrones. The original wooden carved screen has been replaced in marble. Only four of the Byzantine icons have survived, among them "Christ Led Away to the Cross".

104. The church of Agia Sophia, perched of the cliff edge high above the castle of Monemvasia.

105. The curiously shaped rock of Monemvasia seen from afar. The ruins of the castle can be seen on its summit.

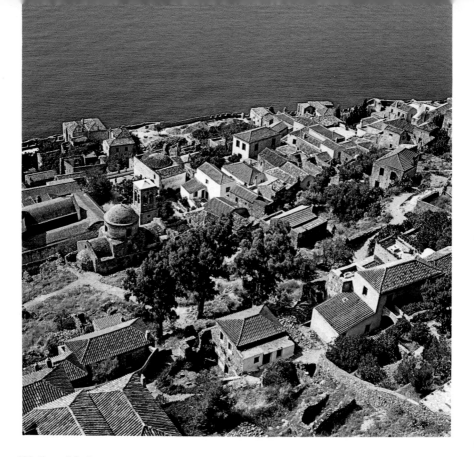

106. *Part of the lower town of Monemvasia.*

All the way up to the castle on the top of the hill, the path twists through ruined houses, passing the tumble-down churches of *St Anne* and *St Stephen*, the still roofed churches of *Our Lady of Crete* and *St Nicholas*. One passes under the arched tunnel of the heavily defended main gate of the Upper City to enter the main square of the dead town, whose palaces rise only as piles of stones from amongst the wild flowers. Close to a chasm on the steepest side of the cliff rises the ethereally beautiful church of *St. Sophia*. Not only one of the finest monuments of Greece, it is also one of the very rare examples of the domed octagonal style of church. It was built by Andronicos II at the end of the thirteenth century, and a few of its wall paintings and the marble decoration still survive. High above the castle, the walls and ramparts appear to be slipping into the sea together with the houses of the lower town, presenting a vista that is unique.

On the northern shore of the bay opposite Monemvasia lie the ruins of **Epidauros Limena** (Old Monemvasia), where Mycenaean tombs have been discovered. Polygonal walling dates to the fifth or fourth century B.C. From Monemvasia a road southwest leads to **Neapolis** (about 61 kms.) which is situated close to ancient Boiai, remains of which have long since been identified at the head of the bay. The style of the remaining houses, public buildings and fortifications suggest that the city enjoyed its greatest prosperity during the Roman period when it was a member of the League of the Free Laconian Cities.

One of the most beautiful parts of the region is the plain of Laconia which extends from Sparta to the sea at Gythion. Its greenness, emphasized by orchards and especially by orange groves, contrasts with the barren slopes of Mts. Taygetos and Par-

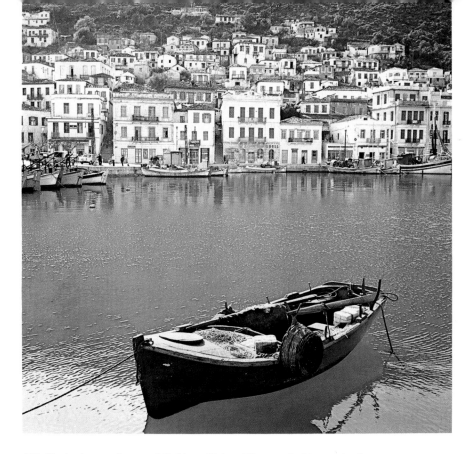

107. *The harbour and town of Gythion with its tall houses climbing up the slopes.*

non. On the Gulf of Laconia the many neo-classical houses of **Gythion** are built amphitheatrically at the foot of Mt. Koumaros, the ancient Larysion. North of the modern town lies ancient Gythion, of which the ruins of the theatre still survive, and which was inhabited in prehistoric times. Later, the Spartans used it as a port, enlarging the natural harbour, protected from the south by the island of Cranae, by engineering works, so that they could use it as a naval base. Despite the damage inflicted on the dockyards in 425 B.C. by the Athenians, it remained largely unharmed. Under Roman rule, most of the produce of the region was shipped from here and, as a member of the League of the Free Laconian Cities, it enjoyed special prosperity. Including the Greek **theatre**, the most important ruins belong to this period: bath-houses, aqueducts, a temple in which the reigning Caesar was worshipped (Caesareion) and various buildings from which mosaic floors have come.

 South-west of Gythion the road leads into the area of the **Mani**, the southern-most cape in Europe excepting only the Spanish Tarifa. Like the backbone of the area, the Taygetos mountain chain divides it into east and west. The east is called "sunny", while the west is called "shady". The configuration of the peninsula with its bare precipitous mountains, sparse vegetation, scarcity of water and its rocky, inhospitable coastline has shaped the character of the inhabitants accordingly: tough, resistant and conservative. Since antiquity, the isolation and impenetrability of the terrain has attracted the settlement of many independent minded spirits. In the Roman period, the Mani broke away from Sparta to whom she had until then belonged, and under Roman tutelage founded the League of the Laconians which later came to be known as the League of the Free Laconian Cities. It was dissolved by the Emperor Diocle-

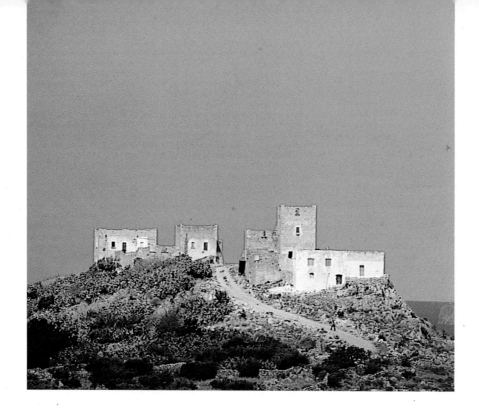

108. A typical Maniot tower house.

tian. According to the Byzantine Emperor Constantine Porphyrogenitus, the Maniots were christianized in the ninth century A.D., during the reign of Basil I of Macedonia. This information, however, can be only partly true, since research and excavation undertaken by Professor N. Drandakis in the Inner Mani has brought to light ruins of Early Christian churches. Part of the area, however, had remained outside the Christian world, and was converted in the tenth century by St Nikon "the Penitent" who traversed the whole of Laconia on his proselytizing journeys.

After their establishment in the Peloponnese, the Franks erected three strongholds to control the Mani – Passava, which controlled the narrow pass from Gythion to the Mani; Great Maina and Leuctro (Beaufort) close to Kardamyli. All three passed to the Maniots after the battle of Pelagonia. When in May 1460 Mohamet II captured Mystras, he did not pursue his conquests into the Mani, but conferred favours on the area in an attempt to win its loyalty in the struggle he foresaw with the Venetians. Nevertheless, the Maniots formed an alliance with the Venetians and for fifteen years (1463-1479) waged war against the Turks. When the fighting ended, the Maniots were deserted by their allies, and left to their fate, with the result that they remained spectators in the subsequent Turco-Venetian wars. When they once again took part, in 1684, they succeeded in capturing the castles of Kelefa, Zarnata and Portocayo.

During the second period of Turkish occupation which began in 1715, the Mani remained independent by paying an annual tribute of only 4000 piastres to the Su-

109. Taygetos seen from the Mani and one of the villages.

110. View of Batheia showing the impressive towers to be seen in other Maniot villages.

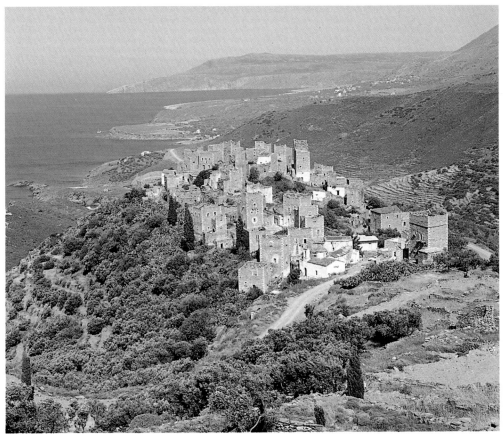

blime Porte. The sum was increased after Maniot participation in the Orloff rising in 1770. On the eve of the War of Independence the *Philiki Etaireia* sought support from the Mani as the safest starting point from which to launch the struggle. Indeed, the Maniots met, and more than met, the hopes and expectations of the *Philiki Etaireia*, organising the forces at their disposal to assist in the winning of many battles. Independent and rebellious by nature, the Maniots found it difficult to conform to the new order they had helped to bring into being – the establishment of the Greek State. On some occasions during the governorship of J. Capodistrias and later during the reign of King Otto I, they resorted to armed resistance. In the end, however, they were forced to adjust to the new conditions.

About fifteen kms. from Gythion on a hillside in a fertile plain surrounded by mountains, stands the **castle of Passava**, which was built by the Frenchman Jean de Neuilly in 1254, guarding the defile and the road which leads to Western Mani. The imposing walls still well preserved hint at how powerful the castle once was, and make it more than clear that if one had both this castle and that of Kelefa one could control from the land the entire Mani peninsula. Passava was built by the French baron Jean de Neuilly in 1254. The site is identified with the ancient town of Las, where various objects dated to Classical and Hellenistic times have been found. Beyond Passava one passes into the rough and barren country of the Inner Mani, "waterless and arid territory, fertile only in olives" as Constantine Porphyrogenitus characterised it.

The first village of the Inner Mani is **Areopolis**, so called since the nineteenth century, before which it was known as Tsimova. The many traditional houses surviving today give it the appearance of a fortified settlement. The cobbled lanes pass tower dwellings whose enclosed courtyards are entered through low arched gateways. Notable amongst its churches are *St John the Baptist* and the *Taxiarchs*.

Beyond Areopolis the harsh land becomes even more rugged; craggy mountains enfold most of the Maniot villages, whose high crenellated towers served the dual purpose of home and fort in the many armed struggles of the Maniot people. All the villages of the Inner Mani boast such towers, albeit crumbling and ruined: the most impressive are to be seen at **Kitta** and **Nomia**. The oldest Byzantine churches in the whole of Laconia also lie in this area. They date from the tenth, eleventh and twelfth centuries, and belong to the cruciform domed two or four-columned type, with narthex and outer narthex. Tile decoration and harmonious proportions combine to form a unique architectural style. At Kitta there are three such churches: *SS. Sergius* and *Bacchus* (12th century) (now rededicated to St. George or Tourloti); the *Taxiarchs* and the *Assomates*. In Upper Boularioi, stands *St Strategos*, at Tigani the *Episcopi*, at Bambakas *SS. Theodore*, which are perhaps the most beautiful examples of this style. Rather later in date are the churches of the *Saviour* at Gardenitsa, *St Nicholas* at Ochia, the *Taxiarchs* at Kaloumi and *St Marina* at Pirgos. These villages can be reached by many different side roads from the main road which runs south to Yerolimena, with its horse-shoe cove and high rock of Kavo Grosso. After Yerolimena the road continues eastward to Alika and Vatheia, where most of the Maniot towers are found, to end at Cape Taenaron, where the ancient Greeks believed the entrance to Hades was in a cave close to the Sanctuary of Poseidon.

111-112. Two views of the fantastic caves of Diros.

143

113. The Bay of Oitylo seen from above. One of the most beautiful places in the Western Mani.

Returning from Yerolimena to Areopolis one takes the road to **Pirgos Dirou** some five km away and famous nowadays for its splendid caves. The most important of the these are Alepotrypa because of its archaeological finds, and Glyphada or Vlychada for its great beauty.

Alepotrypa was discovered in 1958 by Mr and Mrs Petrocheilos. Finds there make it clear that it was used as a dwelling place by prehistoric man. The mouth of the cave is several metres from the shore on rising ground: inside, the ground level is uneven. Side chambers, also with stalagmites and stalactites, open off the central cave and are reached through a maze of corridors. Amongst the finds were weapons, stone and bone tools, Neolithic pottery, rock paintings and complete human skeletons. The skeletons are those of unburied dead, a fact which has led the Ephor of Antiquities, Mr George Papathanasopoulos who conducted systematic excavations, to suggest that at the close of the Neolithic period or at the beginning of the Bronze Age, a severe earthquake shook the area. Large boulders were dislodged, blocking the mouth of the cave, so that its inhabitants were walled up and died of starvation. The entrance remained sealed for some 4500 years. Other finds – including Neolithic sherds and a stone axe – from the area between Alepotrypa and Glyfada reveal the existence of a sizeable prehistoric settlement whose centre, according to Mr Papathanasopoulos, was within Alepotrypa which contained a plentiful supply of water. The finds are exhibited in the Neolithic Museum at Diros. The cave is full of stalac-

tites and stalagmites, and each chamber was given a name according to its shape by the speliologists who first explored it.

The cave of **Glyfada** was first explored also by Mr and Mrs Petrocheilos, under whose guidance the first systematic unterwater search was conducted in 1970. The modern entrance to the cave is artificial, and was opened for the convenience of visitors to the left of the natural entrance. The wealth of stalactites and stalagmites rank it amongst the most beautiful caves in the world. As at Alepotrypa, the various chambers have all been given names.

Leaving the fairy-tale world of the caves, the visitor comes to the harbour of Areopolis, **Limeni**, with the restored tower dwelling of Petrobey Mavromichalis. North-east of this, at a height of 256 m., lies **Oitylo** or **Voitylo** on the site of the ancient city, which is mentioned by Homer (*Iliad* II 585). Remains of walls have been brought to light on the ancient site, together with architectural fragments from a temple of Sarapis and sherds of Mycenaean pottery. On the slopes is the monastery of Dekouloi with wall paintings dated to 1765. On the hill opposite, towards the south-east, rise the now dilapidated walls of the *castle of Kelefa*.

Beyond Oitylo the villages of Western Mani spread out, one after the other, set in a calm and peaceful landscape, which bears no relation to the Inner Mani. Near the spring at the centre of the village of Thalamai, a member city of the League of the Free Laconian Cities, is an inscribed base, of Roman date. Further north, at Kambinari, before reaching Platsa, is the church of *St Nicholas,* built as a three-aisled basilica in the tenth century and renovated in 1348 by a local nobleman. It has some distinguished frescoes. Northwards, the road runs through the remaining villages of Messenian Mani. The most important, **Kardamyli**, retains its ancient name; Homer tells us that is was one of the seven cities Agamemnon promised to give Achilles (*Iliad* IX, 150, 292). In the Roman period, Augustus took it from the Messenians and bestowed it on the Spartans. It was used as the port of Sparta. Above the village lies the ruins of a medieval castle and traces of ancient fortifications. **Kambos** (about 35 kms. beyond Kardamyli) is completely overshadowed by the medieval *castle of Zarnata*, built on the site of ancient Gerenia.

From this point the road descends to Kalamata, the capital of Messinia, passing picturesque villages with Byzantine chapels.

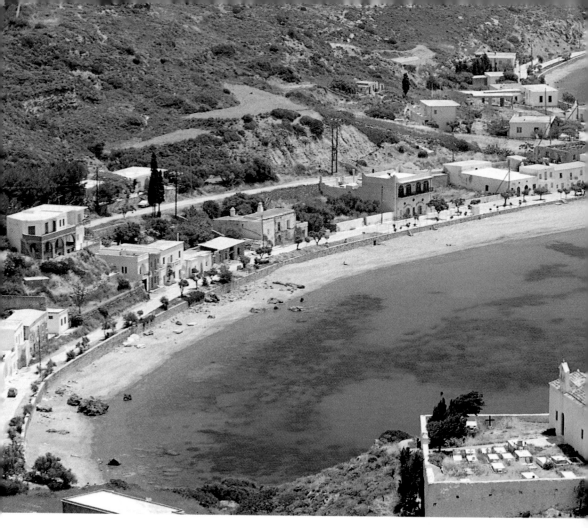

114. The harbour of Kythera. The island closes the southern side of the Gulf of Boia. The

KYTHERA

South-west of Cape Malea lies the island of Kythera. Its old name was Porphyrou-sa or Porphyris because the purple dye-producing mollusc, the *murex*, is found in abundance on its shores. According to the most recent archaeological researches a Minoan trading post existed on the island from 2000 B.C. until the fifteenth century B.C. The Phoenicians also left their mark on the island, shown in its name Porphy-rousa and the place name Phoenix by which the bay was known until Classical times. Herodotus tells us (I, 105) that the Phoenicians built the temple of Aphrodite, where worship continued throughout antiquity. In the Odyssey, Homer calls the goddess Aphrodite *Kythereis* (IX, 288) and the island was apparently regarded as the chief centre of her cult. After the Minoans, the Achaeans established themselves on Ky-thera, to be displaced by the Dorians. They in their turn in historic times were succeeded by the Argives. The Spartans wrested it from the Argives, establishing a permanent garrison and Spartan governor. During the Peloponnesian War, it was

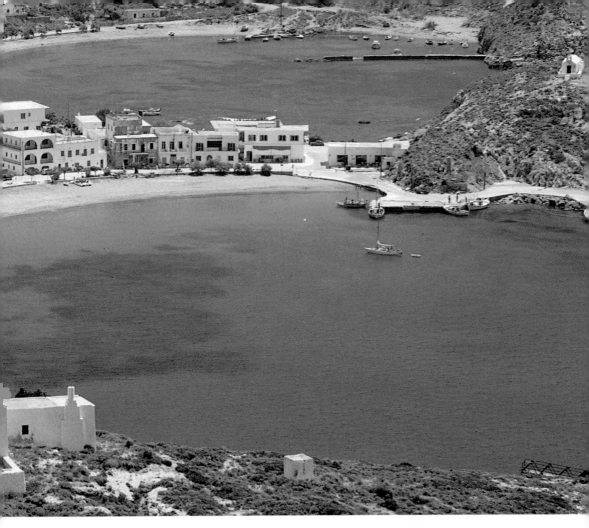

modern capital lies on the southern side of the island far from the ancient capital which lay to the west of Kastri.

captured by the Athenian forces led by general Nicias (424 B.C.). They used it as a base from which to raid and plunder the shores of Laconia. The ancient capital of the island, Kythera, stood on the site of *Palaiokastro* or *Palaiokastri*. On the summit of the hill was a fortified acropolis, while the city itself, also walled, extended across the southern slopes. The site of the famous temple of Aphrodite has not yet been identified with certainty. It is thought by some to lie under the present church of Agios Cosmas. Majority opinion, however, regards the area of Vigles, or Kolones, on the south-western slopes of the hill as the more probable site because of the high incidence of finds made there. **Chora**, the modern capital of the island, retains its island charm, facing south towards the Cretan Sea. Narrow streets and cobbled lanes wind below the castle towering on the hill, a reminder of the medieval and Venetian years. A number of Byzantine and post-Byzantine churches, some of which reveal Frankish influence in their architecture, strengthen the impression of time standing still.

The **museum** contains a display of Minoan and Mycenaean pottery, coins of successive epochs and Byzantine and post-Byzantine icons.

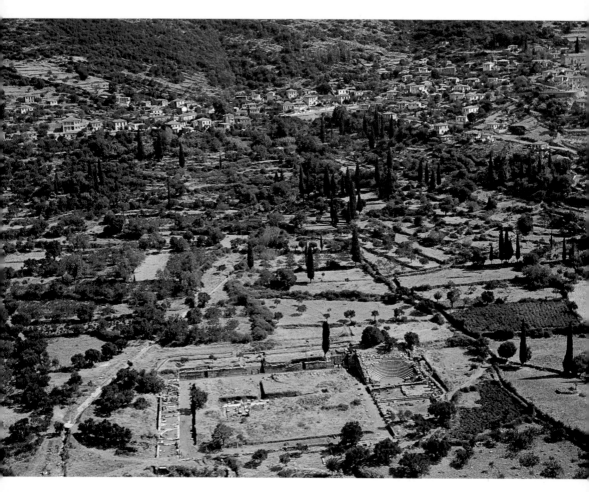

115. View of Messene showing the most important complex, the Asclepieion.

MESSENIA

The prefecture of Messenia, covering the south-western extremity of the Peloponnese, is a fertile and relatively self-sufficient region. It was first inhabited by the Leleges; according to mythology it was named after Messene, consort of the first king of the region, Polykaon. Later, Aeolians and Minyans settled there, while the Achaeans retained their hold on the western and southern areas even after the Doric tribes led by Cresphontes invaded and occupied the central zone of the province. Around the middle of the eighth century B.C. the Spartans also sought a share of its fertile plains in their search for a solution to the problem of surplus population. This resulted in a series of battles, known collectively as the Messenian Wars.

The first war started c. 735 B.C. and ended in 715 B.C.: notwithstanding the vigorous resistance put up by the Messenians, the Spartan victory ensured Spartan supremacy over Messenian soil, with the exception of the westernmost tip and the southern shores. The land-owners were obliged to quit the fertile region around the lower Pamisos river, while the small farmers fell to the social level of the helot class, and were obliged to suffer the harsh exploitation of the Spartans. Inevitably, this led to friction, and to frequent small-scale risings, which finally escalated into the Second Messenian War after the defeat of the Spartans by the Aegives in 669 B.C. Tradition records many tales of Messenian heroism and of the courage of their leader Aristomenes. Nevertheless the Messenians were defeated, and their territory passed to the Spartans; the few *perioikoi* who survived were reduced to the status of *helots*.

In 464 B.C. the Messenians took advantage of the severe earthquakes which caused havoc in Sparta to stage a revolt. Although they succeeded in capturing the stronghold of Ithome, they did not manage to hold it for long. In 460-59 B.C. Ithome fell once more to the Spartans, and the Messenian refugees were established by the Athenians at Naupaktos. They were later joined by other Messenians who had favoured the Athenian side during the Peloponnesian War (425 B.C.). After the defeat of the Athenians, the victorious Spartans expelled the Messenians from Naupaktos (399 B.C.); the latter only regained their independence in 369 B.C. when Epaminondas settled them in his new foundation of Messene. In 146 B.C. it was annexed to Rome and its subsequent history is that of the rest of the Peloponnese.

During the Frankish occupation Messenia became a fee held by the ruler of the Principality of the Morea. To ensure the safety of the province, the Franks erected castles at several places. During the War of Independence in 1821 Messenia was used as a base for the sallies of the revolutionary forces, who, starting from the Mani, besieged and captured Kalamata.

At the head of the Messenian Gulf, in a fertile plain watered by the river Nedon is the capital of Messenia, **Kalamata**. As excavation has shown, the town occupies the site of ancient *Pharai*, whose foundation the traveller Pausanias described in detail. Homer in both the *Iliad* and the *Odyssey* supplies information about its king, Diocles. Homer also is the source of our information that *Pharai* (eastern Messenia) was subject to the kingdom of Agamemnon and participated in the Trojan War. In the eighth century B.C. *Pharai* was annexed as a province of Laconia, and was not independent again until after the Battle of Leuctra (371 B.C.). The name *Pharai* was in use until the Byzantine epoch; in the late medieval period it was supplanted by Kalamata, the etymology and derivation of which is variously explained. One view maintains that the place name belonged to a monastery, that of the Panagia of Kalamata which possessed a miracle working icon.

In 1208, when Geoffrey Villehardouin acquired the barony of Messenia, the name Kalamata was well known. The Frankish rulers of Achaia, although they used Andravida as their capital, showed special concern for Kalamata, William Villehardouin especially, because he was born and reared there. He refortified the castle on the summit of the hill which had existed in Byzantine times, but had since been abandoned. Today its ruins dominate the town; it is difficult to distinguish the original fortifications from later repair work, because the castle underwent many alterations and repairs from the successive seigneurs who followed the Villehardouins. Much that was demolished by the Venetians in 1685 was later rebuilt. Above the outer gate is a relief representation of the Lion of St Mark.

From the castle's commanding position, one has a wonderful view not only of the modern city which is an important commercial centre, but also of the entire Messenian Plain which unfolds in a unique panorama. There are many churches in the city, the oldest of which is the Holy Apostles dated to the thirteenth century. In the old city is a convent, a building of the late eighteenth century, where the nuns weave the famous silk. There is also a **Folk Museum**, a **library** with some 60,000 volumes including some rare books and an **Art Gallery** displaying works of Greek and foreign painters. In the **Benaki Archaeological Museum** is a display of finds from excavations: stone tools and vessels, Proto-geometric and Geometric pottery, and late Classical, Hellenistic and Roman sculpture. Of particular merit is the Roman mosaic floor (1st century A.D.), which came from a public building; at its centre is Dionysos with a panther and satyr, while in half moon projections he is shown fighting wild beasts.

On the site of Palaiokastro, some few kms. north of Kalamata and east of the

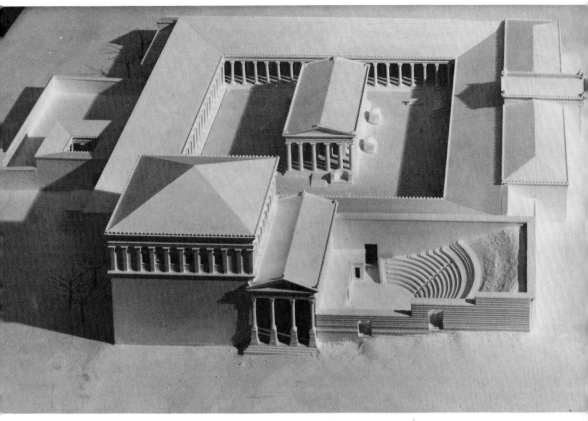

116. *Plaster model of the Asclepieion of Messene, with the Propylon of the entrance, the east façade of the temple, the two wings of the colonnades and the theatre.*

modern village of **Thouria**, are the ruins of ancient Thouria, inhabited from prehistoric times.

Close to the village of Mavromati (29 kms. from the main road to Androusa) the ruins of **ancient Messene** lie on the heights of Mt Ithome. Capital of independent Messenia, it was founded by Epaminondas in 370-369 B.C. at the same time as Megalopolis in an attempt to undermine the influence of Sparta in the Peloponnese. Pausanias (IV, 31.4) is the source for most of our information about the establishment of the city and the reasons which determined the choice of site. Originally known as *Ithome* it was re-named Messene after the first queen of the region. The widely-famed fertile plains of Steniclaros and Makaria were granted to the new city which enjoyed a period of prosperity for as long as it was under Theban protection. After the Theban defeat and withdrawal from the Peloponnese, the citizens allied with the Macedonians (344 B.C.), later deserting them to join the Achaean League. Under Roman rule the city retained its autonomy, but was destroyed by the invasion of the Goths in A.D. 395. For greater safety, the surviving inhabitants withdrew to the slopes of Mt. Ithome.

117. The Arcadia Gate at Messene. The fortification wall can be seen to right and left.

Excavations were first conducted at Messene by Blouet ("Expédition scientifique de Morée") and continued by the Greek Archaeological Society from 1895 until 1925. Excavations, still in progress, were resumed in 1957. Of the city wall, which so much impressed Pausanias, (IV, 31.5) and which effectively protected the Messenians in many sieges, only the northern section, on both sides of the Arcadian Gate, can now be seen. Ruinous stretches help to determine its original course, whose total circumference was nine kms. At intervals were semi-circular battlemented two-storey bastions, and gates flanked by strong towers. The names of each gate indicated the destination of the road which passed through it. Thus the Laconian Gate lay on the south-east and the impressive Arcadia or Megalopolis Gate on the northern side; the present road to the village of Zerbisia still passes through the latter. On the ancient paving below the archway the grooves worn by the constant passing of chariot wheels can still be seen. The buildings of the city, examples of the peerless art of the fourth century B.C., lay close to the southern section of the walls around a peristyle court entered through an impressive monumental gate on its eastern side. The excavation uncovered the most important public buildings: the **Synedrion**, i.e. the hall in which the representatives of independent Messenia assembled; a small

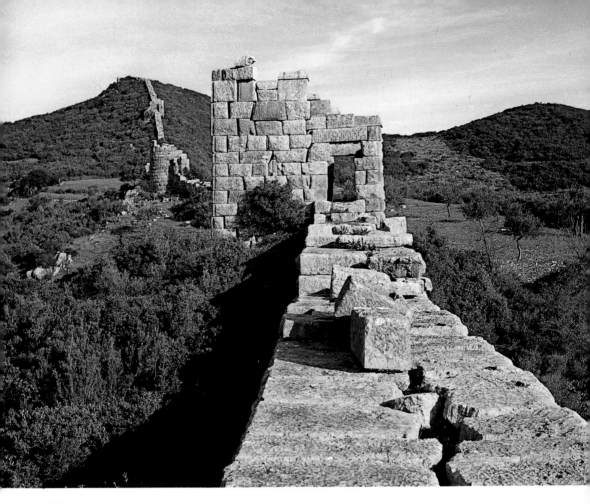

118. Another section of the defences of Messene.

theatre, one of the most impressive sights now that its stone seats have been restored, which could also be used as a meeting place; the **Oikos,** dedicated to the cult of the Roman emperor; the **Sebasteion** which consisted of two chambers for the worship of the Roman emperors; a building thought to be a potter's workshop; a **temple** to Artemis Orthia, which was entered by a door in the western colonnade and had a *sekos* broader than it was long, the reverse of all other temples; the **Heroon;** and the **Asclepieion.** South-west, outside the ramparts, lay the **stadium** and further south the area in which the most important citizens of Messene were laid to rest, the **Hierotheseion.** From the town a footpath leads to the summit of Mt. Ithome, where, just before reaching the top, can be seen the remains of a small **temple of Artemis Limnatis** or **Laphria.** The hill itself is fortified with concentric rings of walls, and on its summit are scattered the remains of the **monastery of Boulkanos,** erected in the Byzantine period. Though the monastery was built on the site of the ancient shrine of Zeus Ithomatas, very little building material from the temple was used in the construction of the monastery, which ceased to function in the sixteenth century when a new monastery was built lower down.

In the village of Mavromati there is a small archaeological **museum** with finds from the excavations on the site of ancient Messene.

From Mavromati the road leads to the plain of *Meligala*, the ancient Steniclaros, to the north-west of which - some 15 kms. north of Ithome - rises the hill of Malthi. On its lower slopes Mycenaean tholos tombs have been discovered; on its summit remains of buildings have been attributed to the prehistoric settlement of *Dorion*, whose greatest prosperity was attained at the end of the Middle Helladic Period (2000 - 1800 B.C.). It was still inhabited in the Mycenaean era, from which period the remains of a megaron-like structure remain a little below the summit.

From Kalamata the road to the south along the Messenian Gulf leads to Petalidi, thought to be the site of **ancient Corone**. On the hill where the ancient acropolis was sited, foundations of structures, inscriptions and sculptured fragments can still be seen. Still visible also at various points in the town are the foundations of the fortifications erected by the Thebans and the founder, Epimelides, in 369 B.C. A little further south, in the village of Agios Andreas, the port of Loggas, the shrine of *Apollo Korythos* has been excavated. It seems to have occupied this site from the Geometric period until the end of antiquity. In Early Christian years, on the same site, a three-aisled basilica was erected, later replaced by the old church of Agios Andreas.

The city of **Corone**, with its now ruined castle, stands on a headland close to Cape Akritas, some 50 kms. from Kalamata. The Pylos tablets suggest that there was a prehistoric settlement in this area. According to tradition, it was here that the refu-

119. Aerial view of the harbour, town and castle of Corone.

gees from Asine in the Argolid were re-settled, expelled from their own city by the Argives because they had been the allies of the Spartans. Hence the place was first called Asine. It is thought that the change of name to Corone took place in the ninth century A.D. following a second migration of peoples, this time from Corone (modern Petalidi), seeking greater protection from the pirates who infested all coastal waters. The settlers repaired the fortifications on the summit of the acropolis, often re-using older building material. However, the most drastic reconstruction and extension of the walls was carried out by the Venetians, who in the thirteenth century A.D. occupied it together with Methone. The Turks tried repeatedly to capture the town, succeeding in 1500 when the terrified inhabitants delivered it to Bayazet II, the destroyer of many castles in the Peloponnese. The Venetians made strenuous attempts to reclaim it, succeeding in 1687 after an intensive siege conducted by Morosini. New repairs to the defences were carried out in 1690, but the Turks recaptured Corone in 1715, retaining possession until 1828 when it was freed by the army of General Maison. The present town of Corone is built on the slopes of the hill below the castle with narrow cobbled lanes, old churches and neo-classical houses.

From the small harbour the road leads to the entrance of the impressive castle. Within its walls are subterranean cisterns, while the greater part of the bailey is occupied by the churches and chapels of the monastery of St John the Baptist built at the opening of this century around the old Byzantine church of St Sophia.

At the entrance to the grove of Eleistra, in a small building, is the historical and archaeological collection of Corone.

From Corone a bad road leads to the western shore at whose southernmost tip stands **Methone**, better reached from the Kalamata - Pylos road. Methone's harbour was renowned throughout antiquity. According to Pausanias and Strabo its older

120. The castle of Corone seen from the sea and one of its gates.

121. Aerial view of Methone and its castle.

name was *Pedasos*, which Homer qualifies with the phrase "rich in wines"; it was one of the seven towns which Agamemnon offered to Achilles to appease his wrath. The name *Methone* or *Mothone* as Pausanias records it, is first known after the First Messenian War, at the end of which the town was granted by the victorious Spartans to the Nauplians, expelled from their homeland by the Argives because they had been allied with the Spartans. After Messenia became independent in 369 B.C. the Nauplians continued to live in Methone because they were known to be friendly towards the Messenians. In the fourth century B.C. Methone's fortifications were reinforced, and it remained a small autonomous town until the Roman imperial period. In the Byzantine period there are references to it as a seat of a bishopric as early as the fourth century A.D., which suggests that at that time it held an important position amongst the cities of the Peloponnese. The Venetians had designs on the harbour from the twelfth century A.D. Upon finally capturing it in 1209, they fortified it, including in the layout several parts of the pre-Christian defences and using in its construction material from older buildings. In 1500, after a long-drawn out siege the Turks captured the town and massacred the population. The Venetians, however,

122. Sunrise from the castle of Methone.

did not repudiate their claims to it. After siege and bombardment they recaptured it in 1686, holding it until 1715 when the Turks regained possession. They held it until 1828 when the forces of General Maison forced them to surrender it.

A stone bridge with fourteen arches, which replaced an older wooden structure, leads over the moat to the entrance to the immense castle, the tremendous fortified enclosure, the imposing walls, the strong towers and the monumental gates. On the southern edge of the ramparts an impressive gate leads to the bridge which joins the fortified town with the Bourzi, the octagonal tower which was built during the Turkish Occupation (after 1500) on a islet to strengthen the defence of the harbour.

A little further north of the castle is the modern picturesque village of Methone.

Continuing northwards for 12 kms. one reaches **Pylos**, the island-like town with many historic associations and much local colour. It was built amphitheatrically on the slopes of Mt. St Nicholas on the southern shore of the Bay of Navarino, to plans drawn up in 1829 by a French architect in the entourage of General Maison. The town fans out in horse-shoe formation, radiating across the slopes of the hill, its picturesque narrow cobbled lanes lined with two-storeyed houses. Opposite the har-

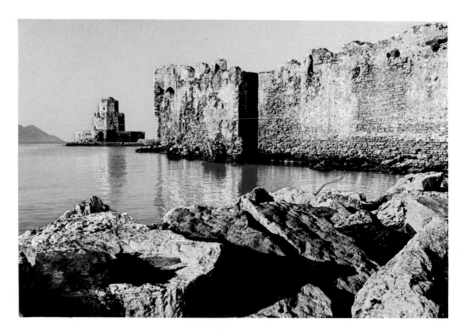

123. The castle of Methone; on the left is Bourzi.

bour, in the Square of the Three Admirals, a three-sided column rises between two cannons - one Turkish, the other Venetian. The column carries the figures of the admirals of the three fleets - English, French and Russian - which defeated the Turco-Egyptian navy in the Battle of Navarino in 1827.

The entrance to the Bay is sheltered by the precipitous islet of **Sphacteria** (4 1/2 kms. long and from 500-1000 m. broad). Two narrow channels, one to the north, the other to the south, are protected by two castles, Neokastro and Paliokastro or Palaio Navarino.

Neokastro, whose name denotes that it is the newer castle of Navarino, was built by the Turks in 1573 after their defeat at Naupaktos so that they could control the southern, and only, entrance to the Bay. An artificial embankment has so reduced the depth of water in the northern channel that no ships can enter the Bay from that direction. It is considered to be one of the best preserved castles in Greece. The fortification wall which girds the slopes of Mt. St Nicholas is accessible both from the harbour and from the Methone road close to the Turkish aqueduct.

The south-west wall, which could be attacked from the sea, was made especially strong. At the highest point of the walled enclosure stands the hexagonal tower, each of its six corners given extra protection by projecting towers. The ceilings of the narrow chambers in each side (6 X 8m)[1] support the stone terracing of the gun platforms and the parapet is also pierced by gunloops. On the west side of the castle stands a small fort, also built by the Turks, together with the subterranean water

124. Bourzi as it appears from one of the gates of the castle.

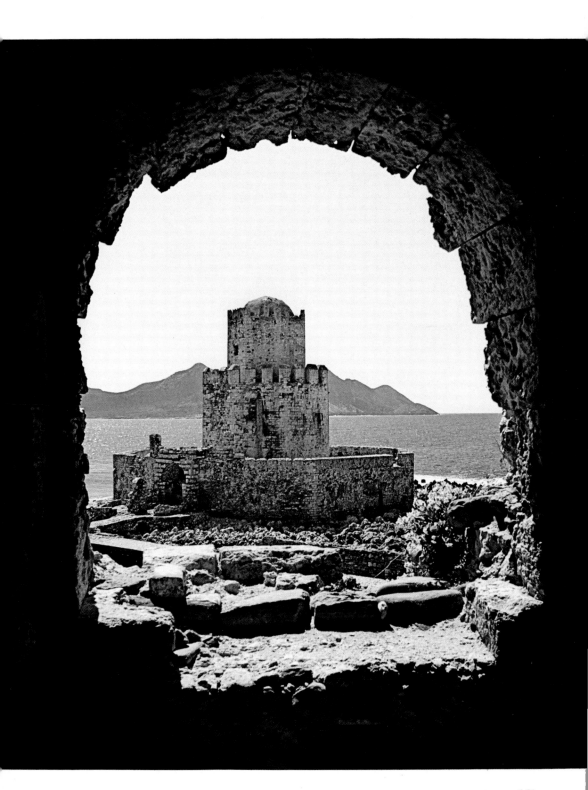

125. The town of Pylos and its harbour.

cisterns and the now ruined houses. The church of the Transfiguration of the Saviour was built by the Franks in the Gothic style; it was later converted into a mosque.

Palaiokastro or Palionavarino stands on Cape Koryphasion, to the north of modern Pylos, on the site of the ancient acropolis and town of Pylos, which according to tradition were built there after the destruction in 1200 B.C. of the original prehistoric town on the hill of Englianos. Pausanias on the other hand believed that this was the site of the original Pylos of King Nestor, and he mentions that there was a sanctuary of Athena Koryphasia in the city of Koryphasion and a house called the House of Nestor with a painting of the king, whose tomb was in the city; there was also a cave that the local people claimed was Nestor's stable. Pausanias also mentions that outside the town there was a tomb belonging to Nestor's son, Thrasymedes. It seems, however, to have been the tomb of some Mycenean ruler in the centre of a circular precinct that was full of tombs, and the "House" of Nestor was some Hellenistic building dedicated to Nestor as hero.

In the calm anchorage of Voidokoilia to the north of the promontory thick layers of sand cover the remains of the Hellenistic town, which was abandoned by its inhabitants in the Early Christian period.

160

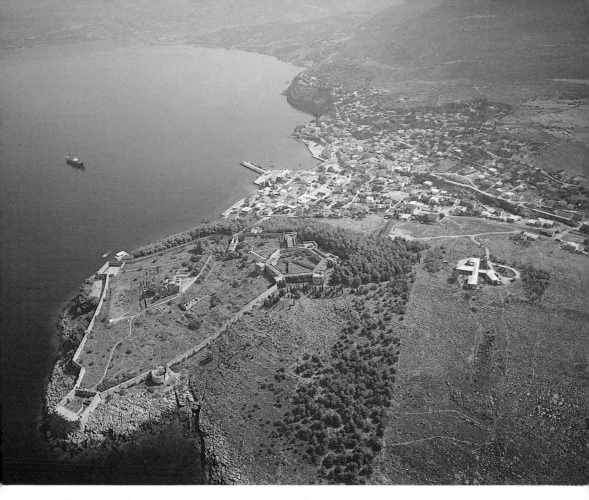

126. The newer castle of Navarino (Neokastro) seen from above.

Remains of a Roman and Early Christian town are preserved on the southern tip of the promontory. Relics of the fortifications erected by the Athenians in 425 B.C. during the Peloponnesian War, to strengthen the most vulnerable part of the promontory, lie on the narrow straits of Sykia - the channel which separates the cape from the island of Sphacteria. Today the summit of the bluff is covered by the ruins of the Venetian castle known as *Palaio Navarino*, with can be reached with some effort by a narrow path on the northern side. Of the castle with its strong defenses, once considered one of the most strategic sites, very little remains today for the visitor to identify.

Within the Bay of Navarino lie the islets of Sphacteria, Pylos and Marathonisi. **Sphacteria**, which in the Middle Ages was referred to as *Jonc* (or *Junc*) and *Gioncho*, has puzzled many trying to write its ancient history. It seems that it was not continuously inhabited. On the heights of profitis Ilias at the north of the island remains of an ancient wall have been found: its construction has been attributed to the Spartans who were besieged here by the Athenians in 425 B.C. On the western side of the island, pottery sherds from Hellenistic, Roman and medieval periods have been found. On the southern shore stand the Tomb of Alexis Mayé, a subordinate officer

161

of General Maison, the cenotaph to Tsamados, the Unknown Soldier and Sachinis, and the memorial to the Philhellene Santarosa, all of whom fell in the Battle of Sphacteria (1827). On the eastern shore, close to the chapel of Panagoula stands a monument to the fifty-nine Russians who were killed in the naval engagement of Navarino.

In the interior of the island is the tomb of Paul Marie Bonapart (1809-1827), Napoleon's nephew. On one of the two islands south of Sphacteria, called Tsichli-Baba or Pylos, is a monument to the French who fell in the naval battle of Navarino, and on the other one inside the harbour, Chelonaki or Marathonisi, is the monument to the British.

The Antonopoulos Museum at Pylos

The museum of Pylos, in Philellinon Street, was opened in may 1951. Its two rooms house a display of finds turned up in the course of archaeological exploration of the area. They include pottery, small finds, metal objects, weapons and tools from Neolithic to the Roman period.

At a distance of about 15 kms. on the hill of Ano Englianos are the remains of the **Palace of King Nestor**. Nestor took part in the Trojan War and, after Mycenae, his city was the largest in the Mycenaean world. At the beginning of the 12th century B.C. the palace was destroyed by a fire of unknown cause. The architectural remains have vanished, but tombs continued to be built around the palace. After the disaster the inhabitants moved down to the Koryphasion peninsula; there they built a new town at the place where Nestor's harbour had been before the destruction, and where he used to repair with his sons to make sacrifices and hold feasts, according to Book 3 of the Odyssey. The hill of Englianos was never inhabited again, and in time the ruins were covered over with earth and men forgot the once rich and powerful Pylos.

In 1939, K. Kourouniotis located the site of the palace. Professor Carl Blegen of the University of Cincinnati, excavated the area, bringing to light treasures similar to those of Mycenae. In constrast with Mycenae, however, the palace of Nestor neither occupied a strongly defensive position nor was it fortified, but spread across a peaceful landscape where nature's beauty reigns supreme, and we must assume that the smaller towns and the adjacent territories depended on it economically and were sworn to loyalty by a strict oath, re-inforced by common customs.

The layout of the palace of Pylos resembles that of Mycenae and Tiryns, but the building is better preserved. It therefore affords us a fuller understanding of the details of the palace complex. The thousands of clay tablets found in the "Archive" on almost the first day of the excavations illuminate for us the multiple functions and transactions which took place there. The similarity of these tablets to those found at

127. The Bay of Boidokilia and the rocky peninsula of Koryphasion on which stands the castle known as Paleokastro.
128. The Mycenaean tomb north of the Bay of Boidokilia traditionally known as the Tomb of Thrasymedes.

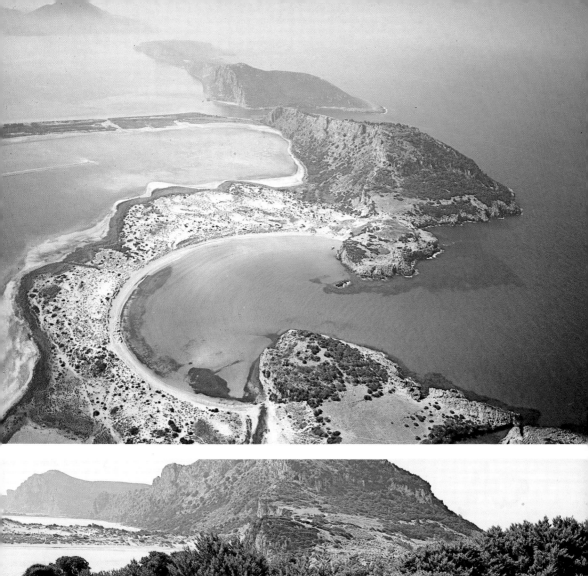

129. The hearth of the great hall in the megaron at Pylos as it was excavated.

Knossos, Crete, led to the theory that it was the Minoan civilisation which influenced the mainland - Helladic - culture. In 1952, the architect Michael Ventris, assisted by the scholar John Chadwick used methods of code-cracking to decipher the tablets with the Linear B script, the script of Mycenaean Greece. The 1250 tablets from Pylos are oblong sheets of clay, not unlike palm leaves. Each bears characters incised with care. Some record financial dealings, others relate to the Levy of taxation, the discharge of debts, distribution of produce and expenses for armament.

The **palace** consists of three main complexes covering half the plateau of Englianos. The buildings are divided into official apartments, wine cellars, store-houses and workshops.

Large square poros blocks were used in the construction of the exterior walls, while the interior walls were built of small unworked stones. Wood in large quantities was also employed for columns, ceilings, door frames and even to provide a wooden framework for the walls. Today the entrance to the central building is reached by crossing a spacious court. The **entrance gate** was simple, closed by a narrow door at its centre, with one column in front and one behind, both of wood, of which

130. Reconstruction of the inner court of the Megaron of Pylos. Left, beyond a doorway, is the Throne Room. (Piet de Jong).
131. Reconstruction drawing of the richly decorated Throne room. The throne stood in the middle of the right hand wall. (Piet de Jong).

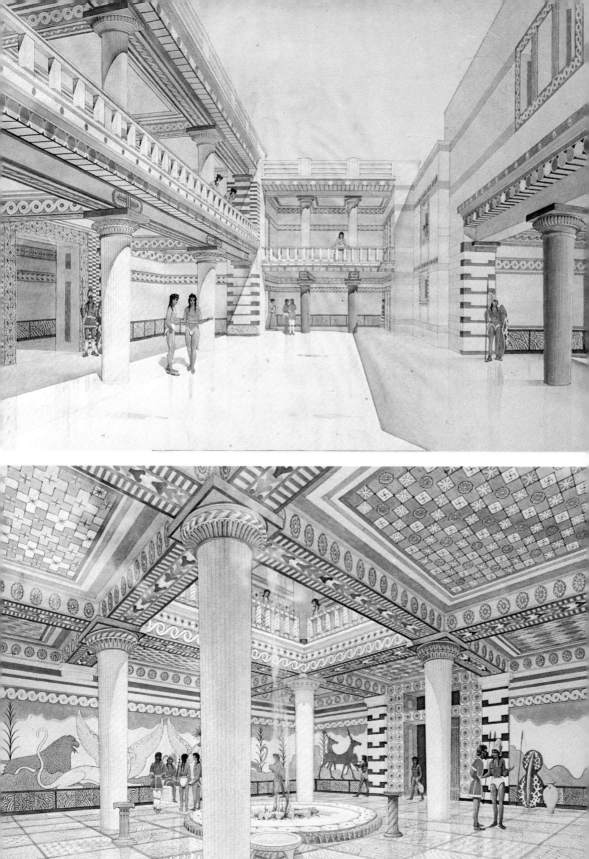

132. Bath found in a room within the palace of Pylos.

only the stone bases can now be seen. To the right is a **guard-chamber**, to the left the entrance to two small rooms where the clay tablets were found. The gate opens into a spacious unroofed **courtyard** with a colonnade on the right which supported a balcony where the spectators gathered to follow the ceremonies which took place in the courtyard. To the left is the entrance to two rooms, the first of which was a **store-room** and on whose floor were found quantities of smashed tall-stemmed clay *kylikes*; the second appears to have been a **waiting room** - so at least the excavators deduced because of the built-in benches on two of its walls. From the courtyard the porch of the central apartments was entered, beyond which lay a **vestibule**, with rich frescoed decoration, leading to the **throne room**. Here the clay cult hearth was placed in the middle of four wooden columns of which again only the stone bases remain. These columns almost certainly supported a light-well or shaft over the hearth and possibly a clerestory rising still higher through which the smoke escaped and by which the room was ventilated. The royal throne, constructed of perishable wood and ivory, was completely destroyed. It stood, however, in the centre of the right-hand wall. Each wall of the throne room was decorated with wall paintings depicting a different subject: specially interesting are the frescoes of the Griffins and of the Minstrel. Even the columns surrounding the hearth, the wooden ceiling, and

166

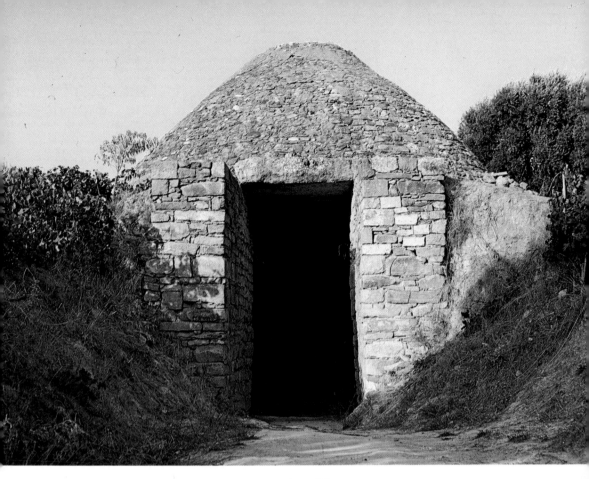

133. Chamber tomb of the 15th century B.C. near the palace of Nestor.

the rim of the hearth were painted, while the floor, divided into squares, had multi-coloured linear decoration. Around the megaron a series of rooms could be reached by various corridors. The five rooms on the south-west side, where thousands of clay vases were found, were obviously used as store-rooms, while the two rooms behind the throne room were used for oil, stored in large earthenware jars set permanently in position. Other oil stores existed in the rooms opening off the opposite corridor, where both large and small oil jars were found. The proximity of these oil store rooms, as well as another on the floor exactly overhead, helped the spread of the fire which destroyed the palace.

Two staircases, left and right in the vestibule, led to an upper storey which extended above the service rooms of the megaron at least, and possibly beyond.

Of the other buildings, which were sited on the south-eastern side, the **bathroom** is of special interest. Its clay bath tub with linear decoration and two large jars which were used for the collection of water for the bath can still be seen. Next to it lay the **Queen's Apartments**, reached through a portico and a corridor. In the centre of the largest room of the suite was a hearth with painted flame decoration. Surviving fragments of pastoral and hunting scenes, griffins, panthers, lions and other animals

show that the walls too were painted. The apartments facing the Queen's consist of a tower-like construction possibly for the commander of the garrison.

To the south-west of the central palace complex lies the South-West range, made up of various rooms and a megaron surviving from an earlier palace. To the north-east is another free-standing range containing store-rooms for wine and another space which has been interpreted as a shrine and the square stone at its entrance as an altar. The large room and its service rooms to the south are thought to be work-shops for the repair and construction of weapons and chariots. On this side also can be distinguished traces of a conduit which brought water to the palace from a spring a kilometer distant. There were no more buildings beyond this. Traces of construction further north-east belong to structures of an older dwelling which was either destroyed or ceased to be used on the construction of Nestor's splendid palace *c.* 1300 B.C., which lasted until 1200 B.C. when it was destroyed by a terrible fire.

Beyond Chora the main road continues on to **Gargaliani** with its harbour of **Marathoupoli** and fine beach some 8 km distant. Opposite Marathoupoli is the island of

134. Wall painting from the Palace of Pylos depicting a minstrel. Reconstruction by Piet de Jong.

135. Wall painting from the palace of Pylos, the Warriors. (Reconstruction by Piet de Jong).

136. Mycenaean warriors; a wall painting from the palace of Pylos. (Reconstruction by Piet de Jong).

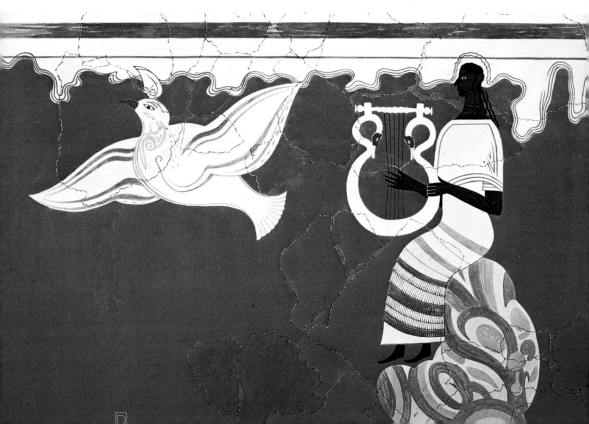

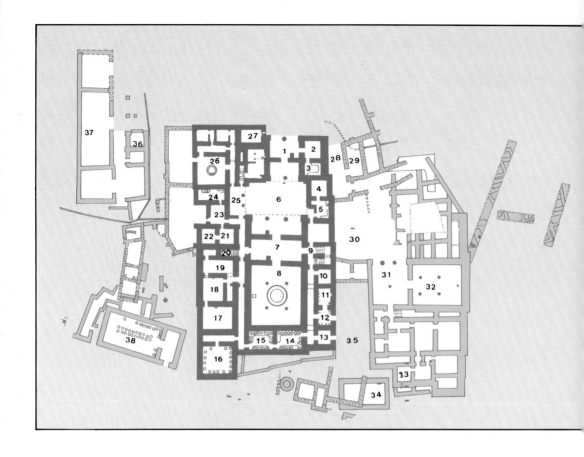

PLAN OF THE PALACE OF ENGLIANOS

1. Entrance (Propylon)
2. Rooms where the tablets were found
4. Store-room
5. Waiting-room
6. Court
7. Stoa
8. Megaron
9. Staircase
10, 11, 12. Store-rooms
13, 14, 15, 16. Store-rooms with the oil-jars
17, 18, 19. Store-rooms
20. Staircase
21, 22, 23. Waiting-rooms
24. Bathroom

25. Stoa
26. Apartment of the Queen
27. Guard-room
28. Sloping ramp
29. Store-room
30. Court
31. Propylon
32. Megaron
33. Bathroom
34. Store-room for wine
35. Court
36. Shrine
37. Workshop for chariots and weapons
38. Store-room for wine

170

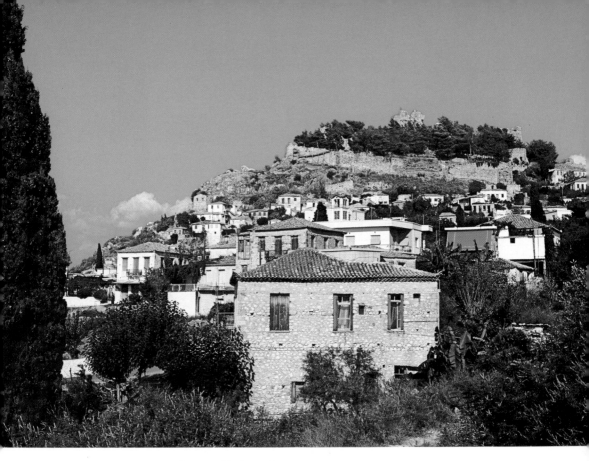

137. The town of Kyparissia dominated by its castle.

Proti, which has an ancient wall. North of Gargaliani is the town of Filiatra and its harbour of Agia Kyriaki, built on an ancient site.

Kyparissia, the next town north, is today one of the three most important towns of western Messenia. Little is known about its ancient history. Mycenaean remains have been found in the area (at the villages of Mouriatada and Peristeria), but its history becomes clearer from the Hellenistic period. The remains of various structures brought to light by excavation suggest prosperity during the years of Macedonian and Roman rule. Traces of old harbour works are to be seen on the shore; a special tax on all merchandise passing through the port of Kyparissia - imported or exported - was levied in the Hellenistic period for their maintenance. On the hill, where in antiquity the acropolis stood, are the remains of the medieval castle of Arcadia, as the town was known to the Byzantines, because it was the refuge for many Arcadians at the start of the invasion of the barbarian hordes, especially the Slavs. Much of the material used in its construction came from the older acropolis. In 1205 the Franks captured the castle and repaired its defences. Later it passed briefly to the Venetians, to Thomas Palaeologos in 1459 and to Mohamet II in 1460. From 1715 to 1718 it passed back to the Venetians and from then until the War of Independence it was held by the Turks. The city, destroyed by Ibrahim, was then re-built and reverted to its older name.

171

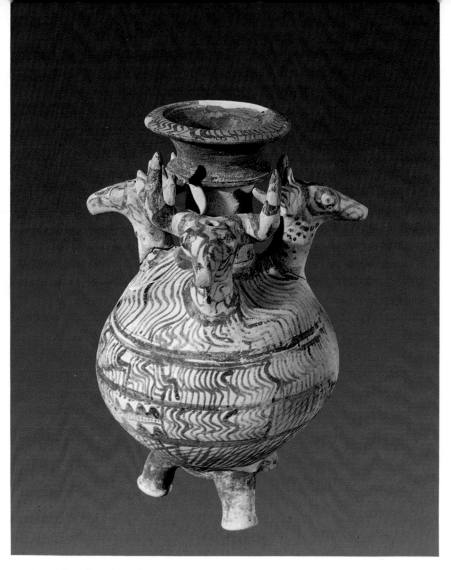

138. Ritual three-footed vase bearing the heads of three animals and painted decoration (Museum of Chora).

THE MUSEUM OF CHORA

In the village of Chora, about 4 kms. north-east of the palace, is a museum which contains some of the many finds both from the palace and from the graves discovered in this area. Examples of pottery from successive periods, and small finds of bronze and gold are to be seen in the cases. Most impressive are the grave goods found in the tholos tomb at Peristeria: gold jewellery, nautilus shells, butterflies and other objects. The second room is devoted to the moveable finds from the palace, and includes the frescoes restored and reconstructed by Professor Blegen's collaborator Piet de Jong, who also executed the reconstruction drawings of the palace. The subjects of the frescoes are impressively realistic and dramatic.

Plaster casts of the clay tablets, the originals of which are in the National Archaeological Museum of Athens, are also on display.

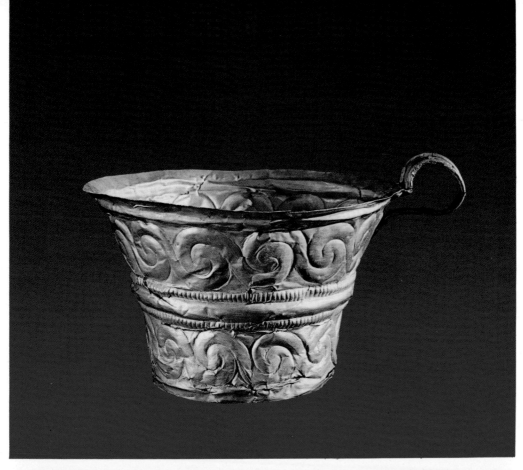

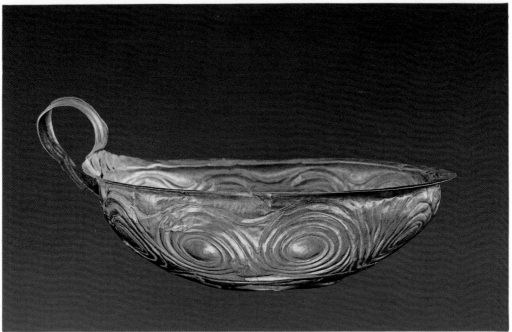

139-140. Mycenaean gold cups from tombs at Peristeria.

173

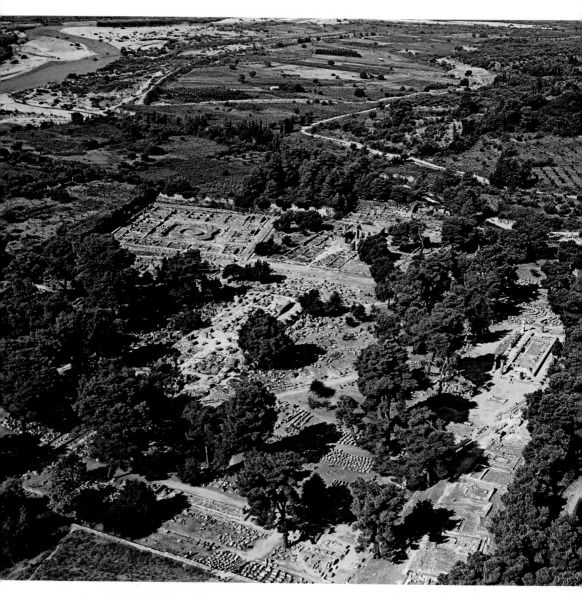

141. Aerial view of the monuments in the Altis. High up on the left is the Leonidaion, lower down the temple of Zeus and on the right the Heraion.

ELIS

The western side of the Peloponnese is occupied by the region of Elis; it lies between Messenia to the south, Arcadia to the east and Achaea to the north. To the west is the Ionian sea.

Recent excavations have shown that the history of Elis is a cross-section of Greek history. It starts in Paleolithic times with sites at Amaliada and Kyllene; during the Mycenaean period, although a large number of cemeteries have been excavated - Samiko, Kakovatos and those on the banks of the river Alpheos, - there seem to have been no important owns. The history of Elis, then, is to be found only in mythology. As Pausanias tells, it, the first king of the region was Aethlios, son of Zeus and Protogeneia. He was succeeded by his son Endymion and his grandson Epeios, after whom the people of the region were for a time known as *Epeians*. However, later when Epeios' cousin Eleios, became king, both land and people took his name Eleia and the Eleians and this name has remained in use ever since.

The destruction of the Mycenaean centres by the invasions of the Dorians resulted in permanent Dorian settlement on the plain of Elis. The town of Elis developed in historic times, and participated actively in the various quarrels which broke out, sometimes as the ally, sometimes as the enemy of Sparta. The final breach with Sparta was precipitated chiefly because in 471 B.C. the Eleans adopted a democratic form of government and in consequence declined to bear any part of the expenses of the Peloponnesian War. Instead, they became the allies of Argos.

In 399 B.C. the Spartans ravaged the area, and destroyed the Elean fleet. The Eleans, however, were not deterred from continuing their opposition to Sparta. In the war of 368 B.C. they threw in their lot with the Thebans and, victorious, put an end to Spartan supremacy. A little later, however, they again sided with the Spartans allied to the Achaeans against the Thebans at the battle of Mantinea in 362 B.C. By

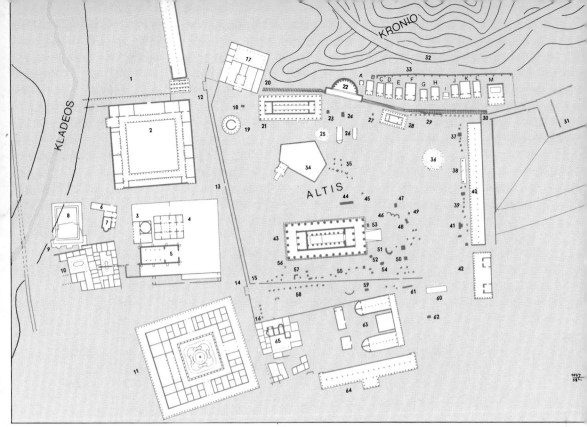

PLAN OF THE SANCTUARY OF OLYMPIA

1. Gymnasium
2. Palaestra
3. "Heroon"
4. Theokoleon
5. Christian basilica, the workshop of Phidias
6, 7, 8, 9. Baths of the Hellenistic and Roman periods
10. Hostels of the Roman periods.
11. Leonidaion
12. Propylon
13. Little entrance
14. Propylon
15. The exit of the earlier enclosure to the south
16. Entrance to the sanctuary
17. Prytaneion of the Eleans
18. Altar
19. Philippieion
20. Gaion
21. Heraion
22. Nymphaeum of Herodes Atticus
23, 24. Altars
25. Altar to Zeus (?)
26. Prehistoric houses
27. Altar
28. Metroon
29. Zanes
30. Entrance to the stadium
31. Stadium
32. To the villages Miraka and Arcadia
33. North wall
34. Pelopion
35. Statue bases
36. Hippodameion (?)

37. Statue bases
38. Monument of Ptolemy II and Arsinoe
39. Statue bases
40. Stoa of Echo, the painted stoa
41. Great Altar
42. South dwellings
43. Temple of Zeus
44. Offering of Mikythos
45. Base of Dropion
46. Base of the Eleans
47. Base of Zeus
48. Base of the statue of the Bull of the Eretrians
49. Altar.
50. Base of the Victory of Paionios
51. Offering of the Achaeans
52. Altar of Zeus of the Lacaedemonians
53. Base of Zeus of Mummius
54. Base of the statue of Zeus
55. Bases of offerings
56. Probable position of the olive tree whose branches were used to crown the victors.
57, 58. Bases of offerings
59. Altar
60. Processional entrance
61. Base of the offering of Mummius
62. Altar
63. Bouleuterion
64. Stoa
65. Baths

A. Temple of Eilythieia and Sosipolis
B-M. Treasuries

176

191 B.C. Elis had become a member of the Achaean League, having
by Philip V, ally of the Achaeans. In 146 B.C. the area passed under R
 Thereafter it ceased to play any significant role until the capture of
in A.D. 1204. When the Frankish forces of Willian Champlitte an
ehardouin, with the support of Boniface of Monferrat, King of Th
pleted the reduction of the western Peloponnese in 1210, the capita
lity of Achaea was established at Andravida in Elis. Successive internal struggles
the Franks resulted in the decline of the Principality which in 1433 was finally ac-
quired by Constantine Palaeologos.
 After repeated Turkish attacks against this rich region its conquest was finally
achieved in 1452 by the general Tourahan. With only a brief spell of Venetian over-
lordship, the Turks retained the region until 1828.
 The modern capital of the nome is **Pirgos** which takes its name from the tower
(*pirgos*) built by John Tsernotas between 1512 and 1520. Its harbour was Katakolon,
where in the sea in the area near Agios Andreas are the remains of *ancient Pheia*.

OLYMPIA

 A road east from Pirgos leads to **Olympia**. The modern village lies close to the
ancient site and the sanctuary of the Altis - i.e. the walled enclosure where the
sacred buildings and ex-voto monumental offerings stood. Excavation shows habi-
tation in the area from prehistoric times. Remains of houses and even of graves have
been found within its bounds, dated to the Middle Helladic period (1900 - 1600 B.C.).
At this time, on the slopes of Mt. Kronion to the north of the sanctuary various
divinities were worshipped, the most important being Gaia, the Earth. In mythology,
the area was said to belong to the Pisaians, ruled by Oinomaos, whose daughter
Hippodameia married Pelops, won by him as a prize in a chariot race. Pelops - after
whom the entire Peloponnese was later called - was amongst the divinities worship-
ped here. His temple, the Pelopeion, is the oldest sacred building within the Altis.
 Although a variety of finds of Mycenaean date (vases, sherds) from tombs and
even a cemetery (below the modern museum) shows that the site flourished in the
Mycenaean period, its outstanding importance and fame were only acquired in the
historic period. With the settlement of the Dorians, changes were inevitable. The
worship of Zeus pre-dominated, and to him the Olympic Games were dedicated.
There is no agreement as to when the Games began, but the official era of the
Olympiads dates from 776 B.C. when Iphitos, king of the Eleans, re-organised the
contests and laid down that they should be held every four years. By 600 B.C. the
sanctuary had become the resplendent centre of the Greek world. From the middle
of the fifth until the fourth century B.C. the fame and popularity of the sanctuary was
at its height. To this period belong most of its buildings. But from the fourth century
B.C. the power and influence of the shrine began to wane, affecting even the sacred
character of the games, which gradually became more and more professional.
 The advent of the Romans ensured the continuation of this decline. In 74 B.C.

*142. Reconstruction drawing of the buildings and statues in the Altis in the Roman period. In the
centre is the Temple of Zeus.* ▶

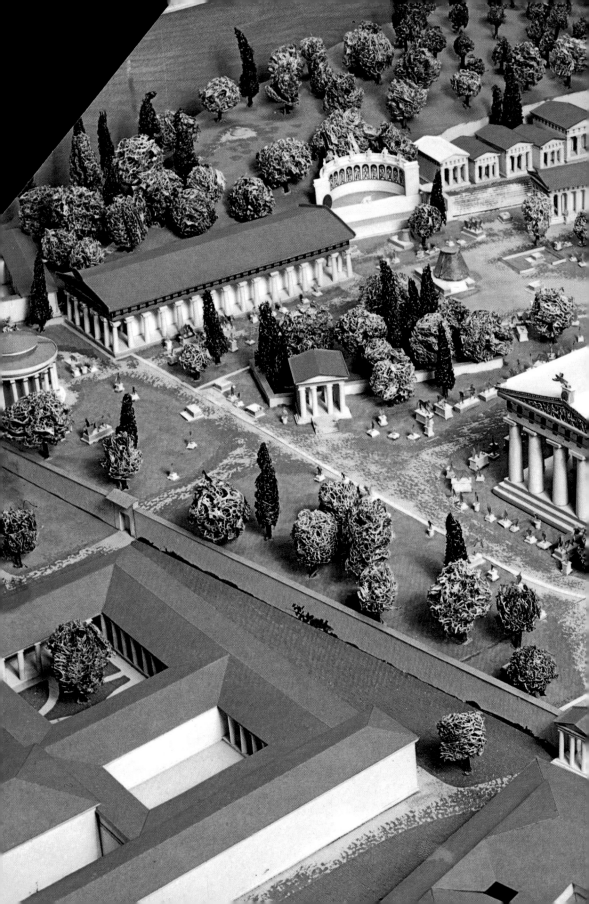

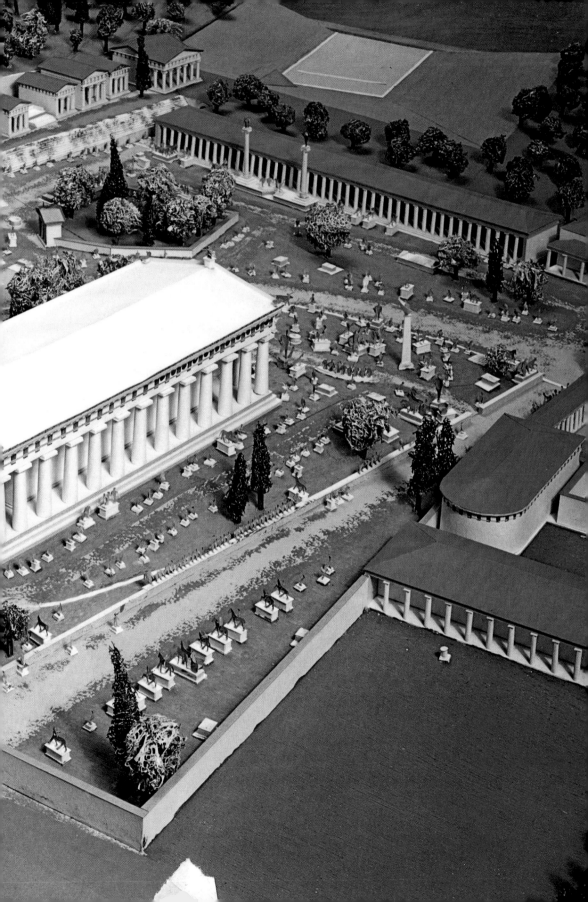

Sulla plundered the shrine while a century later the Emperor Nero took many of the offerings to Rome, built a villa within the Altis and took part in the Olympics of A.D. 67 when he was declared a winner six times. A brief recovery is to be noted in the reign of the Emperor Hadrian (A.D. 117-138), but all political and religious importance was brought to an end with the beginning of the barbarian invasions. In A.D. 267 the Heruleans made a catastrophic attack on the sanctuary. In an attempt to protect the temple of Zeus and his cult statue many other buildings were pulled down to provide material for defensive walls around the precinct. In A.D. 393 a decree of Theodosius the Great abolished the Games. A few years later, the statue of Zeus was transported to Constantinople where it was later destroyed by fire.

In A.D. 426 when a decree of Theodosius II ordered the destruction of the pagan temples and statues, the temple was set on fire and subsequently earthquakes levelled whatever remained. West of the Altis, and close to the river Cladeos an Early Christian basilica was erected amongst the ruins. Towards the end of the sixth, and all through the seventh century, Slavs established themselves, further impoverishing the region. Even the name was lost, and the two large rivers which flow close to the site, the Alpheos and the Cladeos, not only flooded, but changed their course, depositing silt some three to five metres deep and causing the disappearance of both site and name.

The first serious excavation was carried out by Abel Blouet and other members of the *Expédition scientifique de Morée* in 1829 which revealed the site of the temple of Zeus. Systematic excavation was undertaken by the German Institute of Archaeology between 1875 and 1881, when the Altis was explored. Renewed excavation took place from 1936 until 1942 and from 1952 excavation has been continuous.

As we have said, the Games were pan-hellenic and the contests open to all free Greeks.

The organisation and supervision of the Games, which lasted for five days, was the responsibility of the *hellanodices* - umpires. On the first day the competitions of the trumpeters and heralds and the boys' events were held; on the second, the *equestrian* events; on the third, the *pentathlon* and running; on the fourth wrestling, boxing, the *pangration* and the races between fully armed men; on the fifth and final day the prizes were awarded and the victors crowned with a wreath of the "kotinos" the branch of wild olive. The winners dedicated their offerings at the shrine, and many cities erected *"treasuries"* in which to house their offerings.

The sanctuary was entered from the north-west. To the left is the **Altis** (sacred precinct); on the right a row of buildings for the use of the athletes and others for the spectators. The Altis is enclosed by a wall to the west and south, erected in the fourth century B.C. A second enclosure wall was built in the Roman period, parallel with the first. Traces of both can still be seen. The Altis today is entered from the north-west corner, exactly opposite the monumental entrance to the Gymnasium. The first building on the left is the **Prytaneion of the Eleans**, a square building erected at the end of the sixth century B.C. which subsequently underwent additions and alterations in the fourth century B.C., Hellenistic and Roman times. One can today distinguish the central room, where a cult hearth was sited on which burnt the sacred flame of the Community of the Eleans. Double concentric foundations a little south of the Prytaneion were ascribed by Pausanias to the **Philippieion**. This circular building was erected by Philip II to commemorate the fall of Greece after the battle of Chaironea in 338 B.C. Because he did not live to finish it, it was completed by Alexander the Great. In the centre of the *sekos* on semi-circular plinths stood five gold and ivory statues, made by the sculptor Leochares. They represented Alexander, Philip, his father Amyntas, his mother Euridice, and Olympias, Philip's wife and mother of his son, Alexander.

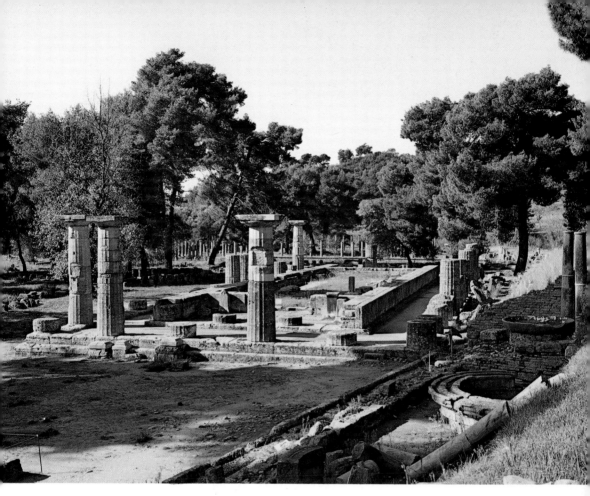

143. The re-erected columns of the Heraion, the oldest temple in the Altis. In the background is the Palaistra.

Immediately beyond the Philippeion are the ruins of the Doric peripteral **Temple of Hera**, (6 X 16) built around 600 B.C. to replace an earlier temple of the late eighth or mid seventh century B.C. which had been destroyed by fire. The suggestion that the columns of the temple were originally of wood, and were only gradually replaced in stone is based on the fact that they are not all identical. It seems probable, however, that the wooden architrave was never replaced in stone. The temple, con- sisting of *sekos, pronaos* and *opisthodomos*, was unusually long (50.01 m. and 18.76 m. broad). A large double door led from the *pronaos* to the *sekos*, which was divided into three aisles by two rows of four columns each. Inside stood the statue of Hera, seated on a throne, and of Zeus standing deside her, bearded and wearing a helmet, according to Pausanias' description. The *sekos* was further partitioned into bays to right and left; in one of these, the second on the right, the statue of Hermes holding the baby Dionysos was found. It is thought to have been made by Praxiteles. East of the Heraion are the foundations of two **altars**, one large, one small. To the south of these can be seen the foundations of two apsidal prehistoric houses, west of which is the large Temple of Zeus and south-west the **Pelopeion**, the sanctuary of Pelops. This stands on an embankment some two metres above ground level, and is enclosed by an irregular pentagonal wall pierced by a monumental entrance in the Doric style. North of the two altars of the Heraion, on the lower slopes of Mt. Kronion Herodes Atticus built a semi-circular **Nymphaeum** between A.D. 156 and 160. It was used as a reservoir for water which was piped to fountains elsewhere.

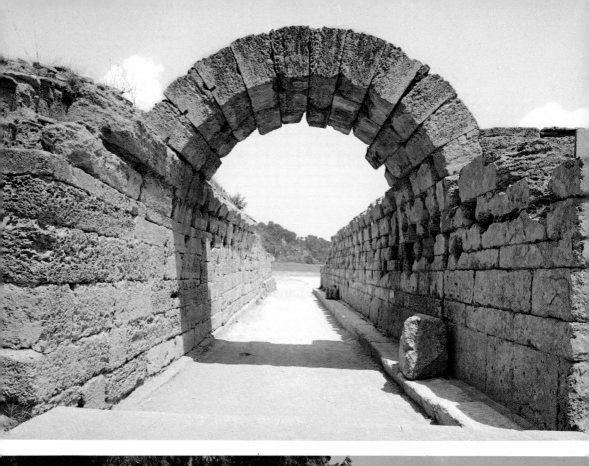

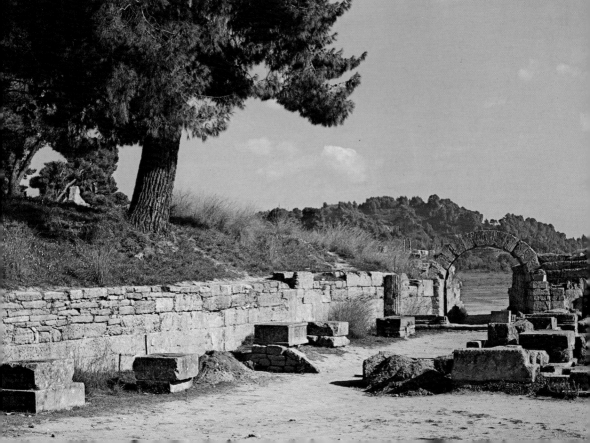

144. *The vaulted entrance, Krypte, which led to the Stadium.*

145. *The stone bases of the Zanes which were excavated in front of the platform of the Treasuries and by the entrance to the Stadium.*

146. *The Stadium of Olympia. 4th century B.C.*

East of the Nymphaeum stood a **temple** where Eilythieia and her son Sosipolis were worshipped. Immediately beyond, on a flat piece of ground on the slopes of Mt. Kronion, but at different levels, stood the "treasuries". These were small square buildings resembling temples, with two columns in antis on the facade. Built during the sixth and fifth centuries B.C., their purpose was to house the sometimes very valuable offerings made by cities to the shrine. The first of the treasuries, built in the 6th and 5th centuries, is the that of the Sicyonians. The others have not been identified with certainty.

Immediately in front of the terrace are sixteen pedestals on which stood bronze statues of Zeus, called the **Zanes**, paid for by fines imposed on athletes who cheated in the Games. A little further south are the ruins of the **Metroon**, a small Doric peripteral temple (6 X 11) with *prodomos* and *opisthodomos*. It was roofed with tiles placed above wooden beams and had a stone architrave and frieze. It was built at the beginning of the fourth century B.C. and dedicated to the Mother of the Gods. During the raids of the Heruleans in A.D. 267 it was one of the buildings whose material was used for the construction of defences. In the Roman period it had been consecrated to the worship of Augustus and then to successive Caesars. To the south-east of the Metroon there was probably a **temple of Hippodameia**. Plinths on which offerings stood are preserved, the most important statue being that of Ptolemy II and Arsinoe. Behind the pedestals was the **Stoa of the Echo**, which also marked the eastern boundary of the Altis. It was built in the fourth century B.C. with an external

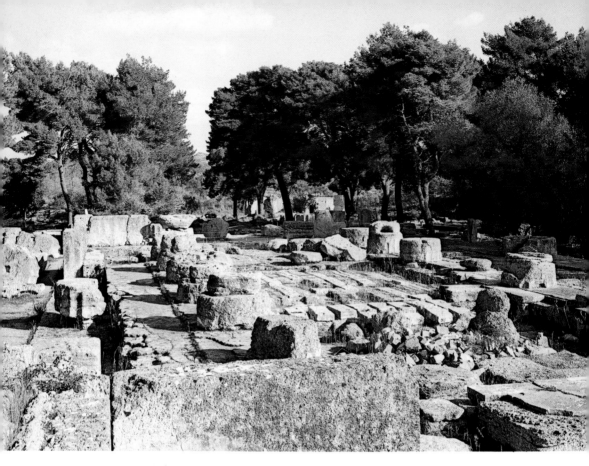

147. The platform of the Temple of Zeus of Olympia, the work of the architect Libon.

colonnade of forty-four columns. On its inner (back) wall were paintings, and hence it was called "poikile" - painted.

An extension of the Stoa towards the south-east represents the foundations of a large complex which originally in the fifth century B.C. was the sanctuary of the sacred hearth or the **Prytaneion** of the Pisaians. In the Hellenistic period it was used to provide accommodation for the officials connected with the Games. In the Roman period the entire complex was covered over by the rooms and large courtyard of the so-called Villa of Nero and later, in the third century A.D. a bath house was constructed.

The back of the stoa of the Echo was used as an embankment for the **Stadium** whose original plan, laid out in the mid sixth century B.C., has remained unchanged by the alterations carried out in the Hellenistic and imperial Roman periods. The total length of the track of the Stadium is 212.17 m.; from the starting point to the finishing point 192.27 m. - the Olympic Stadium.

Spectators watched the Games from artificially created earth banks. In the second century five rows of wooden benches were added in front of the **altar of Demeter Chamyne** on the northern side of the stadium. A temple dedicated to Demeter stood a little way away. Opposite the altar is the *exedra* of the umpires. It was a low platform supporting a single row of wooden seats. Eight rows of stone benches replaced the wooden single row in Hellenistic and Roman years. The Stadium today is entered by a vaulted tunnel which in antiquity was used only by the umpires and contestants. An impressive monumental gateway faced towards the Altis: today only its sill, column bases and threshold remain.

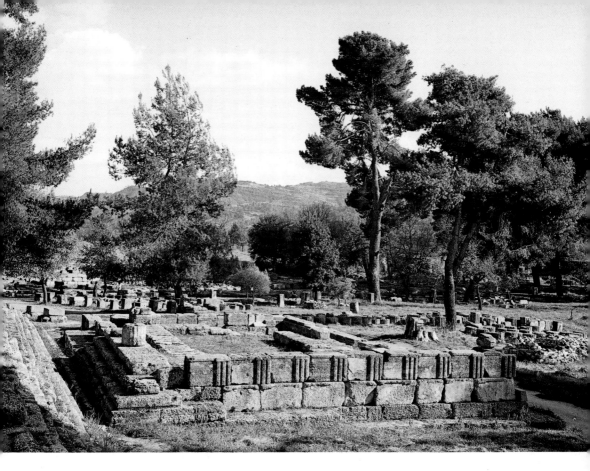

148. The Metroon, built to the east of the Heraion in the 4th century B.C.

Returning to the Altis and progressing westwards one comes to a row of bases for marble or bronze statues, offerings made by cities. The area is dominated by the large **temple of Zeus**, built *c.* 472 B.C. from the spoils taken by the Eleans in their war against their neighbours, the Pisaians and Triphylians. The Doric peripteral temple (6 X 13) measures 64.12 X 27.60 m. and was built of shelly conglomerate. Both *pronaos* and *opisthodomos* had two columns *in antis*. Because of the great height of the raised foundation platform (3 m.) the temple was entered by a ramp on the eastern side. The sculptured decoration was of Paros marble, while Pentelic marble was employed when three of the figures on the western pediment were later replaced.

Six of the Labours of Heracles are represented on the metopes of the *pronaos*, six on those of the *opisthodomos*. The metopes on the side, however, remained unworked, and it was from these that, later, Mummius hung twenty-one bronze shields (ten on the east and eleven on south). A gilded figure of Victory was the central *acroterion* on the eastern pediment on the base of which the Spartans hung a gold shield presented as a thank-offering after the victory of Tanagra in 457 B.C. The corner *acroteria* were tripods with gold cauldrons. The sculpture of the eastern pediment depicts the preparations for the chariot race between Pelops and Oinomaos; its central figure was the impressive figure of Zeus Orthios. The western pediment portrayed the War of the Centaurs, its central figure being Apollo. The interior of the *sekos* was divided into three aisles by a double row of seven columns aside. A gallery above the aisles afforded a view of the chryselephantine statue of Zeus, the work of Pheidias, which stood on a pedestal surrounded by a railing. Zeus, seated on a

185

throne of bronze and ebony, held in his right hand a winged victory made of gold, and in his left a sceptre surmounted by an eagle. The statue was set with precious stones and painted; the drapery was sculptured. He was crowned with an olive branch.

South-west of the temple, beyond the many bases for offerings, one passes outside the enclosure wall of the Altis through the impressive Roman monumental gateway. To the west are the foundations of various structures. The first of these, the **Bouleu-terion**, is a building erected piecemeal, consisting of two similar narrow wings with apsidal ends linked by a corridor on their eastern side. The northern wing is dated to the middle of the sixth century B.C., the southern to the fifth century B.C. Between them lay a square space, probably unroofed, where it is likely that the statue of Zeus Orkios was erected. The colonnade, or corridor, with twenty-seven Ionic columns was added in the Hellenistic period on the eastern side, completing the Bouleuterion as we see it now. It was the seat of the parliament of the Eleans and the place where, in the presence of the umpires, competitors swore to observe the rules of the con-tests. The foundations which are seen to the south belong to the so-called South Portico, built in the fourth century B.C. In front of it passed the road which led from Elis to the Hippodrome south of the Stadium. To the north of the Portico and west of the Bouleuterion are the foundations of two rectangular buildings whose function is unknown. The ruins further west still belong to houses and baths of the late

149. *The foundations of the impressive guest house known as the Leonidaion at Olympia.*

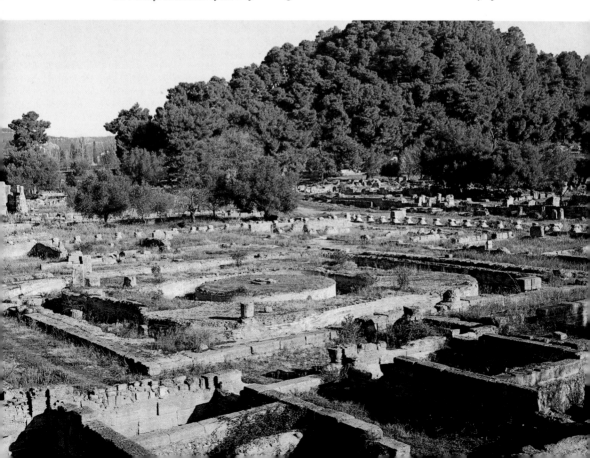

Roman period. In the south-west angle of the enclosure wall are the foundations of a Roman monumental gate.

Opposite this gate are the ruins of the large building called the **Leonidaion** after its founder and architect, the Naxian Leonides. The inscription cut on the architrave of the outer colonnade reads "Leonides (son) of Leotos, from Naxos made me". The square structure measures 80.18 X 73.51 m. and was built in the mid fourth century B.C. to provide accommodation for official visitors to the Olympic Games. Externally its four sides were colonnaded (138 columns in all) while inside it was divided into rooms opening off a large central court. In Roman times the court was converted into an artifical lake and garden. The buildings to the north are part of an Early Christian three-aisled apsed basilica, with narthex and two service rooms on the west side of a small porch on the south side of the narthex.

The church was erected in the fifth century A.D. on top of the foundations of an earlier building which excavation has shown to have been the workshop of Pheidias in the years 430-420 B.C. The various sherds, small slivers of ivory, bone and semi-precious stones and tools of the goldsmith's trade indicate that it was here that the famous chryselephantine statue of Zeus was fashioned. The finds also included a small clay *oinochoe* engraved with the name «Pheidias». North of the workshop are the foundations of two buildings: the eastern is the so-called **Theokoleon**, a square structure perhaps dateable to the mid fourth century B.C., which was used as the

150. The three-aisled Early Christian basilica which was built in the ruins of the workshop of Phidias.

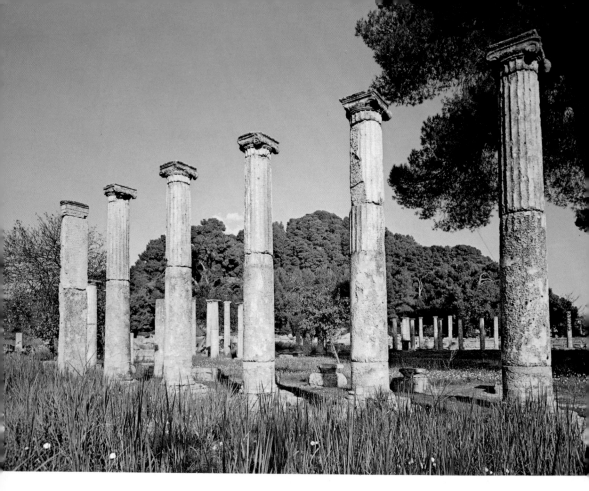

151. The re-erected columns of the Palaestra which dates from the Hellenistic period.

residence of the priests and officials who served at Olympia. The building was enlarged from time to time, and in the Roman period it acquired a peristyle court and many new rooms on its eastern side. The building to the west was part of a so-called **Heroon**, a rotunda placed within a rectangular court with an entrance on the west; it was originally used as a bath-house, and later, in Hellenistic and Roman times, for the worship of some unknown hero.

Further west of these structures are the foundations of two guest-houses of the Roman period, the **Cladeos Baths**, and further north an earlier complex of baths of the fifth century B.C.

The re-erected columns to the north-west are part of the **Palaestra** and the **Gymnasium**. The Palaestra was a square enclosure (66.75 X 66.35 m.) with a square internal peristyle court and Doric colonnades. Doors opened off the colonnades into the dressing rooms, waiting rooms and practice rooms for the athletes. The Palaestra also served as a place for the discussions of rhetoricians and philosophers. In the north-west corner a monumental gate with Doric columns marked the main entrance to the Palaestra. Of the Gymnasium only the colonnades on the eastern and southern sides have been excavated.

152. The gymnasium, built in the 2nd century B.C., as it appears today. In the background is the Palaestra.

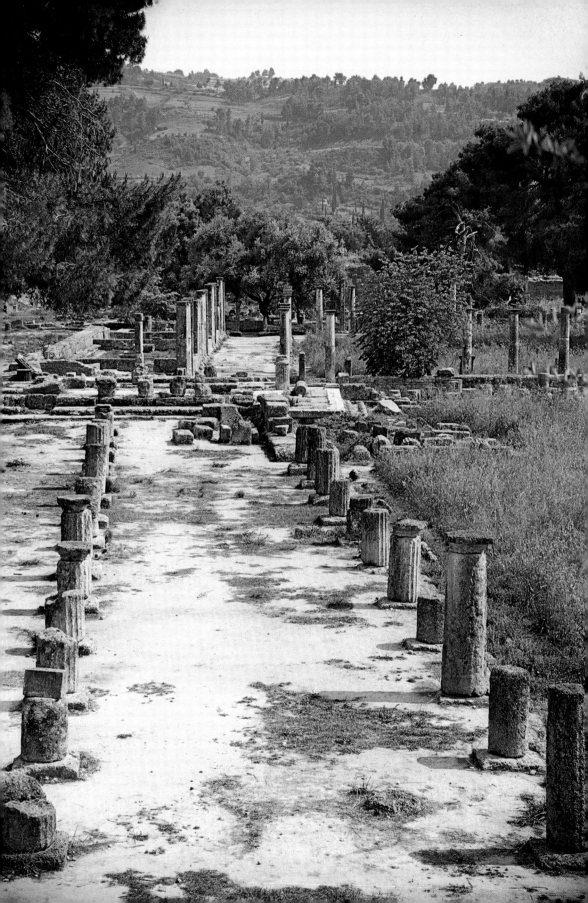

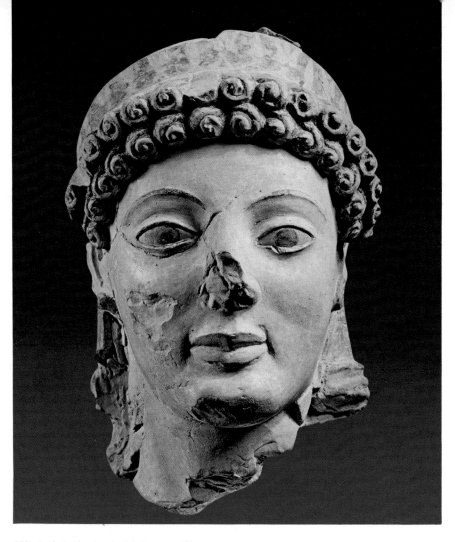

153. Archaic clay head of Athena. c. 490 B.C.

THE MUSEUMS OF OLYMPIA

The new museum of Olympia, built opposite the site, displays finds from the area, arranged in chronological sequence. There are vases from the Neolithic, Mycenaean and Archaic periods: clay and bronze statuettes of the Geometric and Archaic years and bronze offerings to the shrine including weapons and metal plates with rich hammered decoration. Pieces of special distinction include the colossal stone head from the statue of Hera, fragments of the terracotta decoration of the Heraion, the helmet of Miltiades with its dedication to Zeus, the terracotta group of Zeus seizing Ganymede (470 B.C.) and the head and fragments of the figure of Athena from a Gigantonachy.

154. The striking terracotta group of Zeus and Ganymede. In most places the colours have been well preserved. c. 470 B.C.

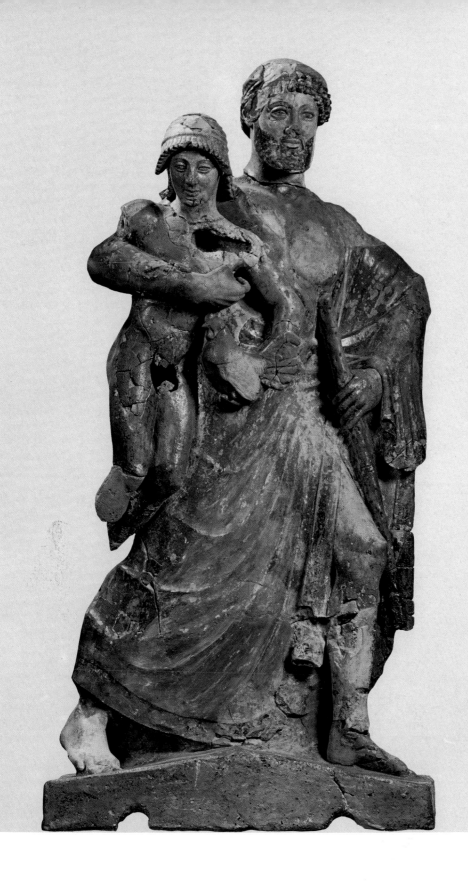

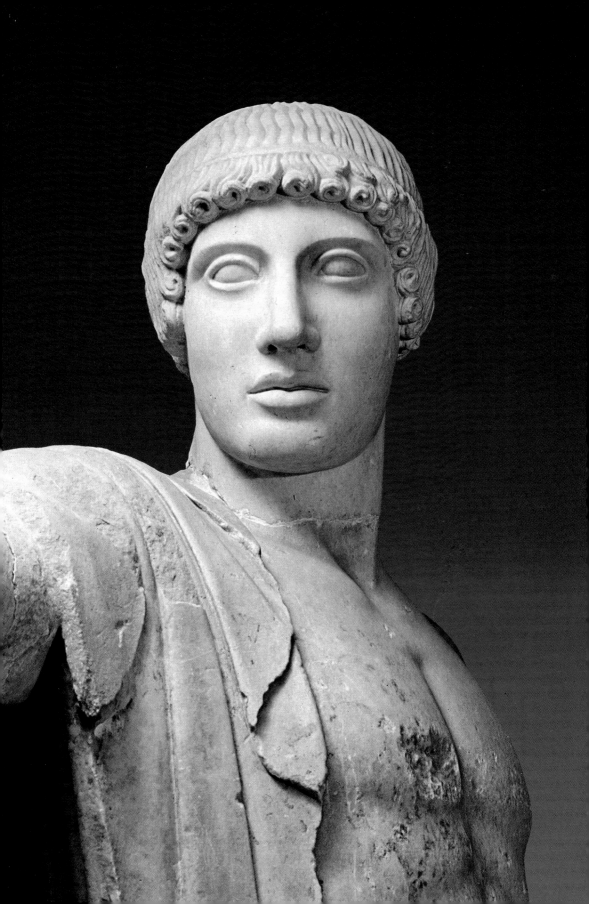

155. Apollo, the central figure of the western pediment of the Temple of Zeus.

156. Hermes with the infant Dionysos, a work of Praxiteles found in the Temple of Hera. c. 330 B.C.

The surviving parts of the sculptured compositions from the Temple of Zeus are one of the most important creations of Archaic art. The east pediment depicted the preparations for the chariot race between Oinomaos, king of Pisa, and Pelops, betrothed to his daughter. The central figure is Zeus, and left and right the other characters in the story, while the outer edge of the composition is closed by the allegorical representation of the two rivers, Alpheos and Cladeos. The subject of the western pediment was the War between the Lapiths and Centaurs; the central figure is Apollo and on his right Theseus, on his left Peirithos: reclining figures of Lapiths and Centaurs at the edges of the pediment follow the struggle.

Many fragments of the metopes which divided *pronaos* and *opisthodomos* are today in the Louvre Museum, Paris. Their theme was the Labours of Heracles. Of the fragments to be seen at Olympia the best preserved are those showing the Lion of Nemea, the Bull of Crete, the Stymphalian Birds which Heracles is offering to Athena, Heracles receiving from Atlas the Apple of the Hesperides and the Cleansing of the Augean Stables.

The most impressive exhibit is in room 7, which contains the marble statue of Hermes holding the baby Dionysos. It is the work of Praxiteles, and was found in 1877 at the same spot where Pausanias had seen it in the *sekos* of the Heraion (on the right as you enter). The statue is dated to 330 B.C. and represents Hermes, nude, standing erect on a base, and holding by his left hand the young Dionysos. It is assumed that it represents Hermes on his journey to the mythical country of Nusa where he would hand Dionysos over to the care of the nymphs. The work is characterised by its sense of movement, its expressiveness and the sweetness of the face with its dreamy expression, elements which plead strongly for its being an original work of Praxiteles.

A series of portrait statues of Roman emperors and generals together with a marble bull inscribed with the name of the donor, Regilla, wife of Herodes Atticus, are to be seen in the next room.

In the museum of Olympia one may see some of the finds from the workshop of Pheidias, and the marble statue of the Victory of Paeonios which was found southeast of the Temple of Zeus. This Victory, in Parian marble, was erected on a triangular base of twelve recessed courses which bore an inscription in the Doric dialect. It is dated to *c.* 421 B.C. and represents the figure as though it were floating through the air. On the base of the Victory there was also a dedicatory inscription of the Messenians of Naupaktos of *c.* 135 B.C.

In the new building of the **Museum of the Olympic Games** is a collection of commemorative items from modern Olympics and the only complete collection in the world of stamps issued for the Olympic Games. Modern athletic installations of the International Academy are to be found on the road which leads to Tripolis, a little beyond the ancient Stadium. In the same direction, at Frangonisi, is the Roman cemetery of Olympia. At Lala, fifteen kms. further on, the Greeks defeated the united Turkish and Albanian forces in 1821.

157-158. Bronze helmets of Illyrian type of the 6th century B.C. The first is decorated with three silver figures on the brow and a silver rider on the cheek-pieces. The second bears the heads of rams on the cheek-pieces.

159. The helmet of Miltiades. According to the inscription it was dedicated to Zeus after the battle of Marathon, 490 B.C.

Some 18 kms. south of Pyrgos is **Krestena** thought by many to be the site of ancient Scillus, where Xenophon lived in exile on an estate presented to him by the Spartans.

Remains of ancient installations are preserved a little further south at Makrysia. From Krestena, a turning off the road to Andritsaina leads to Scillountia where there is a cemetery of the late Classical period, and on the summit of the hill the ruins of a Doric peripteral temple of the fourth century B.C., perhaps dedicated to Athena Scillountia.

Following the main road to Andritsaina we come to **Platiana** (19 kms.) where the remains of a fortified town are preserved, which many scholars identify with Aepion. The last site before arriving at Andritsaina is **Aleifira**, with the remains of an ancient city on a hill (the Castle of Nerovitsa).

The old houses and cobbled lanes of **Andritsaina** preserve the atmosphere of bygone times. Here, it is worthwhile visiting the library which contains many rare books and a display of documents relating to the War of Independence. A small vitrine contains finds from the vicinity (vases, statuettes, coins, bronze objects and sculptured fragments). From Andritsaina the road south-west brings one to the **Temple of Apollo Epikourios** at Bassae. This temple, the work of Iktinos, is dated to c. 420 B.C. and was built over an older temple by the inhabitants of Phygalia to thank Apollo for everting sickness.

The temple, which is the most fully preserved in Greece (excepting only the Theseion in Athens) is built of local limestone in the Doric peripteral style. At the level of the stylobate it measured 38.25 X 14.60 m. The *pronaos* has two Doric columns *in antis*, a *sekos* and *opisthodomos* also with two Doric columns *in antis*. Unusually for a Greek temple, it is oriented north-south, probably because of the slope of the ground. It was entered from the north. The *sekos* was divided into an elongated front section and a smaller inner sanctum or adyton; on both sides of the front section five Ionic half-columns marked the termination of buttresses projecting from the long side walls, and creating a series of recesses. On the axis of the *sekos*, between the innermost buttresses, set diagonally, stood a single Corinthian column. Above it was an entablature which continued all round the *sekos* above the half-columns and it incorporated a frieze depicting scenes from an Amazonomachy (battle between Amazons and men) and a Centauromachy (battle of Lapiths and Centaurs). Much of the sculpture is now in the British Museum. It is thought that the cult statue stood in the inner section of the *sekos*, against the west wall and facing a special entrance in the east wall. Others maintain that it stood in front of the Corinthian column, facing the entrance to the north.

North-west of the temple a path leads to the summit of Mt. Kotyli, where the foundations of two small temples of Artemis and Aphrodite can be seen. From the Temple of Apollo a bad road leads to Upper Phigaleia, the site of ancient Phigaleia.

Continuing west one may see in the village of Lower Phigaleia a three-aisled Byzantine basilica, and a little further on, visit the ruins of the ancient city of **Lepreon** in the modern village of the same name. The ancient and medieval fortifications of the citadel and the ruins of a Doric temple to Demeter remain. From Lepreon, a side turn brings one to the Mycenaean chamber tombs of Kakovatos (9 kms.), the finds from which are in the National Archaeological Museum of Athens. Beyond the tombs, following the main road north, one reaches the medicinal baths of **Kaiapha**, with its spring of sulphurous water in the cave of the Angrides, nymphs of antiquity.

160. The Temple of the Epicurean Apollo at Bassae.

Mythology has it that it was here that the Centaur Nessos bathed his wounds when pierced by the poisoned arrow shot by Heracles; to this action the offensive odour of the waters is atributed.

To the north, above the lake formed by these waters, were the walls of ancient *Samia*. The cyclopean remains on the hill towards the sea are thought to belong to ancient Arene. Finally, at *Epitalion* one may see the ruins of the Hellenistic and Roman city.

Returning to Pirgos and taking the road north one may then fork left after three kms. to visit the monastery of *Skafidia* with its imposing Venetian tower. Of the towns on either side of the road to Patras, *Amalias* is entirely new, built in the middle of the nineteenth century. North of Amalias a side road to the right leads to the ruins of ancient **Elis** close to the villages of Paleopolis and Kalyvia. Elis, one of

161. The picturesque lake of Kaiapha.

the most important and interesting centres of the Peloponnese in antiquity, reached a peak of prosperity in the Roman period, at which time a large number of buildings were constructed, especially athletic installations, because athletes regularly gathered at Elis for the required month's training before the Olympic Games. Today two colonnades represent the remains of the buildings in the ancient agora that formed part of the gymnasium. Parts of the skene of the theatre are also visible, and of the auditorium and the two entrance passages to the orchestra, as well as the remains of buildings and a cemetery that were in use in the 4th c. One kilometer further on there is a section of the city wall, which was built in 312 B.C.; until that time Elis had remained unfortified because of the sacred truce that was in effect during the period of the Games.

10 kms. after returning to the main road to Patras one arrives at **Gastouni** (derived from the French "Gastogne") an important centre during the Frankish Occupation. From here one road north leads to Andravida, another west to Kyllene. Andravida (Andreville), capital of the Principality of the Morea, retains nothing of its medieval splendour except for part of the thirteenth century church of Agia Sophia.

Kyllene, the port of Elis in antiquity, was known during the Frankish occupation as

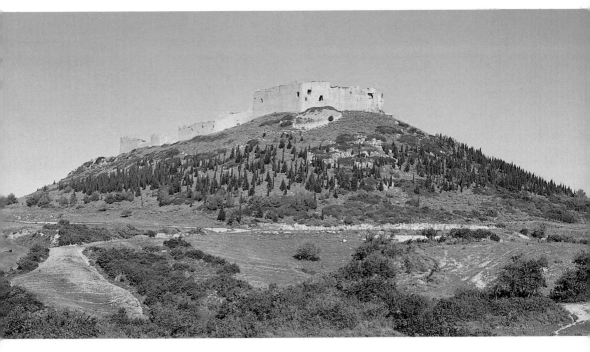

162. The impressive castle of Chlemoutsi as it appears today.

Glarentza (from Clarence) and was the chief port of the Principality of Achaia. Constantine Paleologos claimed it as part of the dowry of his wife, Theodora, captured it and destroyed it in 1430 so that the traces of its prosperity are slight. But as the ruins of the castle gradually fall into the sea, they have brought to light sherds which bear witness to the habitation of the area in the prehistoric era.

Six kms. north of the present village of Loutra Kyllene the Franks sited their fortress of **Chlemoutsi**, on a hill which had also been a prehistoric settlement. The castle, built by Geoffrey I Villehardouin in 1220 was called Chateau Tournois by the Franks. Later, the Venetians who captured it in 1687 changed its name to Castel Tornese. The castle occupied a strategic position, not only commanding the hinterland, the plain of Glarentza, but also commanding the sea approaches to the islands opposite (Cephallonia, Ithaca, Zakynthos and Leucas) and the shores of Aitolia and Acarnania. It was the most imposing and important castle in the Principality of Achaia, and today is one of the best preserved. It consists of two fortified enceintes (an outer and an inner) with an entrance on the north-west side. Its vaulted galleries underwent alterations by the Turks. Narrow posterns pierced the east and south walls. A hexagonal keep dominates the inner enclosure. A mint functioned within the castle, producing Tournai coinage.

Beyond Andravida the road continues northwards to **Lechaina** (13 kms. from Kyll-ene) and Old Manolada, an important centre during the Frankish occupation. From here the road leads to Kounoupeli, where on a headland are medieval remains and traces of a Mycenaean acropolis which has been identified with Homeric Hyrmine.

163. The ruins of ancient Elis.

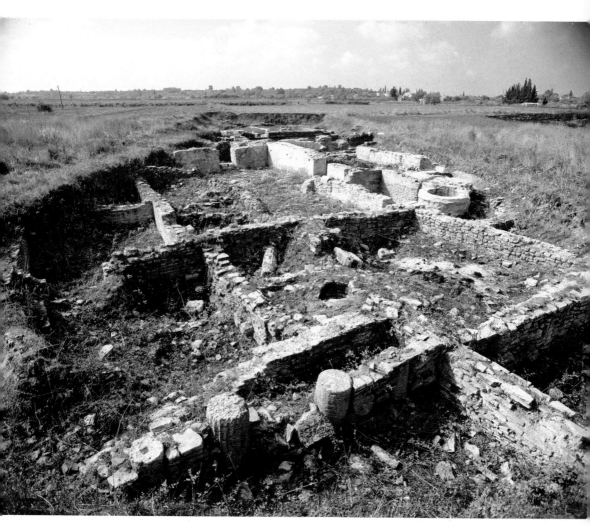

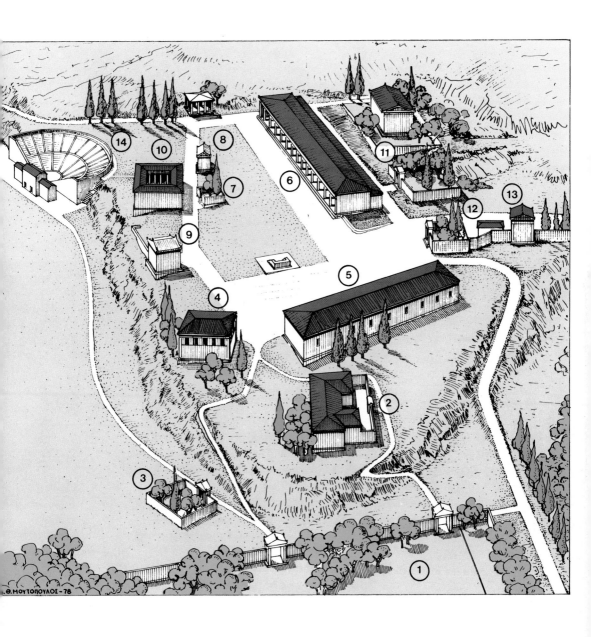

164. *Reconstruction drawing of the buildings of the agora at Elis.*

1. *Gymnasium; 2. Baths; 3. Temenos of Achilles; 4. Hellanodikaion (?) 5. South facing Stoa;*
6. *Corcyrian Stoa or double stoa; 7,8,9. Shrines; 10. Square building; 11. The sanctuaries of*
Aphrodite; 12-13. Wall of a shrine, small temple and sanctuaries 14. Theatre.

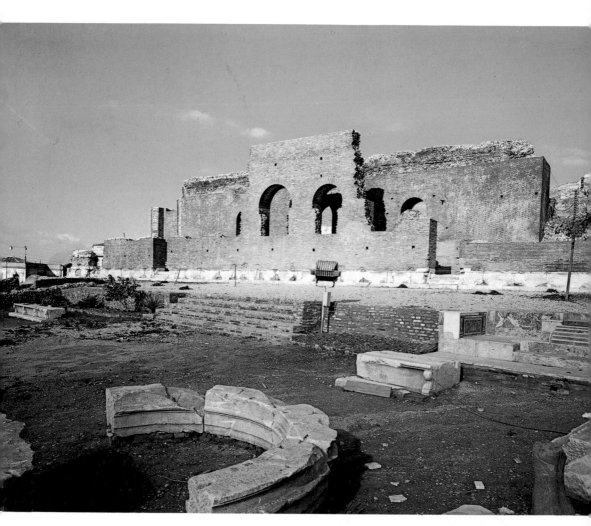

165. The Odeon at Patras.

ACHAEA

Achaea, which occupies the north-west part of the Peloponnese, is a mountainous region with a very old history. Around Araxos excavation has provided evidence for the habitation of the area from the Paleolithic Age. Excavations elsewhere on the coastal strip from Araxos to Aigion, at Kalavryta and on the plateaus of Mts. Panachaichon and Eurymanthus indicate the existence of communities in the Mycenaean period. Large Mycenaean centres did not develop here, any more than in neighbouring Elis. With the destruction of the Mycenaean centres in the eleventh century B.C. and the settlement of the Doric tribes, the Achaeans from the Argolid moved westwards, defeated the Ionians of the district and settled in twelve towns which they founded: Dyme, Tritaia, Olenos, Pharai, Patrai, Aigion, Helike, Bura, Aigeira, Aigai and Pellene.

The region which they subdued they called Achaea, although gradually the Dorians established themselves here displacing the Achaeans. With the exception of its participation in the founding of the colonies of Southern Italy in 700 B.C. the area played an insignificant role in politics until the fourth century B.C., remaining outside the main stream of events. The establishment of garrisons in various cities during the Macedonian overlordship excited revolt in these same cities and led to the formation of the Achaean League which later developed into a vigorous coalition of almost all the cities of the Peloponnese. The reforms of Cleomenes III at Sparta aroused fear of renewed Spartan overlordship, with the result that the Peloponnese passed again to the Macedonians. The Achaeans sought Roman support in 198 B.C. and with their backing brought Sparta into the League. This later led to war with the Romans because the Spartans made continuous attempts to break away, and the Romans intervened more and more in the affairs of the League.

In 146 B.C. the last general of the League, Diaios, was defeated at the Isthmus of Corinth by the Roman Mummius, and Greece passed under Roman rule. The region was introduced early to Christianity, for St Andrew taught and preached at Patras, where he was martyred in 68 A.D.

In subsequent centuries Achaea contributed little to political affairs and was affected only by the repercussion of events. It suffered from the barbarian incursions (the Goths under Alaric in A.D. 395, Avars and Slavs from the end of the sixth century). The Normans of Sicily, covetous of the area, twice plundered and ravaged it (1080, 1147).

With the Sack of Constantinople by the Franks in 1204 and the subsequent establishment of the Principality of Achaea (or the Morea) the area came to the forefront of history and was divided up into baronies.

The Principality was gradually acquired by the Palaeologues of Mystras, who lost it to the Turks in 1460.

Achaea was prominent in the Revolt of 1821 and the castle of Patras was amongst the first to be besieged. The town was finally liberated from the Turks in 1828 by the French forces led by General Maison.

The capital of the nome is **Patras**. According to Pausanias it was formed by the amalgamation of small hamlets wich already existed in the neighbourhood: Aroe, Antheia, Mesaitis. The Achaeans arrived at Aroe from Lacedaemonia under the leadership of Patreus, who became the founder of Patras when he united seven small settlements around the acropolis of Aroe. In Patras, excavation has ascertained the existence of a flourishing community before the Mycenaean period. Finds from tombs date to the last phase of the Mycenaean period (1230-1050 B.C.) but no Mycenaean acropolis or megaron has come to light and this has led to the conclusion that the Achaeans settled there after the destruction of the Mycenaean centres. During the seventh and sixth centuries B.C. life in the area was tranquil and based on agriculture. The inhabitants remained isolated, taking no part in the communal undertakings of the rest of Greece, such as the Persian or Peloponnesian Wars. Active involvement began only in 280 B.C. with the foundation of the Achaean League. Although Corinth was razed to the ground by Mummius in 146 B.C. Patras escaped his avenging fury, and entered on a period of prosperity much assisted by relative autonomy. When Pausanias visited it, Patras was a cosmopolitan centre. Thanks to the efforts of the Apostle Andrew a Christian community was established very early.

Towards the end of the reign of Justinian (527-565), it seems that the acropolis of Patras was fortified, by re-use of material robbed from older buildings. Thanks to their fortified citadel, the people of Patras were able to withstand the attacks of the Slavs who together with Saracen pirates besieged the city in A.D. 805. The production of silk, which had begun in the seventh century, assisted the economic well-being of the town, which continued to flourish even after the Byzantines ceded privileges in the harbour to the Venetians (1199). It continued to thrive throughout the Frankish occupation (1205-1430) when it was the capital of a barony under the overlordship of the Pope. The town was involved in the Turco-Venetian struggles, suffering repeatedly from attack, incendiarism and massacre. In 1460 it was captured from the Venetians by the Turks in whose possession it remained until 1828 when it was freed by General Maison. Patras is now one of the four most important cities in Greece, and the most important in the Peloponnese. The town extends from the quaysides to the heights of the castle: divided into an Upper and a Lower city, it is marked by its regular street and its gardens and squares.

Remains from the past are few. There is no trace of the many temples mentioned by Pausanias in the market place, which lay near the church of Pantocrator. Only the **Odeon** has been preserved in good condition, sited in St George's Square west of the castle. It dates to *c.* A.D. 160 and is thus a little older than the Odeon in Athens.

The massive ruins of the castle still dominate the town. Stone robbed from earlier buildings was used in its original construction, surviving in the many alterations the castle has since undergone. The enclosure wall forms an irregular triangle; a large round tower projects from its north-east corner, specially heavily fortified, in which the defenders could make a last stand. It is surrounded by a moat.

The **Archaeological Museum** in Queen Olga Square contains Roman sculpture and a Roman mosaic floor depicting scenes from the palaestra and the theatre. Vases,

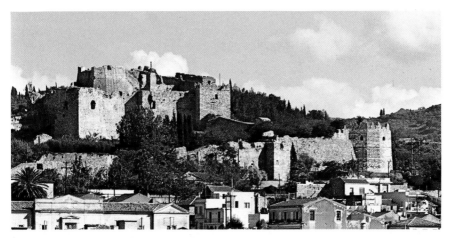

166. *The hill top castle of Patras.*

small finds and weapons from all periods from Neolithic to Roman are on display. On the ground floor of the Public Library there is an Art Gallery, and a Museum of the Press in King George I Square.

About 4 kms. beyond the town lie two monasteries, Moni Gerokomeiou and Moni Omblou.

Rion, 6 kms. east of Patras, is the departure point of a ferry across the Gulf of Corinth to Epirus and Northern Greece. The castle of Rion was built by the sultan Bayazet II in 1499 and repaired by the Venetians in 1713. On the opposite shore at Antirion stands the Castle of Roumeli. In antiquity the two promontories were of particular importance, they controlled the narrow entrance to the Gulf of Corinth. Known as Achaean Rion (south) and Molykrikan or Aetolian Rion (north), Strabo tells us that on the southern cape stood a temple to Poseidon (VIII, 335-336).

Beyond Rion the road passes through many picturesque villages on the way to **Aegion** (8 kms.), which is built on two levels, the Upper and the Lower Town, on the site of the ancient city which excavation has shown to have been continuously occupied since prehistoric times. Aegion was the religious centre of the Achaeans in antiquity, and from 276 B.C., the headquarters of the Achaean League. Pausanias' account of the second century A.D., informs us that the city still retained its political and religious importance. During the Frankish occupation it was the seat of a barony, whose lordship changed hands many times, from French to Florentine to Navarrese, until it surrendered to the Turks in 1458. Until 1821, when it was one of the first cities to be liberated from the Turks, it was known as Vostitsa.

The scenic road continues on to **Diakophto**, the terminus of the rack-railway to **Megaspilaion** and **Kalavryta**. The railway passes through especially majestic and impressive scenery. The first stop is at Zachlorou, where at a height of 924 m. stands the eight storey monastery of Megaspilaion on the steep slopes of Mt. Chelmos. Its original buildings were erected in the fourth century A.D. by two monks from Thessalonica, Simeon and Theodore, but the monastery has been destroyed and rebuilt many times since. In its *Katholikon* is an icon of the Virgin, which tradition claims was painted by St Luke himself. The sacristy contains many manuscripts, icons and

valuable examples of the art of the gold and silversmith. 10 kms. further on, the town of Kalavryta stands in the foothills of the Aroania Mts., on the site of the ancient city of Kynaetha. A medieval fortress was built above the walls of the ancient acropolis.

167. Fragments of the marble statue of Athena, a copy of Pheidias' statue in the Parthenon, with part of the shield which bears a relief presentation of the Amazonomachy.
168. Bird-shaped vase, a representative example of Achaean Mycenaean pottery found in the Mycenaean cemetery close to the winery of Achaia-Klaus.
169. Mycenaean bronze greaves from Kallithea, near Patras.

During the Frankish occupation Kalavryta was the capital of a barony established by the Franks. In 1330 it passed to the Palaeologue dynasty of Mystras who in 1440 sold it to the Knights of St John of Rhodes. They in their turn restored it to the Palaeologues in 1444, from whom, it was captured and occupied by the Turks until 1821. During the War of Independence it played a leading role.

About an hour from Kalavryta lie the remains of the castle of Oria: according to tradition, Katerina Palaeologina committed suicide by jumping from the ramparts to avoid falling into the hands of the Turks in 1463. About 7 kms. further on stands the monastery of Agia Lavra founded in the tenth century by Athanasios the Athonite. Of the earliest buildings only a two-aisled church survives; a newer church (1689) stands to the north. In the old katholikon the standard of revolt was raised in 1821. The monastery owns many historic momentoes of the Struggle for Independence, including the standard, in addition to its relics.

Some 16 kms. south of Kalavryta lies **Lousoi** from which a side road to the village of Lousiko leads to the remains of a temple to Artemis Hemera or Lousiatis. North-west of the temple are the remains of various buildings, amongst them the Bouleu-terion and a meeting hall built like a covered theatre. Close to the ancient city, below the village of Lousiko, is an extensive cave with stalagmites and stalactites, explored in 1971.

On the National Highway towards Corinth stands **Akrata** after which a right turn leads to the waterfall of the Styx, now known as Mavronero. The waters which spring from the Neraidorachi of Mt. Chelmos fall into a precipitous gorge whose rocky sides are black. Here, according to mythology, the gods of Olympos took their oath.

Of the coastal towns which existed in antiquity it is worth noting ancient **Helike** (9 kms. before Aegion) on the site of the modern village of Rodion, one of the most important centres in the prehistoric period, the cult centre of Poseidon Heliconius. The city sank into the sea after a severe earthquake in 373 B.C..

The road from Patras to Tripolis runs through many picturesque villages. 22 kms. from Patras lies **Chalandritsa**, renowned in the Frankish occupation as the seat of a barony, and where remains of several churches are still to be seen, indications of its prosperity in the 13th century A.D. In this area, as also further west, Mycenaean buildings and cemeteries have been found.

Twenty-four kms. southwest of Patras on the Pirgos road lies **Kato Achaia**, site of ancient Dymi, the second largest city in western Achaea, one of the founding cities of the Achaean League and a Roman headquartess under Augustus.

Kato Achaia is one of the most beautiful places in the nome of Achaea and affords the visitor possibilities to visit many picturesque villages. Amongst these, Santameri preserves the castle built in 1311 by Nicholas II Saint-Omer.